D1591555

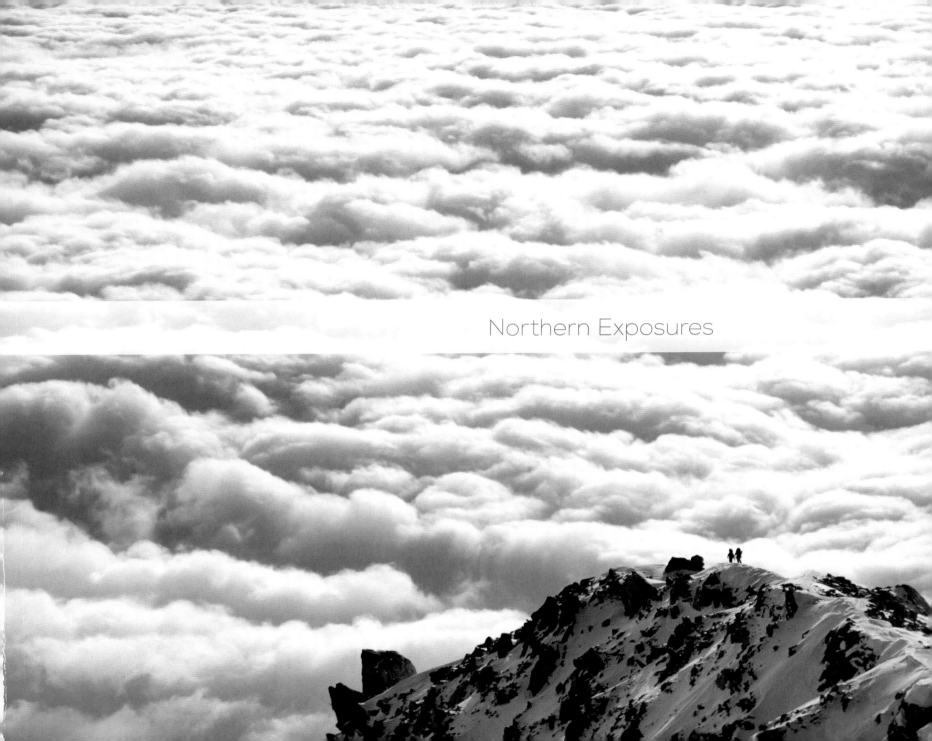

Northern Exposures

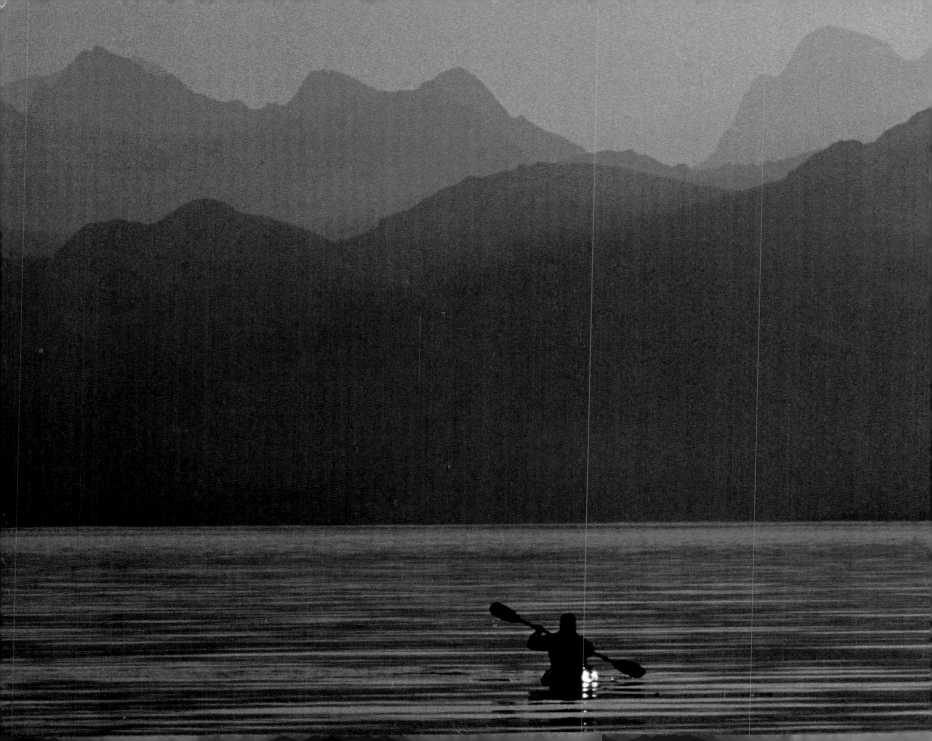

University of Alaska Press
P.O. Box 756240
Fairbanks, AK 99775-6240

ISBN 978-1-60223-192-4 (cloth); 978-1-60223-193-1 (paper); 978-1-60223-194-8 (electronic)

Library of Congress Cataloging-in-Publication Data

Waterman, Jonathan.
 Northern exposures : an adventuring career in stories and images / by Jonathan Waterman.
 p. cm.
 ISBN 978-1-60223-192-4 (clothbound : alk. paper)—ISBN 978-1-60223-193-1 (pbk. : alk. paper)—
 ISBN 978-1-60223-194-8 (electronic)
 1. Waterman, Jonathan. 2. Mountaineers—Arctic regions—Biography. 3. Conservationists—Arctic regions—Biography.
 4. Travel writing—Arctic regions. 5. Travel photography—Arctic regions. I. Title.

GV199.92.W38A3 2013
796.522092—dc23
[B]
 2012034801

Cover design by Andrew Mendez
Text design by Paula Elmes
Cover photos:
Front: Andy Lapkass and Peter Cooley beating out of the Alaska Range along the flooding Yetna River. Photograph by Jonathan
 Waterman. Back: The tallest mountain in North America, known to Alaskans as Denali (a.k.a., Mount McKinley), rising an
 incredible 20,000 feet above the forest—at 320 feet above sea level—on its south side.

This publication was printed on acid-free paper that meets the minimum requirements for ANSI / NISO Z39.48–1992 (R2002)
(Permanence of Paper for Printed Library Materials).

Printed in China

Northern Exposures

An Adventuring Career in Stories and Images

by Jonathan Waterman

University of Alaska Press
Fairbanks, Alaska

For Nicholas and Alistair

Contents

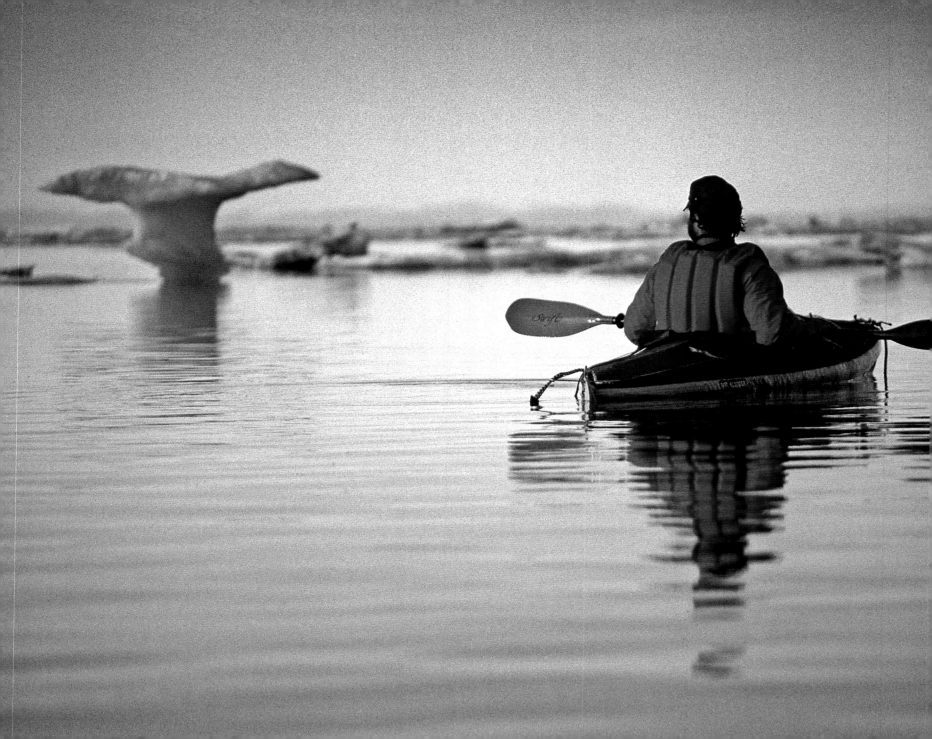

Introduction

FOR THIRTY YEARS I have traveled north with a journal and camera. I went to these cold places so that I could climb, paddle, ski, dogsled, walk, and sail. To lose myself in the natural world. Often in subzero conditions, sometimes dog-tired or scared, I exposed photos with single-lens-reflex cameras. I wrote with stubby pencils about these adventures in journals stained with tea, squashed mosquitoes, and blood—exposing naked emotions, my fears, and the beauty of the wilds. Back at home, while studying these two different types of *exposures*, I wove them into a tapestry of words built with pictures. My northern exposures gave me bliss, a writing and photography career, and a lifetime of indelible memories. Now in lecture halls or at my kids' bedsides I also tell these stories about

Along the Arctic National Wildlife Refuge's Beaufort Sea coast a paddler contemplates a mysterious form: is it a whale tail or an iceberg?

bear encounters, climbing mountains, or remote kayaking trips. And my stories became books—twelve (seven about the North), counting the one you're now holding.

The books define me as a writer, but I'm also a lifelong photographer. Capturing images has always given me joy and a sense of accomplishment; writing in my journal, let alone turning these entries into cohesive stories, has always seemed unending work. The best stories can always be improved, but the best photographs remain complete. Taking pictures can also be a lot of fun.

I exposed thousands of color slide photographs and then, as my recent panoramic-gigabyte-scale photography consumed one hard drive after another, more than twenty thousand digital images. Still, quantity doesn't equal quality. Early in my career, but long after I started publishing my stories, I, like most dilettante shutterbugs, rarely published my images. Occasionally, they were pulled out of

Kodak carousels (for lecture tours) to illustrate articles; scores of these images eventually graced book, magazine, or journal covers. Even when they appeared as ghosted-out black-and-white chapter openings or shared space with glossy color advertisements in magazines, I took consolation that my images were more than just research tools for injecting imagery into my prose. Among the competitive and poorly remunerated ranks of struggling free-lancers, I sometimes doubted the power of my words or images, but I had an advantage that kept me going: my northern journeys rewarded me more than any paycheck.

It's no coincidence that most of my stories in-volve cold places and risk-taking—a small price to pay for the pleasure of reaching high ridges, isolated shores, untraveled glaciers, or remote rivers in order to witness natural beauty. As the French airman Antoine de Saint-Exupéry told his mother, "At times like these one risks one's life with a great deal of generosity."

It became part of the risk-taking to write stories to try to explain the sense of incomple-tion—the hungry worm gnawing from within.

I've also done it, like a short-story writer warm-ing up for a novel, because I can experiment with form ("A Near Miss on Mount Fairweather in Winter" was an opportunity to employ a second-person narration). Or while crossing the Northwest Passage ("Arctic Solitaire") I was stretched, both physically and spiritually, dur-ing the most strenuous and lonely journey of my life.

As the doubts and memories of suffering fade, I'm drawn back north anew. The names of places still unvisited roll from my tongue like mantras: Black River, Ellesmere Island, Repulse Bay, the Juneau Ice Cap, the Kamchatka Peninsula, Banks Island, the Coppermine River, and Greenland.

Before I figured out that I could support my-self (and later a family) with pencil and camera or by telling stories from a podium, I dreamed my life from one expedition to the next. Thirty-six years later, I still can't help myself. The trips I took north of latitude 58—where popula-tion densities thin out and the rivers roar in direct proportion to the size of the mountains above—offered me an expedition template

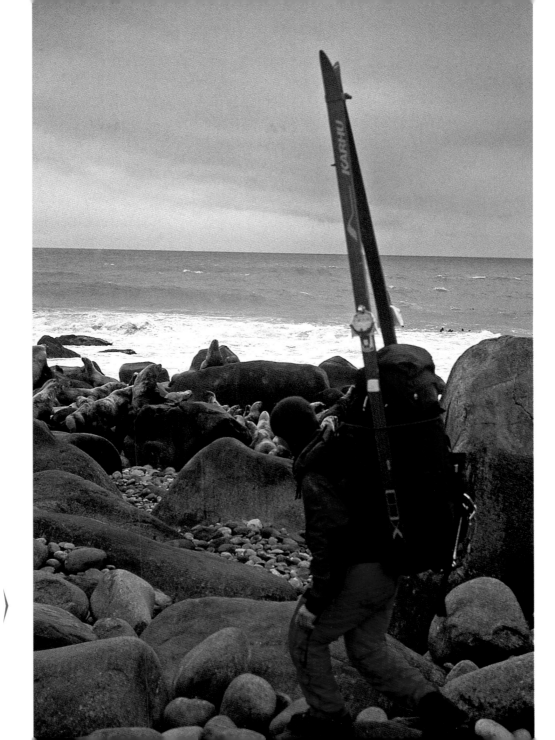

Nancy Pfeiffer at a remote sea lion colony along the Pacific Ocean after an epic winter retreat from Mount Fairweather.

that empowered me to pull off expeditions anywhere in the world. Once you've kayaked twenty-two hundred miles across the Arctic, paddling from source to sea on the Colorado River (the research trip for my last two books, *Running Dry* and *The Colorado River*) doesn't seem terribly daunting.

Herein, my confession: on these comfortable larks—where nothing can eat you, cellphone towers are usually in range, and a night caught out in the open merely means that you lose a little sleep instead of your big toes—I often come home comparing my Lower Forty-Eight adventuring to my northern exposures. Until I die, it is these northern journeys that will define me, give me a sense of completion, and enrich my imagination.

My writing was inspired through ice climbing in the early 1970s. I was frustrated about communicating the beauty and joy of clambering up frozen mountains. To account for myself, I wrote poetry. I strove for the form of the great northern balladeer Robert Service. One February, after hitchhiking north on Interstate 93 to a peak in the White Mountains of New Hampshire as a sixteen-year-old high school truant, I scribbled and stashed away this poem:

> Working hard to reach the peak
> I realize that summits are not all that I seek
> Being surrounded by nature comes a
> feeling called 'free'
> Excluded from the modern world of
> technology

My father expressed contempt for exposing oneself to the freezer but had composed piano music to Robert Service's *The Spell of the Yukon*. Inadvertently my dad helped lure me to adventuring in the North by giving me that book of verse. I had already been inspired by such high-latitude books as *Endurance: Shackleton's Incredible Voyage*, *One Man's Wilderness*, *The Hall of the Mountain King*, *Call of the Wild*, *Minus 148 Degrees*, and *The Mountain of My Fear*. I visualized the northern lights blazing in the black canvas of sky, hundreds of glaciated mountains and icy rivers brimming over with mystery, and air so crisp and frigid that you could spit then hear your saliva freeze like a zapped bug before it hit the permafrost beneath your mukluks.

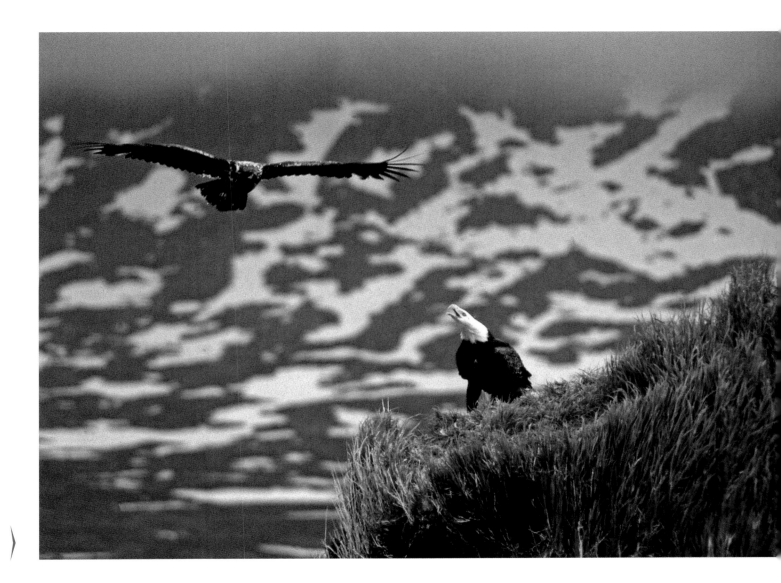

Immature bald eagle harassing an adult sitting atop a salmon (hidden in the grass), McNeil River State Game Sanctuary, Alaska.

In 1976, at nineteen years old, my dreams came true. I went to Denali with my Explorer Scout troop and hundreds of other climbers who were celebrating the bicentennial year by trying to stand atop the continent. Slogging up the easy West Buttress route—never really scared or hungry or deeply moved—showed me how to realize my northern ambitions. The story I published in the scouting magazine exposed my disappointments about traveling all the way to Alaska only to join the crowds. The first animals we saw upon landing at the Anchorage airport were a colony of gulls, swarming like the species I knew from New England landfills, rather than the hoped-for convocation of bald eagles. I chafed at being a member of a naive and large team that carried backbreaking loads (we didn't pull sleds) "up the Butt" (as the guides call that route).

Fortunately for accomplished poets everywhere, at this time I got a camera and substituted photography for poetry. By 1978, having learned about the crowds on Denali, along with other tricks of efficient glacier travel, I packed twenty-four rolls of film and a camera into Mount Logan's unclimbed West Ridge in the Yukon Territories. The route was a watershed for a budding mountaineer, allowing me to apply principles of self-sufficiency and safety on a dangerous route. We supplemented the freeze-dried food with high-fat margarine for calories. We dragged (rather than shouldered) our loads while traversing glaciers. And we learned patience—making crossword puzzles for one another out of our cardboard cereal boxes—during the pervasive Gulf of Alaska storms.

Most of my photographs are more landscape than action scenes, deliberately exposing how nature dwarfs humankind. I took closeups of peach-lit seracs, freighter-size crevasses, and mountains filling the field of view. When climbers appear within these images, they're distant insects below hungry cornices or silhouetted as dark Lilliputians in front of serenely lit giants. Inspired by Eric Newby's book *A Short Walk in the Hindu Kush*, I wrote a similarly self-deprecating and whimsical apologia of our new route in the Yukon. *Climbing* magazine published "A Walk Across Mount Logan."

Steve Davis, Roger Hirt, and an elephant-shaped shadow on the first ascent of Mount Logan's West Ridge, Yukon Territories, Canada.

At first I did not delude myself into thinking that I could make it as an adventure writer. I worked at a climbing store because I got wholesale discounts on expensive equipment. I cleaned swimming pools in Massachusetts, worked as a guard-dog agitator in Arizona, and borrowed money from my wealthier partners all over the world (the Logan story earned me $175, or 14 cents per word). My photographs from these early expeditions earned less than the cost of camera, lenses, and film. A quarter of a century later, such unclimbed routes can be tilled into profitable excursions through numerous outdoor equipment sponsors, grants, and magazine contracts that now pay up to several dollars per word and several hundred dollars per page for images.

Back in the day, however, to support my photography, writing, and adventuring habits, I became an Outward Bound instructor, a climbing and wilderness guide, and a park ranger. For eight years, most of my stories or book manuscripts were rejected (in one year, I garnered twenty-one rejection letters on an unpublished novel). But I was blithely following my adventuring passions in the North, initially around Denali. I would eventually publish three books (and expose countless rolls of film) in an attempt to define that mountain.

In the winter of 1982, I climbed the Cassin Ridge in windchill temperatures dropping to one hundred below. The camera lens of my Rollei froze shut early on, after we climbed over the bergschrund at dawn. For the next ten days, the climb was one continuous calculated risk. My two partners and I knew that one storm would have blown us from our tenuous position on the south face of Denali—our bodies, invariably, would have disappeared where they landed, buried beneath the snow. I swore I'd never take these kinds of chances again, and although I've since been on longer and more extended expeditions, I never again trusted so completely to luck as I did during that climb. From 1982 to 2004, I also tilled this near-demise into work: rewriting the story and publishing different versions in the *Denver Post*, *Anchorage Daily News*, *Appalachia*, *Climbing*, *Ascent*, and *Rock and Ice*. In the latter "book" (as editors proudly refer to their magazines), I candidly admitted

how far we had hung it out and why we may have failed as teammates (see "Cavemen").

One photograph—of two hooded men hunched over and digging for shelter in a subzero blizzard—got published a lot over a quarter century and may have told the story of our suffering as well as the written narrative. Out of context, the photo simply looked like desperate conditions you might encounter on a bad winter weekend, but alongside the story, the photo shows how small we all felt during a month-long ascent into a cold, inverted hell.

In terms of making my living as a writer or photographer I couldn't afford rent, and I briefly reduced myself by collecting unemployment. I rescued myself by conceding to my own mistakes during the winter climb and published my first book, *Surviving Denali: A Study of Accidents on Mount McKinley*. I broke the book into chapters on history, frostbite, falls, and altitude illness then identified the patterns of death, disaster, and mishaps among hundreds of climbers. To date, it's my most successful work in terms of identifying exactly *who* my

reader is (the aspiring Denali climber), providing a service to that readership, saving a few lives, and reducing taxpayer-financed rescues. The photographs—contorted limbs on climbers' corpses, incoming lenticular clouds, and iced-over beards—say it all.

In these years, I queried the Random House editor Joe Fox with book proposals that would have potentially financed more expeditions. Fox, in my mind, was the gatekeeper to New York publishing. He held many luminary authors—including Peter Matthiessen, James Michener, Truman Capote, and John Irving—in his stable. He wrote:

> Dear Mr. Waterman:
>
> Good luck on the climb; when I'm shivering in New York at 20 degrees above I'll be thinking of you on that mountain at high altitude and 50 degrees below and will pray for you.

Mr. Fox—given names are shied away from until you gain entry into the inner sanctum of a New York editor's stable—rejected my novel,

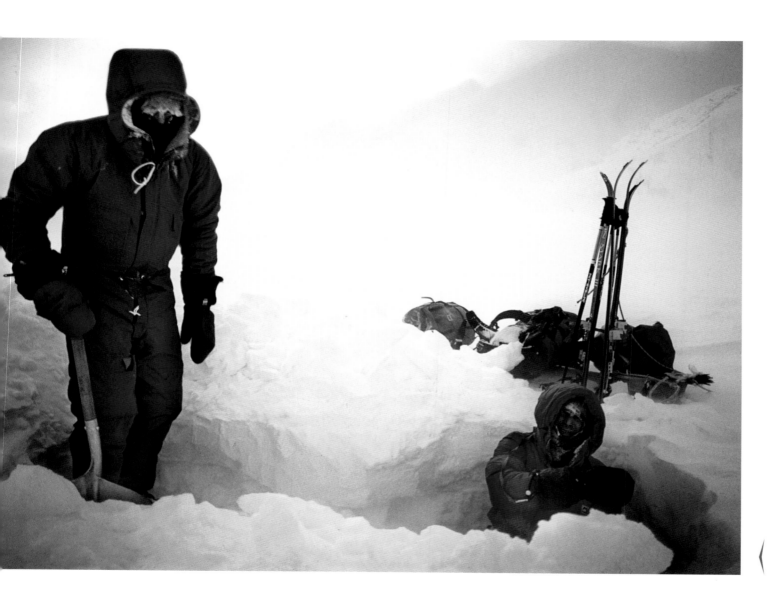

In a tent-destroying blizzard with -60 F wind chill, Mike Young and Roger Mear stay warm by digging a snowcave shelter during our winter ascent of Denali.

Wolves, with kind advice about the weakness of the characters:

Dear Mr. Waterman:

Don't be discouraged by this; it would be miraculous if you'd sat down and written a publishable novel your first time out—just as miraculous as my climbing the Cassin without any previous climbing experience.

This happened again twenty years later, when another legendary Random House editor, Gary Fisketjon—who bankrolled my *Arctic Crossing* project and the nonfiction book by the same title—rejected my fiction manuscript, analogizing the workings of a good novel to a race car that needs endless tuning, parts, and a powerful engine.

Once, in the mid-1980s, sweating in a cheap sport coat in the New York humidity, I rode the elevator up to Mr. Fox's office on the seventeenth floor at 201 East Fiftieth Street. He looked cool in his stylish jacket and tie, and I felt daunted by the pile of learned and literary manuscripts, wondering if my pages would ever be graced by touching his desk. I couldn't help staring out the huge windows at his view of the river and seascape that is Manhattan's best-kept secret. The implications of this exposure—a vertical village utterly removed from nature—and what it might mean to the future of our race perturbed me. In distraction, I could scarcely speak as he finished a fascinating story about Siberian eagles trained to kill wolves. I became even more anxious when he shook my hand goodbye because he felt how sweaty my palms were from wiping my forehead; fortunately, he couldn't see that my shirt was drenched with sweat beneath the wool sport coat.

I thanked him for his time, but he had already turned back to his mountain of manuscripts. He was a dedicated soul, and I never forgot his thoughtful correspondence or the time he took to visit with me—a veritable stranger—amid the demands of his work.

Several years later, Mr. Fox sank back on his leather couch and with the din of downtown blaring seventeen floors below, he died of a heart attack. It was a calculated risk of

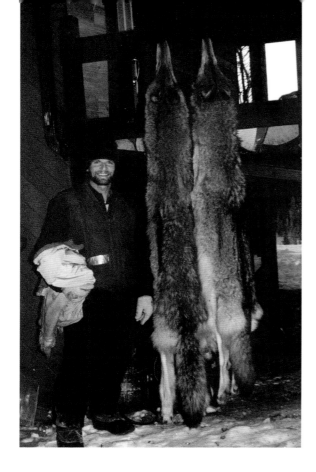

Chuck McMahan and wolf pelts drying at his home in Gakona, Alaska.

this high-stress business for such a respected editor, perched above New York, happily obsessed with the endless pitches above him: manuscripts to be uncoiled and protected as books that would have the lasting eternity of mountains.

Concerned about succumbing to a similar fate, and to stay true to his dreams, *Mr. Waterman* kept returning to the North. And, mostly, I stuck to nonfiction. To better understand wolf poaching for the novel that Mr. Fox rejected, I investigated an aerial hunter and wrote "Sheep's Clothing" for *Outside* magazine—my photos of the poacher posing beside his dead trophies haven't been published until now, but this controversial wolf "sport" still continues.

In the late 1980s, I began writing stories on the most symbolic environmental issue in America: drilling for oil in the Arctic National Wildlife Refuge. Although ANWR is the acronym that the uninitiated still use ("Ann-Wahr" resonates like another oil-rich Arab emirate that Big Oil would like to exploit), I learned to call it "the Arctic Refuge" instead. The salvation of its 1.5-million-acre coastal plain would become a consuming passion for me over the next two decades—defining me and the role that I believe all adventurers should play in defending untrammeled wilderness. On these trips, I shot many rolls of film. I filed the pictures, then

Claustrophobic head nets are no replacement for insect repellent and a Buddhist outlook: without bugs there wouldn't be so many beautiful birds.

took them out again and again as handy reference materials and scene "painters" as I wrote my stories.

I had already taken dozens of kayaking and rafting trips as an adjunct to mountaineering expeditions. Eventually I started paddling as a means to an end, because kayaking—along with skiing, backpacking, and dogsledding—gave me the same joy as mountaineering. Kayaking trips to the North, in fact, demand the same level of mastery implicit in a cold-weather mountaineering expedition. Air temperatures aren't sub-zero, but sitting atop or capsizing in the glacial rivers or in the Beaufort Sea demands a winter mountaineer's sensibilities. Bears and mosquitoes and ice-bound surf replace crevasses and avalanches and wind. Storms, at least north of the Arctic Circle, are the equal of anything I experienced on high mountains. The only ingredient in northern kayaking happily absent is high-altitude illness—my Achilles' heel. And the soft light, impossibly bent through the northern sky, was a photographer's heaven—*if* you could find a windy spot without a cloud of mosquitoes blurring the scene.

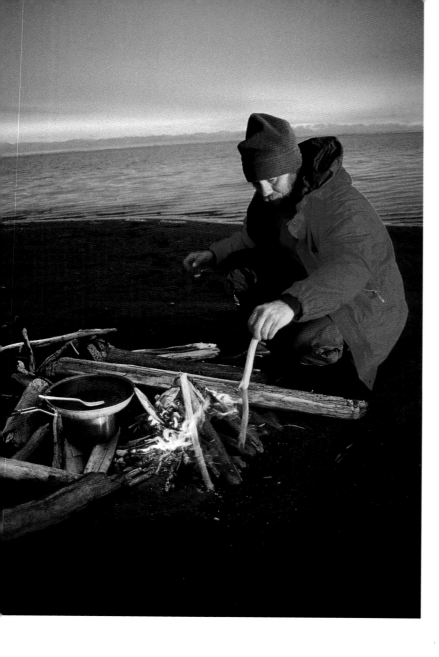

Far from any forest, the icy northern Alaska coastline—decked with driftwood from the Mackenzie River—offers guilt-free campfires.

On my second assignment to arctic Alaska I received several dozen rolls of film and a generous cash advance from one of many now-defunct magazines to bring back photographs of the international Porcupine caribou herd migrating through the mountains or calving on the coast. But all 178,000 caribou stayed in Canada that year.

Two decades later, I wrote a first-person narrative about that two-week expedition from the headwaters of the Kongakut River to the coast and then another sixty miles along the Beaufort Sea to Barter Island (see the title story "Northern Exposures," a story that also cribbed from a college-accredited course I guided in 1989). Mostly I exposed images of long-tailed ducks, geese, and gulls raiding eider eggs. Or a set of velveteen antlers left by a hunter atop an oil barrel. And a dead seal, on a section of beach that reeked of spilled oil—the same fossil fuel they hoped to drill from beneath the tundra.

Like climbing Denali's easy route in 1976, these arctic kayaking trips gave me invaluable experience and would allow me to conceive the ultimate expedition. I had met several Inuit,

and these cultural interactions—along with the breathtaking splendor of a land and sea where the sun doesn't set for two months—would eventually allow me to shift into a higher spiritual gear as an adventurer.

After the trip down the Kongakut River to Barter Island—twice having to rescue my capsize-prone partner—I realized that being alone would free me from the onerous responsibilities of caring for a less-experienced partner (or competing with a tougher one). Furthermore, the land and the sea spoke of ancient unseen beauties, and there was enough curious wildlife that it would be difficult for an imaginative person to ever feel truly alone. So I decided to solo the Northwest Passage in a kayak.

It took me a decade to find the courage to go. During the ten-month trip, taken over three summers from 1997 to 1999, I closed a circle on my earlier expeditions, which often left me with an indefinable sense of pathos and anticlimax. On this journey, by virtue of traveling in the mythical vessel invented by the Inuit, whenever I paddled into their camps, I unwittingly drew their attention. (The villages I visited had stopped using kayaks a long time ago.) Uncharacteristically for a culture disinclined to ask questions or talk to strangers, they shared their lives with me. In turn, I told stories. This included my experiences with truculent bears, beluga whale sightings (the blubber, or *muktuk*, is a sought-after delicacy), and discussions on the mysteries of the landscape: for example, no one knew what causes the strange humming noise heard along much of the arctic coast—the inexplicable sound was maddening. A few elders, however, understood the different meanings of the many forms of ancient rock cairns, or *inuksuit*—literally, "in the form of a man"—I saw piled as eerie stone markers along the coast. So, as I passed the muktuk, they too held forth with their time-honored stories.

To bring back something relevant for my own culture, I needed to capture a photo that unveiled the wonders of the North. So before leaving my home in Marble, Colorado, I practiced in my front yard mounting a camera atop a kayak mast. After exposing two rolls with a handheld remote, I found the perfect

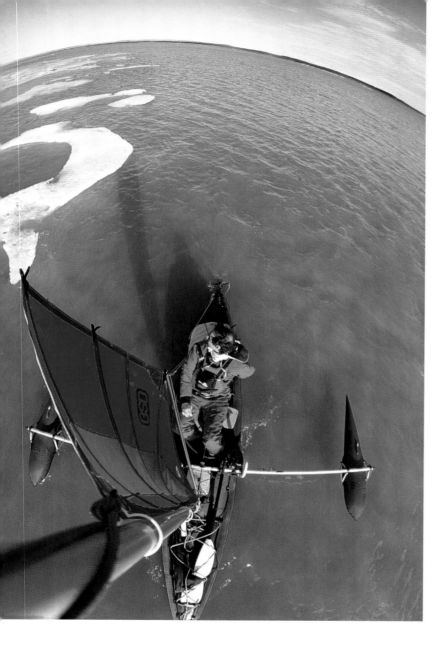

While sailing through the ice pack, outriggers stabilized my kayak. The vast space of the Canadian Arctic gave me considerable joy.

positioning for a fish-eye lens to show how the aspen forest (which I would later reshoot and replace with the Arctic Ocean) dominated my flimsy craft, with the lens unnaturally bending the horizon as if I was on top of the world. The photograph that I shot while rounding Whitebear Point, in Nunavut, Canada— exposed on twenty-nine different frames on a single roll—was a natural choice for a book cover and the lead for my *National Geographic Adventure* magazine article, the cover of my book *Arctic Crossing*, and a score of other newspaper and magazine articles.

While publicizing these stories, I clung to perspective and avoided the hero mantle that the public is conditioned to attach to conquering adventurers. After all, "conquering" nature— summits, rivers, the poles, or ocean/continent crossings—will leave an adventurer stung by the aforementioned anticlimax. Escaping on athletic journeys through the wilds to attain mastery or chalk up another first ascent is merely narcissistic sport. It may have worked, for instance, in Hermann Buhl's more innocent times, during his record-shattering solo climb of Pakistan's

Nanga Parbat in 1953. But not for his more accomplished disciple, Reinhold Messner (see "All Fourteen Eight-Thousanders"), who first soloed Everest in 1980. Messner, the greatest alpinist of the twentieth century, often wrote (albeit in psychobabble at worst or poorly translated German at best) about his feelings of pathos and anticlimax. Shortly thereafter, he took a stand by proposing that trashed-out mountain ranges be protected as "White Wilderness."

Herein are more shining examples of adventurers who speak out for the environment and avoid beating their own chests: the wildlife biologist George Schaller (see "Sacred Place"), for daring to cross over the boundary of neutral science into politics; the dogsledder Will Steger (see "Price of Adventure"), a spokesperson for global warming; and the Japanese mountaineer Masatoshi Kuriaki (see "Divine Wind"), who prizes mountain reverence over conquest.

My discoveries—detailed in twenty-three stories within the sixteen chapters herein—are about environment (and cultures) at risk. To wit: landlocked polar bears, invasive cruise ships, the commercialization of adventure, climbers lacking self-sufficiency, endangered wolves, musk oxen on the verge of depletion, rogue grizzlies, Big Oil run amok, and places still untouched by the hand of man. Anyone paying attention and taking notes or pictures can begin to show us what's really going on out there.

It amazes me that most adventure writers (that is, passionate expeditioneers, *not* the weekenders, editors, or staff journalists given an assignment about the wilds) stick to their narratives of adventure mastery and leave the politics to the nature writers and environmentalists. Piss off half your readership, as my literary agent Susan Golomb once wisely counseled in the 1990s, and you'll lose half your sales. But times are changing.

If we fail to report on the health of wild places, the next adventure-seeking, wilderness-loving generation will be forced to live vicariously through our old narratives of the bygone days when the caribou herds still ran prodigious across international boundaries and the northern coast of Alaska was not one continuous oil field (at press time, only 10 percent of that six-hundred-mile shore is not open to oil

drilling, but that could change by the time you read this).

The publishing world too has changed and become much more competitive than when I first started submitting manuscripts in the late 1970s. Internet technology and recession have revamped the industry: a half-dozen stories in this collection were published by three different magazines that folded and collapsed shortly after my pieces were published.

My experience with editors might serve as helpful advice. Magazine, newspaper, or journal editing is a thankless task: consuming deadlines, endless rewrites, ungodly work hours, and advertising hypocrisy that sandwiches an organic story of wilderness between full-page ads for four-wheel-drive vehicles. Few editors sought me out. I badgered most of them to accept and print my work. The overworked editorial soul rarely returns phone calls or correspondence in a timely fashion and is often disconnected from the ecology-oriented adventure that is my beat. So if you choose to follow this path as a freelance photographer or writer, pack plenty of humility, be prepared for accepting

the burden of compromise—let alone the sting of rejection—and consider working as a guide, naturalist, ranger, or any number of other great outdoor jobs. If you're a writer at heart and you must enter the servitude of a magazine or newspaper editor career, quit editing and start writing again as soon as you've learned the basics of the trade. There's no quicker route to crafted prose than a brief editorial internship.

Still, someone—preferably one with a steel-rat-trap mind and a universal intolerance of cliché—has to take these trying jobs. And I am grateful for the professionalism of those editors who fine-tuned my rough manuscripts and images for these stories. The pieces originally appeared in *Alpenglow, American Alpine Journal, Backpacker, Climbing, Envoy, Hooked on the Outdoors, Mountain, National Geographic Adventure, Outside, Patagonia, Rock and Ice,* and the *Washington Post.*

My ideal writing destination is in book-length narratives, where editors are more sympathetic to artists, where you are allowed to espouse your ideals and Photoshop your pictures—even

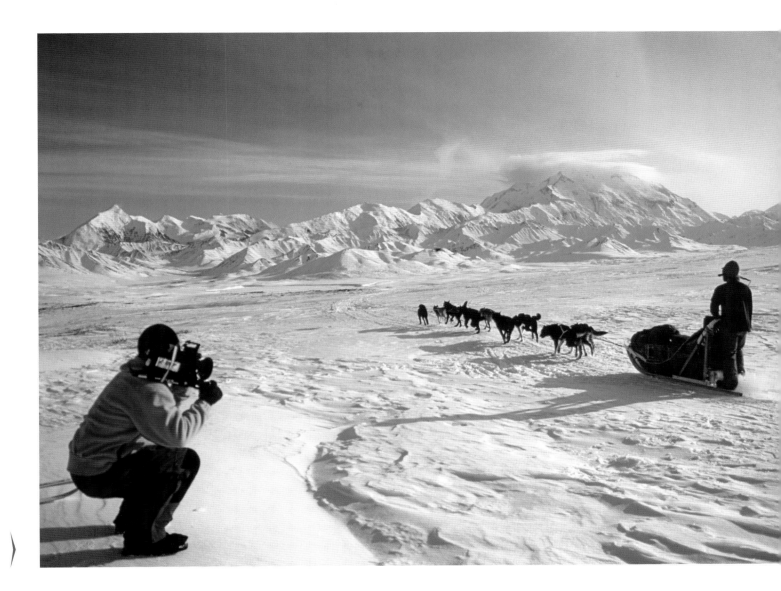

Making TV films (we traversed Denali by dogsled, ski, and kayak for ESPN) is a great way to share the North with a large audience.

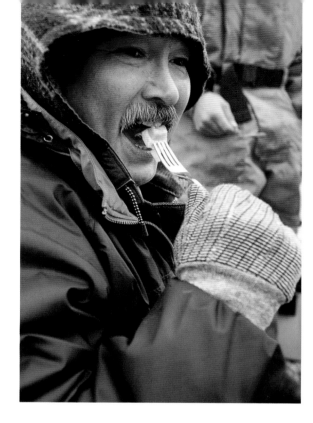

if most book editors can't match the magazine paychecks. In this regard, I remain indebted to my literary agent, Susan Golomb, who boosted my book-publishing career more than anyone else. Books can promote wilderness instead of SUVs. And in a book such as the one you now hold in your hands, the volume will outlive you in a way that has already failed the original glossy magazine pages.

I would have stopped freelancing if not for the rewards: autonomy, plenty of fresh air, and ceaseless travel to wild and colorful landscapes where shaggy creatures, avalanches, or storms might someday allow my family to collect the proverbial life insurance policy. In the face of all this, I still consider it a privilege to publish my work—the research for which can be more like *play*—in magazines or books.

In some of the expedition stories that follow, I deliberately sought refuge from the madding world and focused solely on the challenges of the mountain above, occasionally deluding myself into thinking that these adventures were a separate reality from the world I was escaping. But the more I traveled, particularly in a kayak, the more it became apparent that wild places are part of one world that is desperate for a defending voice. So I won't be able to return to the remote Gulf of Boothia and paddle eastward without contemplating shipping lanes in the soon-to-be-ice-free Northwest Passage. Nor could I return to Denali without considering, let alone publicizing, how that mountain's principal drainage, the Susitna River, is now

threatened by a dam. And I would never write about Mount Fairweather or Mount St. Elias again without noting the cruise ships, extensive logging in the virgin forests, and the surrounding marine world and ice fields at risk.

We live in a world that is rapidly changing. As we turn toward one global market, cultures are being assimilated and natural resources depleted; the availability of fossil fuel and fresh water determines the wealth of whole nations; economies are stuttering. Amid this change can we find it in our hearts to save rather than exploit the last wild places of the North?

Many cultures, including those villagers I visited in the Arctic, have long found answers to similar conundrums through storytelling. Through our age-old stories, we try to make the world a better place, share beauty, and revere life—just like in those Inuit camps, as I passed the muktuk, the caribou meat, and the coffeepot.

This is my life's work.

—Jonathan Waterman, January 2013

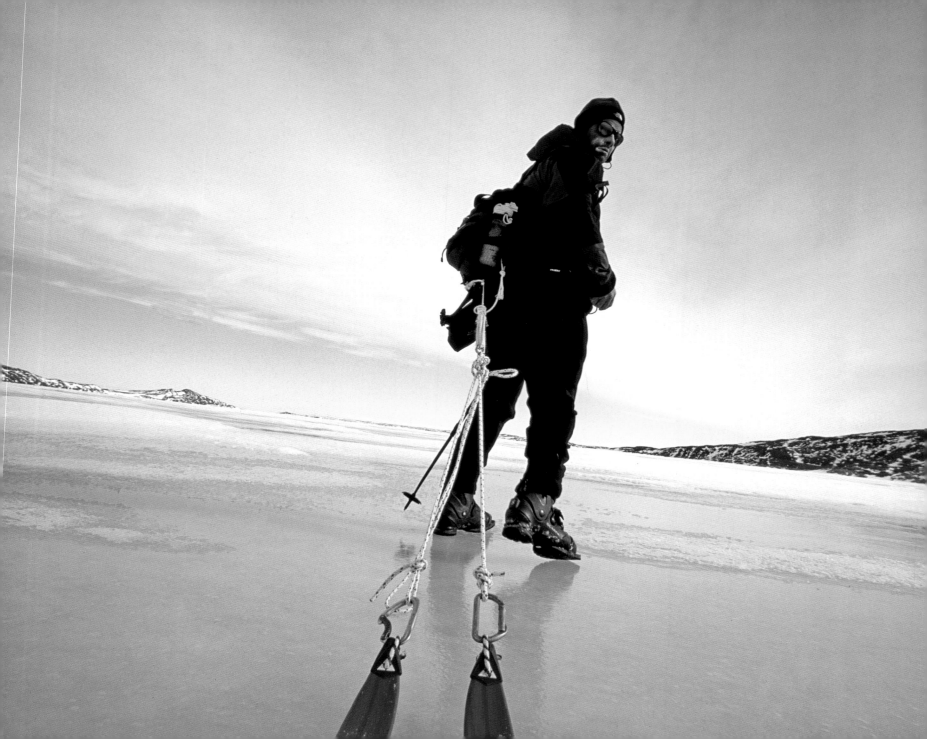

This twenty-two-hundred-mile journey across the roof of North America was the most challenging expedition of my life. Amid the rigors of arctic travel and the psychological demands of being alone, I also had to capture a compelling story. I remained vigilant for bears, wolves, or caribou to share the scenes with me so that the pictures and film wouldn't just amount to a lone talking head. I soon learned that in a remote wilderness so rich with wildlife, it wasn't hard to get these species and others to share the show with me. I had so many mishaps and so many amazing wildlife encounters that the Outdoor Life Network stretched my footage into a two-hour time slot on TV. In three villages along the way, a Dutch cinematographer met me and provided crucial support, but mostly I traveled alone and employed tripods and a camera remote. The upshot of this constant work was that the act of photography and journaling gave me a creative outlet that effectively removed me from the crushing solitude and drudgery of repetitive paddle strokes, exhausting portages, and lonely nights. Half mad at times, I talked to the camera as if it were my companion.

I wrote this story for National Geographic Adventure as I composed the book Arctic Crossing: A Journey Across the Northwest Passage and Inuit Culture. While it took ten months to paddle, sail, ski, and dogsled across the top of the continent, it took twelve months to write the 120,000-word book. I edited the final draft, including the story that follows, by reading the narrative aloud each night to my wife, June. As I learned from the Inuit, oral storytelling is a revered tradition. Reading aloud also showed me cadence and pacing; whenever

Since the arctic summers were so short, I took advantage of good weather and easy walking to make miles on the spring sea ice, Bathurst Inlet, Nunavut.

June's eyes wandered in boredom, I drew quick excisions over the pages. And to provide more immediacy about such a distant and alien landscape, I wrote the story in present tense.

The year after the book was published, I submitted a thirty-page section (with some of the same prose as the following narrative) to the National Endowment for the Arts. To my delight and surprise, the judges awarded me that year's nonfiction literary fellowship, replete with a large check, which allowed me to take the next year off from writing as June and I built our energy-efficient solar home.

ON A HOT, fifty-degree arctic morning in early July 1998, I ply the wind across the Northwest Passage. As the sail flies tight above my sea kayak, I lean to starboard to avoid capsizing into the icy Beaufort Sea. Along the cliff-lined shore, naturally burning seams of subterranean shale send wavering plumes of smoke skyward like eerie, alabaster tree trunks. Then the wind shifts, fanning noxious, choking clouds out to sea. I steer farther away from shore and tie a bandanna over my face.

When I started paddling this morning, the sea was calm. Then, a few minutes ago, the wind picked up, and I raised the sail. Sailing a kayak without outriggers might seem foolish, but going ashore to inflate sponsons and assemble outriggers is as distasteful to me as capsizing. Along with rockfalls and fumes, the shoreline hazards of the Smoking Hills of Franklin Bay include mosquitoes as thick as schools of herring. I've read that swarms of these arctic insects can inflict as many as nine thousand bites a minute, which would exsanguinate a man in four hours.

So I compromise by sailing a hundred yards from shore, riding the wind just beyond the choking smoke. If I were to capsize in a temperate ocean, I could easily swim to the cliffs. Removing my glove, I dip a hand into the sea: in just ten seconds, my fingers ache with the cold. If I were to drown here, my body would probably never be recovered—not a happy thought. But there would be some consolation: having

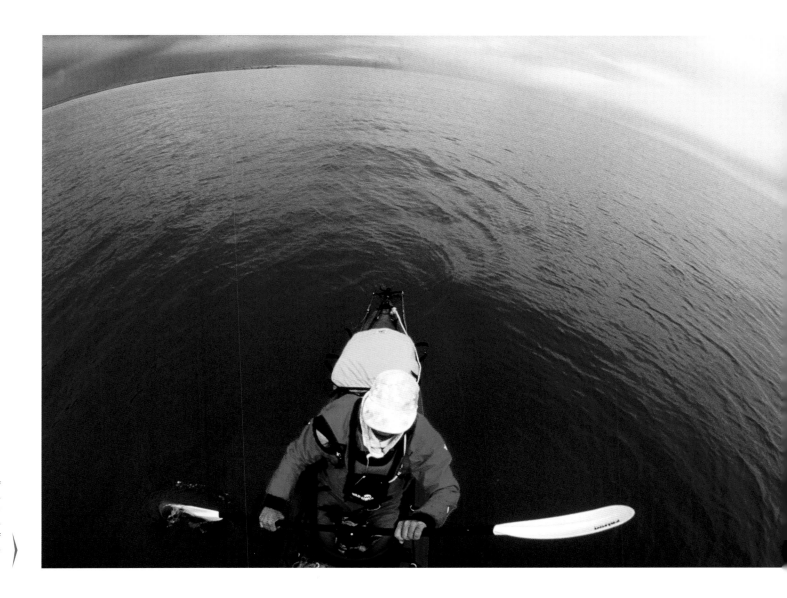

On my third summer of paddling (alone in the isolated Queen Maud Gulf, Nunavut), I wore a dry suit to ward off hypothermia in the frigid water.

my remains picked clean and helping to sustain the spacious Arctic would be far preferable to feeding worms in a crowded graveyard.

I haven't seen another soul for more than two weeks. Although crossing the Northwest Passage has long been my dream, the plunge into solitude continues to unnerve me. To help me focus, I remind myself that I'm up here to do something unequivocal. Something that will satisfy me in my old age. While I was explaining myself to skeptical friends and family back home in Colorado, my thoughts seemed coherent, but out here, I often feel lost. Mostly I tremble at how quiet and huge it all is. I haven't spoken aloud in days. I wonder whether I will lose the ability to talk.

When the wind starts to gust, I gauge the strength of oncoming flurries by the size of the whitecaps. At each hit, I loosen the sheet and let the sail swing to the lee. As the wind diminishes, my speed drops to about four knots. Then I sheet the sail back and accelerate to eight knots. As I round a point, a rogue gust surprises me. Before I can release the sail, it's filled with a blast of air that rolls the kayak, throwing me into the sea. I grab the kayak's stern line and begin kicking madly toward shore, towing my boat behind me. Thirty yards out, my arms stiffen and my legs drop. To my relief, however, I realize that I can stand up: my chin is just above the water. With new determination, I lumber up onto a narrow beach beneath the cliffs.

Shivers rack my body, which feels as if it no longer belongs to me. I strip off my clothing, grab a dry bag, a thermos, and some dried fish, then bolt forty yards to the nearest smoking vent. Dressed only in smoke, I try to sip warm tea, but my cold lips feel scalded by the liquid. I drop the cup and towel myself with a shirt. Acrid fumes rasp the back of my throat, but it's worth breathing foul air in exchange for heat. With strange detachment, I watch my weeks' worth of food bob in the surf next to the kayak. Stupid brain, stupid brain, stupid brain. What am I doing here anyway?

My inspiration for attempting the Northwest Passage came from Knud Rasmussen's *Across Arctic America*, published in 1927. In the book,

a shaman named Igjugarjuk provided the Danish explorer and anthropologist with insights into Inuit culture. Igjugarjuk told Rasmussen, "All true wisdom is only to be learned far from the dwellings of men, out in the great solitudes, and is only to be attained through suffering. Privation and suffering are the only things that can open the mind of man to those things which are hidden from others."

The shaman's wisdom might elude the average citizen, but any real adventurer eventually learns that suffering is a necessary step along the path to enlightenment. Once you break through your own doubts and discomfort, the world suddenly makes sense. You feel as if you belong to the great solitudes.

I pump my boat dry as a means of purging my spinelessness—a dizzy, breathless feeling that I might not be capable of completing the passage. I clip together the aluminum outrigger poles, inflate and attach the nylon sponsons, rehaul the sodden sail, and stow my wet clothes. Dealing with equipment is curative, if only because it puts me back in control, moving me forward in logical, familiar sequences, as if I actually belong out here. As I head back out to sea, I swear never to sail again without the outriggers.

By early evening, I have cruised twenty-six miles to the delta of the Horton River—slightly more than my average daily distance. Wearily, I set up camp. Instead of contemplating how close I came to disaster, I spread my maps out to dry, then take my binoculars and look through the tent windows for bears.

Like climbing Mount McKinley in winter, crossing Antarctica, or rowing the Atlantic, traversing the Northwest Passage offers long odds of success. It also demands several summers of travel. Only a few kayakers, usually with lots of company, have made it all the way.

On a small-scale jetliner map, I have penned my own version of the fabled route: a twenty-two-hundred-mile line between Prudhoe Bay, Alaska, and Hudson Bay, Nunavut. I plan to travel as much as possible in the Inuit way, by kayak. Muscle power was how these nomads once ranged the Arctic, so by following their

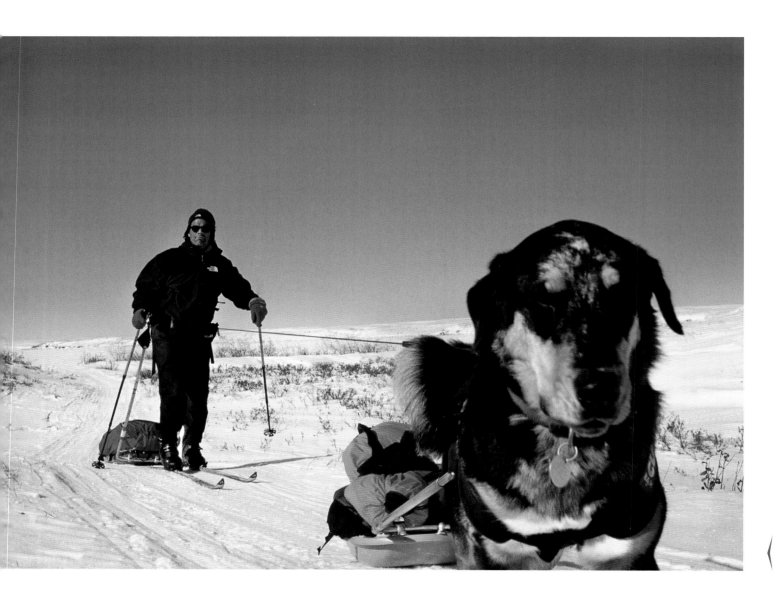

Spring sled travel with the well-trained Elias, east of Tuktoyaktuk, Northwest Territories, Canada.

advice and legends, I stand a good chance of surviving and learning something "far from the dwellings of men, out in the great solitudes."

So far, I've completed 650 miles of my journey. In July and August 1997, I kayaked from Aklavik, on the Mackenzie River Delta northwest to Prudhoe Bay, following the route that British explorer Sir John Franklin took from 1825 to 1827 on his second trip to the Arctic.

Thus reassured that I was ready for the rest of the passage, I returned to the Northwest Territories in April 1998 with my dog Elias, who trotted alongside me as I skied from Tuktoyaktuk east to the mouth of the Anderson River. Then Elias and I went back to Colorado, and I waited for the ice to break up. By late June, I was back at the Anderson River, where I began a long solo paddle east.

The day after my dunking, I continue paddling along the bottom of Franklin Bay. My eyes are agog at a charred shoreline where smoke pours out of the smoldering shale. I stop several times to fill my water bottle, but the streams run black and taste of rotten eggs. In a sud-

den and unexpected delineation, ocherous cliffs give way to hills covered with mauve and pink lupines. Striped as if a giant harrow had plowed the tundra, these gently sloping elevations stretch south for untold miles, the verdant home of whistling arctic ground squirrels and grazing caribou and bears and musk oxen. The green hillcrests are dappled with snow.

After midnight, I find myself paddling through the coruscated light of a sun that rolls along the horizon, never setting. Rounding a peninsula, I find a grizzly sauntering at the foot of a hill pockmarked with squirrel holes. I sail in closer and attempt my first conversation in more than two weeks: "Hello, mister bear."

My voice seems to bring the grizzly straight into the surf. Without changing speed, it slams through two breaking waves and swims after me. Ears wiggling, head held high above the water with its fur ruffled out, the bear is strangely beautiful and harmless looking.

A screeching glaucous gull swoops past. The bear startles and turns its head with sudden aggression: in a split second, the animal has

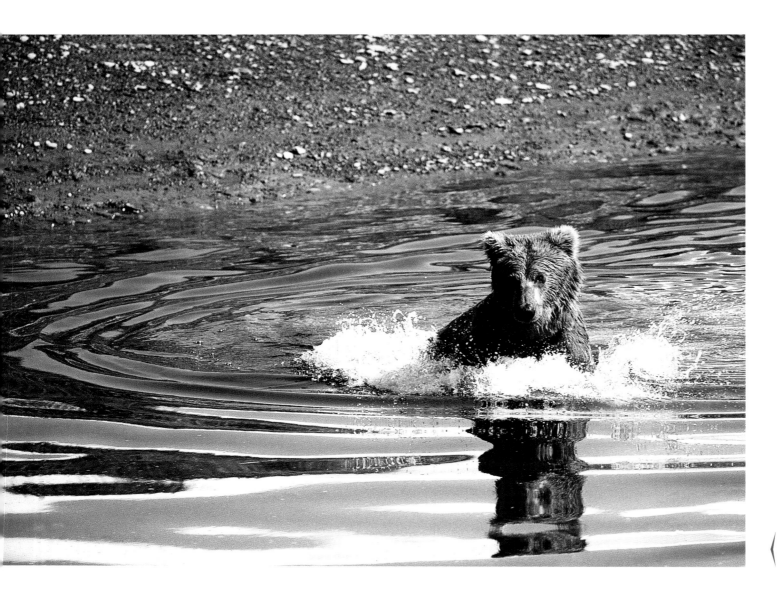

Arctic grizzlies lack the plentiful salmon of southern Alaska, so these hungry bears will swim after caribou and other large mammals—including people.

gone from curious to ferocious. I sheet the sail, kick over the rudder pedal, and paddle as fast as I can. Even so, the bear appears to be gaining on me. I paddle harder. Finally, after several minutes, the bear gives up and swims back toward shore. By splaying its legs and paws wide, it catches a gathering wave and rides up onto the beach. The grizzly steps out of the water gracefully, in measured movements, without losing balance. There is no shaking off, no looking back. For the bear, it's as if the whole chase had never happened.

I'm shaken, but I can't stop for the night at the bottom of this bear-filled bay. Although the grizzly's charge is still palpable in my pulse, I feel as if I'm on the verge of breaking through to some previously unattainable connection, tangible proof of what I consider to be a main tenet of Inuit theology—that animals and men share the same souls. I know that I'm lonely and yearn for companionship, and I am convinced that there is a way to reach out to the bear. I want affirmation that I am not prey, that the bear and I occupy some common ground. As the sun scalds the sea beneath a layer of clouds, the wind dies. Utterly exhausted from paddling all night, I pull down the sail and head into Langton Bay, on the eastern shore of Franklin Bay. It's five A.M.; I hope the grizzlies have settled down so that I, too, can get some sleep.

I unroll my tent on a narrow, fetid sand spit that I share with three bearded seals. The matriarch of the group swims back and forth, watching me, surrounded by a brown halo of mosquitoes. I dive into my tent and spend half an hour slapping and brushing. The yellow walls are soon smeared with my blood.

Suddenly, a woman's voice that I don't recognize sends a chill up my spine: "Everything is all right, Jonathan. You can sleep here without fear." Half expecting the voice to belong to a bear, I zip open the tent. Nothing is there. No tracks, either. I glance down the beach at the seals; they look too earnest to try to tease me. I zip up the tent, lie back on my sleeping bag, and drift off to sleep.

The next morning, nothing can convince me that the voice I heard was not real. I have

been alone too long. I need to see people again—quickly. And I'm still a week from my next resupply in the village of Paulatuk. By the time I reach the settlement, in mid-July, I've gone twenty days without seeing another person. After Paulatuk comes yet another twenty-five days of solo kayaking to Kugluktuk, a tiny settlement on the Coppermine River. I have learned to cope in the great solitudes, but now I crave companionship. My fiancée, June Duell, joins me for the last leg of the season. In early September, we stop for the year at Umingmaktok, at the northern end of Bathurst Inlet. I am two summers and fifteen hundred miles into my northwest passage.

In the summer of 1999, sea ice and wintry conditions delay my departure until mid-July. From Elu Inlet, on the Kent Peninsula, northeast of Umingmaktok, I drag my kayak across a narrow neck of land and start paddling and sailing again at Labyrinth Bay, on Queen Maud Gulf. In ten days, I put two hundred miles behind me, alone, wary about hearing voices and talking to animals.

It is another 180 miles across the gulf and through Simpson Strait to Gjoa Haven, my next resupply point. I sail in wave troughs as long as possible, then quickly rudder downwind before the waves break. In the calm lee of islands, I compose myself with deep breathing, some cheese and tea, and a quick nature call—courtesy of a waterproof fly on my new customized dry suit.

One afternoon, my toes go numb. With no sheltering islands in sight, I can't stop. Holding the sail sheet in my teeth, I pry off my boots to expose neoprene socks. I undo my fly and fill my boots. As I pull them back on, my icy feet quickly return to body temperature.

Snow geese bleach the hillsides. A black-headed Sabine's gull cries melodically. Squadrons of brown-shouldered jaegers perch like shamans on red, rocky atolls. Every time I'm ready to quit for the day, I spy another bird flying with such verve against the wind that I can't help but be inspired.

Finally, my nerves strung tightly, I drive my kayak up onto boulders padded with scarlet

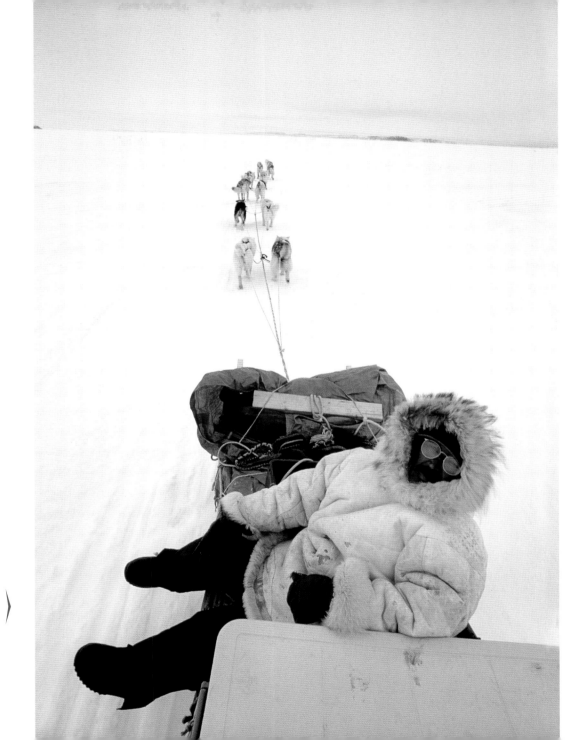

To learn more about Inuit culture, I lived in villages during the winters and travelled with a dogsledder. His caribou skin parka is warmer than an expedition down jacket.

seaweed. Rain pours from the sky. Walking fifty yards up a bouldered hill winds me. All potential tent sites are too rocky, so I close my eyes, dip my fingers into a jar of emergency peanut butter, and try to figure out what to do. In this state, beyond rational thought, I sense the presence of another being. It's here somewhere, smelling me, approaching steadily. I wheel around and see it lumbering along the shore toward my kayak: a huge grizzly.

I run down the hill, racing the bear to my boat. Twenty feet from the kayak, I throw the peanut butter jar onto the seaweed in front of the bear, then push the boat through a breaking wave. I flip the boom and take the next wave in my lap, which half fills the cockpit. As the grizzly works over my peanut butter, holding the jar between its forepaws, I drop the sail and suck out the water with a bilge pump.

Bouncing out in the chop, I try to remain calm. After pulling the sail up the mast, I bow slowly and, out of respect, hold the position for another minute as I try to imagine the bear's thoughts. When I sit back up, the bear shows no interest in swimming after me.

For another two hours, adrenaline buzzes in my fingers, but my toes are so wooden that I am forced to perform the boot trick again. As I weave in and out of big breakers, I whoop with exhilaration—and think about my new connection. Whether it was smell or intuition, I sensed the bear before seeing it. I'm elated: Being alone out in the Arctic is sharpening some long-dormant instinct.

For the next few windy days, I eke out a dozen to two dozen miles a day as I weave through the vaguely charted islets of Queen Maud Gulf. Then, in early August, I sail across a wide, nameless bay in a hard breeze.

Halfway across, an ice fog blows in, and I'm forced to sail blind. I careen past an islet thrumming with surf. Defended by arctic terns, the rocky hump bristles with stone cairns called *tammariikkuti*, some of which the Inuit use as directional markers. I steer south, taking my cue from the *tammariikkuti* until an island suddenly looms out of the fog. I tack abruptly and land broadside on a steep, steel-gray beach. I stagger out of the boat to study the map and my GPS device, but I can't place the island. I tie

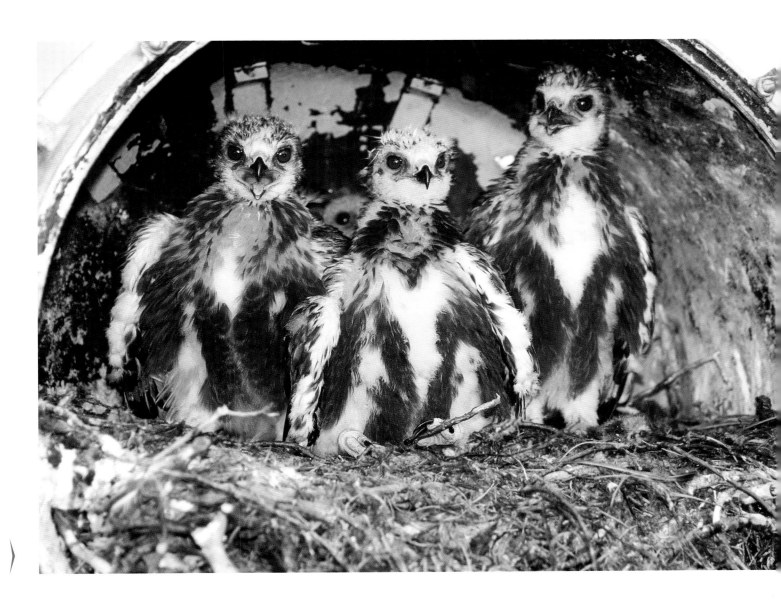

Nesting rough-legged hawk chicks eat a lemming in a floodlight at an abandoned Air Force landing strip in the Alaska Arctic.

the kayak to two boulders, then jog uphill to get warm.

All afternoon, I sail through fog and big breakers as the humanoid forms of stones pass in a blur. Thousands of molting old-squaw ducks paddle on the frothing seas, gabbling and croaking like frogs, jumping from under my bow. I have to stop two more times on islets to run in place until the shivering goes away. In the early evening, by sheer luck, I land at a protected cove on the mainland.

After I pitch my tent, I notice that I have set up for the night in a circle of half-buried rocks that were once used to hold down skin tents. I lift one head-size rock and finger a crusted swatch of caribou skin that probably dates back hundreds of years to the Thule culture. I am camping with the ancient ones.

By the time I reach the southern shores of Simpson Strait, I am twenty-eight days and 325 miles from Elu Inlet. Gjoa Haven is only a few days away. The nights are dark again, so I stroll away from camp to stargaze, wondering if I should stop for the summer at Gjoa Haven.

If winter comes early, I could be trapped in the ice. I gaze into distances that make all my own quandaries seem small. From what I've read over the years, the Inuit believe that the stars, portals to the afterworld, hold their ancestors. If the stars flicker, as they are doing tonight, it means that the people are moving around in the heavens and snow will soon fall.

In the morning, I'm happy to see the brown mass of King William Island. I sail east across Simpson Strait, reveling in the last placid waters of summer. Beneath the bluffs of the Malerualik River, on the island's south shore, I spy an Inuit hunting camp—and the first people I have seen in nearly a month.

At first, I look away, panicky about resocializing. Then I recognize the ursine profile of Paul Iquallah, a friend from Gjoa Haven. He runs down to the water to greet me. I sail the last fifty yards to shore upwind, then splash into the water and across the boulders. We embrace. "Paul, it's great to see you!" "The grizzlies didn't get you, eh, Jon?" The first mosquitoes land sluggishly on our cheeks. Kids run off with my

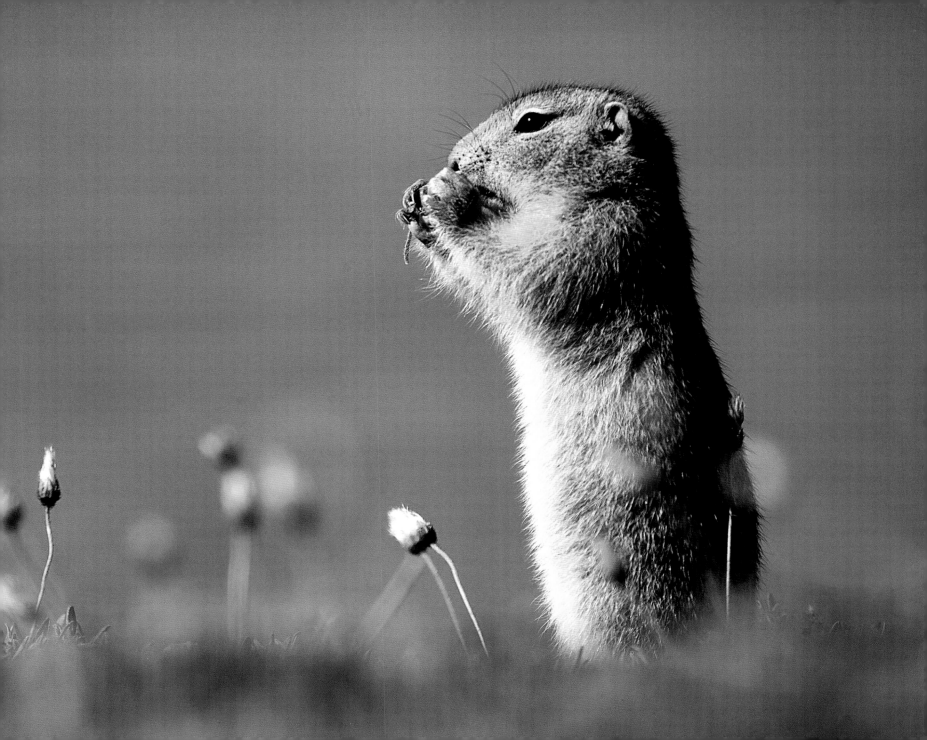

rubber boots. Paul's wife, Rebecca, starts to pluck some snow geese. For the first time in a month, I laugh out loud, pausing to listen to the sound of my voice, pleased to think that it is registering against other people's eardrums.

Paul sees the exhaustion in my slow movements, so he lets me nap on a musk ox robe in his family's tent. At midnight, Paul growls like a bear to wake me, smiling as he sees the surprise on my face. He thrusts a plate full of boiled goose legs toward me.

Before dawn, I creep out, careful not to wake anyone. Outside the tent, I'm startled to find a pale old man eerily waiting for me. I blink my eyes to make sure he really exists. His skull bristles with a few bits of snowy stubble, gaunt cheeks cave into a toothless mouth, and his penetrating gaze goes through my corneas and down my frontal lobe. He offers me some raw char from a ten-inch slab of slate that serves as his plate. When I refuse, he gargles something in Inuktitut, jiggling his plate. He looks up at the sky, pries his gummed-together lips apart with his tongue. "Big water Douglas Bay," he says, referring to a body of water farther east along the south shore of the island. "Maybe big wind, snow."

"Yeah, looks bad," I respond, detouring around him and striding down to the water.

"Long time alone." It is a statement, not a question. Then he adds the age-old wisdom of shamans that has propelled me through my passage—eight months over the past three years. "Being alone out on the land can open our minds," he says, tapping his head and smiling cadaverously. "You know this thing?"

"Yes, I do, but I have to go," I say. After thanking him, I push my kayak out into the current, haul up the sail, and steer east, hurrying to beat the snow and to escape the elder's disquieting prescience. He keeps his hands at his sides and smiles with a wink, as if he knows me. Then the wind luffs the sail, catches it tight, and violently shoves me out toward Simpson Strait. I lock my rubber-booted toes around the foot of the mast to hang on.

As the black delta water riffles with the fins of arctic char, I feel inexplicably satiated with

human company. It's time to be alone again— two more days to Gjoa Haven, and then, as I recently decided, two weeks to the Gulf of Boothia. Opening one's mind to all of life's possibilities, let alone being gracious to hospitable people, is not always easy when you're trying to make miles. Before letting myself go, I turn to thank the elder again, worried that my restiveness might have offended him.

But there is only a field of boulders, a drying rack of reddened char meat, and a sleeping camp. The old man has vanished. I can't help but wonder if I have just met a shaman. I look up to the heavens. A snowflake drifts down from the pale morning stars, settling on my cheek like goose down as I steer, once more, into the great solitudes.

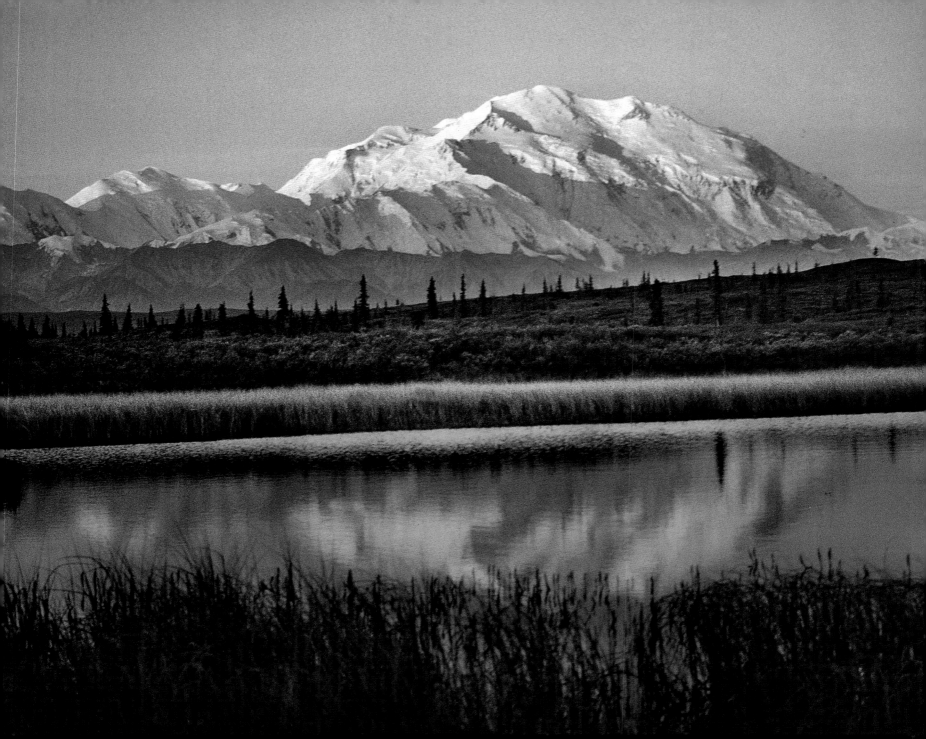

Correspondence

Letter to Mom;
Serious Writers Never Oversleep

While working as a mountaineering ranger at Denali National Park, I researched and wrote my first book, Surviving Denali: A Study of Accidents on Mount McKinley. *This gruesome project compelled me to take a break and expound upon the joyous side of mountaineering that I had found during a summer climb of Denali's West Rib in 1981. As a writer I was always interested in expanding my potential readership and singing beyond the choir to the uninitiated who would never climb a mountain, let alone Denali. So I wrote a story for the park newspaper, read by thousands of tourists. Good exposure for your writing doesn't always come with a paycheck, and that's why I worked six months of the year for the park service, performing rescues, educating climbers, and taking innumerable patrols into a wilderness otherwise patrolled only by grizzly bears.*

While I was on duty at the ranger station, climbers gave me a lot of grief for this piece, written in the form of a letter to my mom, replete with a picture of me posed on the summit of Denali, ice axe thrust to the sky, underneath the bold title that the editor (unbeknownst to me until publication) assigned to the story: "Rare and Remarkable." It was printed on the front page of the Denali Alpenglow *in summer 1983.*

From tundra ponds to the north, Denali climbs 18,000 feet above its base—the largest vertical rise of any mountain in the world.

Letter to Mom

Ms. Kay Waterman
Stuart, Florida
January 21, 1983

Dear Mom,

Thanks for your letter. Hope everything is well with you. I'm doing great but I miss Alaska. Last summer I went on my fifth expedition (I'm sure

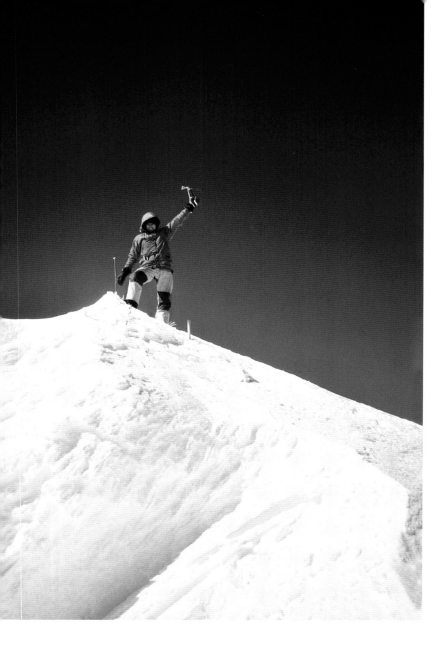

On a balmy, 20-degree day in early May 1981, the summit was deserted and I felt elated for this rare, wilderness experience on an otherwise popular mountain.

you're painfully aware) up the mountain. It was a fine trip.

In your letter you wondered if I wasn't climbing for the wrong reasons, and why anyone would want to climb McKinley—particularly more than once. I desperately want you to understand, so please bear with me and I'll try to explain my fascination with McKinley, which might seem so foreign and dangerous from your perspective.

Imagine your favorite place: the Hutchinson Island shoreline, where you like to lie alone in peace under the sun amidst the sandpipers and the stark serenity of sky, ocean, and sand. When you get restless you go for long walks, play in the surf, and stop to look at shells, just as I might place my ice axe, catch my breath, then contemplate the vast space below my feet. But when you go back home you know you love that beach like I love Denali. And you're sure that you'll go back because you've found a peace of mind in nature that can't be found anywhere else.

I should explain why I call the mountain Denali. Mount McKinley was the name given

feigning unconsciousness. You summon up the dream: your novel was accepted and the world rushed past in a giddy bubble, like Marjorie Rawlings's astonishment when Max Perkins said he'd buy it, Scott Fitzgerald weeping in the taxi, William Kennedy proudly sweeping up the Pulitzer after years of anonymity and rejections...

Swing your feet onto the cold, cold floor. Then downstairs. You spill earthy-smelling grounds on the floor, insert the filter, pour the water, and watch the pot fill. The morning ritual. Reality comes with the first sip: hot and bitter and eye-opening.

Your novel is New York City–bound, sure, but only a miracle will sell it. A genius's work, you think, needs an editor on the same wavelength. And Doubleday finally shut out your nonfiction after pitching false promises for seven months. *Powder* accepted your proposal a year ago, but won't return your calls. *Ascent* won't let you off the ground with the novel excerpt. While the *Backpacker, We Alaskans,* and *Outside* editors have locked themselves inside; "very busy," they say, neglecting your slaved-over pages.

Each rejection hits you down low in the gut, leaving you slightly breathless and dizzy. Before you experienced rejections, you never realized that the mail could kill. As a veteran, you have learned a method, a means of surviving editors' fusillades. You read each rejection slowly, letting the disappointment rise over you, letting it hit you fully. Then you wait a day for objectivity, when your ears stop buzzing, when the urge for vengeance has subsided. You poke through the letter and consider the rare constructive comment, finally hinging it into the rejections notebook as if it was another stamp in your considerable collection.

You swallow more coffee. Why couldn't you be a best-selling politician, athlete, or carmaker? Or if your daddy was a great American writer who embraced five wives and two Pulitzers, you would swallow pride, fire out a scandal-torn biography, then your agent would let the finest New York houses squabble over it. The sad fact is, you are another unheard-of name drowning beneath deep slush piles.

If something doesn't turn up, you are in trouble. With the sharp-edged predawn clarity

(and a little caffeine) you realize that alcohol, self-pity, and cynicism are all within your grasp. Temptations revolve on the same axis as the failures.

Still, there is no turning back. You have no contracts, you have quit your seasonal work, and money is trickling away. But you are a writer. First and foremost. Time for the mantra:

> writer,
> a writer,
> you are a writer....

You take your coffee and your guarded optimism up the stairs. They creak beneath you. A glacial wind rattles the polyethylene tacked inside the windows. The farmhouse is a refrigerator and you feel like a side of beef, enclosed by walls that are thinner than your novel. You could not afford to be an Alaska writer if you lived in a regular warm house and paid regular rent. You arrive at your studio—a cold, windowless cave—and flip on the electric heater that singes your leg hairs and keeps your fingers warm enough to type.

Lately the words surface harder and harder. You have been fighting for them tooth and nail and you wish you just had an agent or a publisher or a "Papa" Ernest who could pat your shoulder and keep you going like a champ.

You need something easy, so you work on a brochure for an air taxi. It will get edited to pieces and it's glorified crossword puzzle–type work and it's advertising. But it's money. You work furiously until the bare lightbulb doesn't seem so bright. Until you can take no more.

You want to feel good again. Put on your running shoes, hat, scarf, wind shirt. Run downstairs. Whistle for Mika. She comes, jumping with excitement, and you thump her. Laughing. You burst out the door together.

Sometimes to find perspective you've got to get away and look at it from a different angle, let it spin in the sun and see the colors light the way. For the moment you try to clear your head, concentrating on breathing. Your feet squeak against packed snow, searching for the rhythm, like putting words on paper.

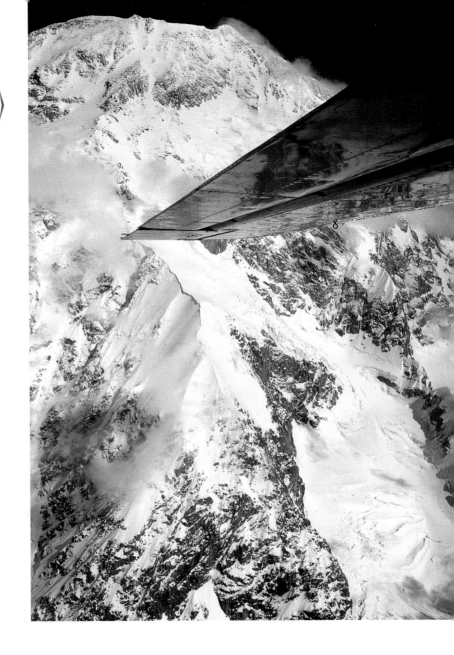

The seldom-climbed West Rib below the wingtip, rising 9,000 feet from the Valley of Death (Northeast Fork of the Kahiltna) to the summit.

Mika sprints after a statuesque ground squirrel, her legs blurring and spraying snow as the chattering fur ball dives holeward. You call her back. And she lopes in front, tongue lolling, leaving you behind.

Then a character leaps out of your novel, alongside you on the road. You think about her peach fuzz moustache flashing in a sunbeam, her boyish breasts, and the clove orange smell of her skin. (You realize you should not live alone during the long, dark Alaska winters.) However, you know she is genuine, for you have made her truly, as truly as the Creator would have done, provided Creation took six days on a typewriter.

Your breath freezes tightly on your beard, so you wrap your stiffening cheeks with the scarf as the soft rose light caresses the Talkeetna Mountains.

You are touched by Alaska and want to capture its colors, its shape, its very textures, then give it to your hoped-for readers. You are writing straight from the heart, bleeding your soul into stories as hard and truthfully and kindly as you can. And if your hoped-for publishers see

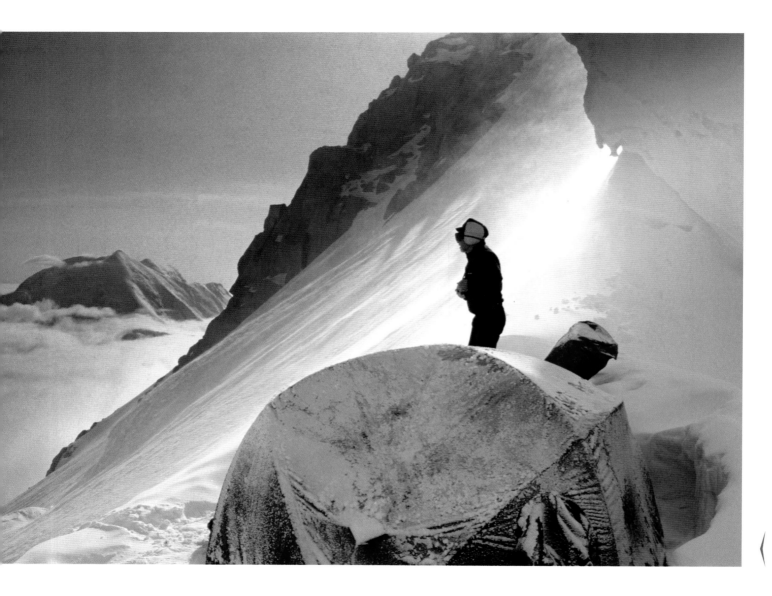

Storm clearing
above Mount
Foraker, from
15,500-foot camp
on Denali.

only a bit of it—only your beard, without feeling the icicle—that is not your fault.

The valley is at your feet now: braided river bottoms and windblown dust kicking up amber in the early morning light. It is going to be a good day. So you turn back.

Back to your studio: the refrigerated farmhouse.

The work has been hard but there is never a morning when it doesn't come to you. In the meantime, there is the writer's workshop. And if push comes to shove, you can always self-publish your nonfiction book. You wish money wasn't important, that there was no pressure to sell your work, but then you would have no incentive.

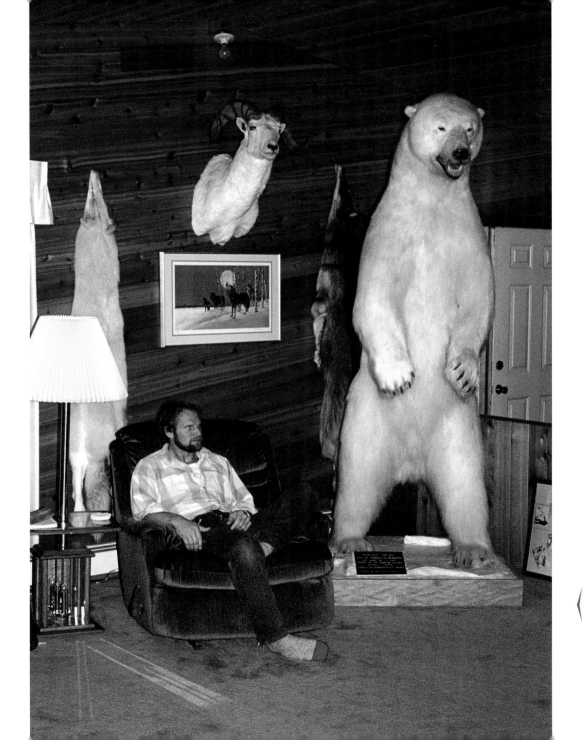

The alpha male relaxes amid his trophies in the McMahan living room.

Sheep's Clothing

As a teenager growing up in a compromised suburban Boston ecosystem, I was inspired by both adventure books and conservation titles like Never Cry Wolf, Desert Solitaire, and Silent Spring. Consequently, as I got to know Alaska, I never took a trip without considering how each region and its wildlife were protected. So even while writing simple climbing or adventure stories, I tried to serve as a voice for the otherwise defenseless wild places of the North.

"Sheep's Clothing" was my first ecological, nonadventure story. I took on the daunting task of profiling a wolf hunter because I was outraged that Alaskans used (and continue to use) airplanes to hunt wolves. My first encounter with a family of wild wolves alongside an arctic river in 1983 had shown—as the mother swam its pups across the river and away from intruders at the den—the species' intelligence and family compassion. How could men chase them with airplanes and gun them down?

Even if editors shared my outrage, I couldn't find a magazine that would assign me the story. So I did it on speculation, knowing that the newsworthiness of the controversial aerial wolf-hunting practices in the early 1990s would eventually allow me to place the story. It wasn't hard to find a cooperative subject, because most frontier Alaskans believed that they had a right to their way of life, regardless of how hunters "Outside" treated animals.

There was no reason to be clandestine about my mission. I told my subject, Chuck McMahan, the truth: I wanted to understand his point of view, and if he showed me how he hunted wolves I would try and publish it in a magazine. I spent an equal amount of time in the city of Anchorage, attending wolf meetings and profiling the wildlife biologist Vic Van Vallenberghe. The editors cut most of his story from my final draft, but even if he is only mentioned briefly in this final version, I remain indebted to Vic for my

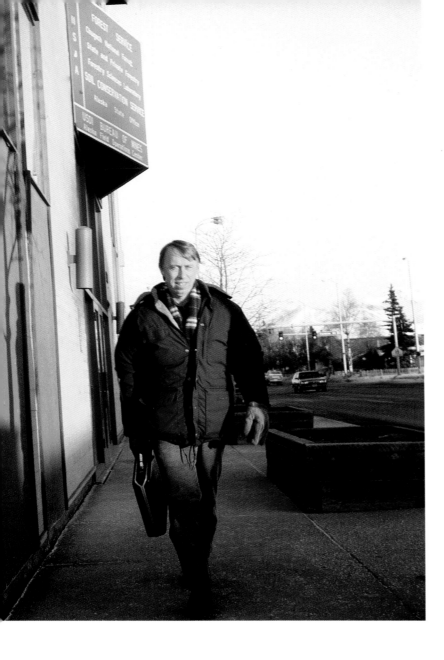

education in game management and Alaska politics. I also sent Chuck the final draft, and he replied with an angry letter suggesting that I misrepresented him, but he didn't suggest any corrections. I wrote the story while studying his portraits on my light table. Since larger circulation magazines rarely publish their writers' photographs, this story appeared with a gratuitous stock-agency photograph of a wolf in the May 1993 Outside *magazine.*

CHUCK MCMAHAN is ready to fly. He yanks on some Sorel boots, pulls the flaps of an otter-skin cap down over his ears, and steps outside. It's a calm, sunny, five-below day, perfect for hunting wolves.

He walks past his porch, where chestnut and gray wolf pelts dangle above. While McMahan is one of hundreds of citizen wolf hunters in Alaska, his pelts have been culled from some seven thousand wild wolves. Their noses are nailed to the top railing, and their bushy tails sweep the driveway. Both specimens of *Canis lupus* are several days dead and their dried

blood fluoresces against the midday twilight of Alaska winter.

Several cords of firewood are neatly stacked beneath a newly built shed. Above the garage, a basketball hoop awaits warmer weather. And next to a snowbank lies a naked-looking, white-gristled wolf carcass. There are no fifty-five-gallon drums or rusted snowmobiles or discarded moose antlers. Except for the wolves, this yard could be more Denver foothills than Gakona, Alaska.

The McMahan airfield is a bright swath riven from the forest with tractor and chainsaw. Four airplanes—all mounted on skis—sit beneath power lines at one end of the football-sized field. McMahan's brother, Harley, and their father, Cleo, own three of the four Piper Super Cubs. A raven's wings beat the air above the treetops, octane-eighty fumes linger, and snow squeaks with rapid tempo underfoot. McMahan stops at the right wing of his own canary-and-black-trimmed plane and pulls off a frosted wing blanket. He then slots his Winchester .243 with five rounds of six-mm shells and inserts the rifle back into a scabbard mounted on the wing strut. McMahan flips the starter switch. The prop spins, chortles, then blurs to a high-pitched whine. He taxies the Cub forward, tacks bumpily beneath the power lines, then guns the engine. In sixty yards the skis trade the rasping slip of snow for the smooth whisper of air. McMahan adjusts the throttle, eases back his flaps, and banks southward. There is a snow-plated lake crisscrossed with snowmobile tracks, a vast sea of stunted spruce trees, then the muffled sighing of a truck carrying goods on the frost-heaved highway from Fairbanks to Valdez. Scotch-taped amid the instrument panel that McMahan faces constantly while flying is a typewritten message: "God will follow you wherever you go—Judah."

In November 1992, David Kelleyhouse announced that radio collaring twenty-five wolves would allow the state to track and shoot three hundred to four hundred more wolves from helicopters. Kelleyhouse, a director with the Alaska Department of Fish and Game (ADF&G), called it as forthrightly as a coach announcing his sluggers' tactics for the upcoming season. Controlling wolves, Kelleyhouse said, would

allow caribou and moose herds to propagate and "create a wildlife spectacle on a par with the major migrations in East Africa."

Kelleyhouse's game plan hit the front page of the *New York Times* on November 19. Biologists who weren't employed by the ADF&G said that playing God would upset natural cycles. Animal-rights groups immediately placed newspaper ads calling for tourism boycotts of Alaska. Even in the Last Frontier, two different surveys show 55 and 74 percent of the Alaska public opposed to the state's aerial wolf control. But killing wolves is not fresh copy in Alaska. The *Anchorage Daily News* borrowed the *Times*'s story from the wire service and buried it in the Metro section.

Twenty thousand letters opposing wolf control flooded the ADF&G. Irate phone callers turned it up so hot that employees gave pseudonyms over the telephone; five thousand phone calls were logged on the three lines at Kelleyhouse's Juneau office. Wayne Pacelle, director of the Fund for Animals, says, "We recognized early on that the governor would not be persuaded by biology, but only by naked economic pressure." Indeed, Governor Walter J. Hickel is purported to hear dollars being dropped in the posh hotel and shopping malls that he owns in Anchorage. According to the Alaska Tourism and Marketing Council, the 1993 boycott will cost the $1.1 billion tourist industry $85.6 million.

On December 22, Hickel bowed to the pressure and rescinded the radio-collared wolf-killing program for 1993; in turn, the boycott was dropped. The governor fired out letters to newspapers—as well as 120 conservation, hunting, and tourist groups around the country—inviting all to Fairbanks in mid-January for a Wolf Summit. Hickel wrote, "With your help, perhaps we can find a better way to balance wolves, caribou, moose, and the nutritional needs of Alaskans who count on wild game for protein." Since Fairbanks is commonly known in Alaska as "the hotbed of wolf control support," a newly formed coalition of environmentalists lobbied Hickel to keep the summit agenda objective and move it to Anchorage. Hickel would not budge. The governor is renowned for fantastic schemes: a railroad to Nome, paving the

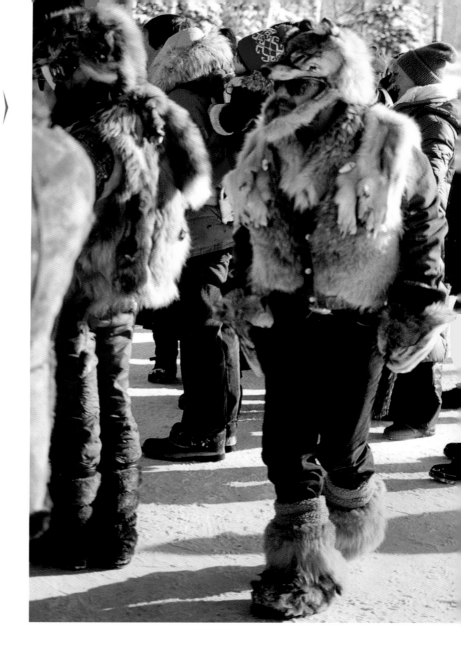

One of many "fur-heads" (aerial wolf hunting supporters) at a rally near Anchorage, Alaska.

Arctic National Wildlife Refuge, a water pipe to California, and mining outer space. Alaskans refer to these fantasies as "Wally World." But to pin wolf control on Hickel alone would be overlooking decades of Alaska game management that is one part biology, nine parts politics and economics.

Hunting is, after all, big business in Alaska. In 1992 110,977 hunters and trappers paid the ADF&G $5,471,349 for licenses. Guided big-game hunts cost up to $15,000 per animal, with no money back for lousy shots.

A respected Inuit elder, Charlie Kairaiuak, proposed that if the state stopped lucrative trophy hunting for the biggest bulls, a healthier gene pool could wend among the caribou and moose and sheep. Then, Kairaiuak says, wolf control would be unnecessary.

Planning the Wolf Summit in Alaska just prior to the media-intensive presidential inauguration in D.C. was perceived by the animal-rights camp as Hickel's damage spin control. When a couple hundred stateside conservationists and tourism bookers (and no mainstream

media networks) flew into the Alaska "night" on January 15 and 16, they were confronted by nearly five hundred demonstrators shouting, "Go home, we don't want you here!" Clad in blaze-orange hunting clothes or furs with wolf heads, the "fur-heads" shook fists and waved placards at the "eco-extremists": "This is a state rights issue." And: "Wolves eat lead!"

Ralph Seekins, president of the Alaska Wildlife Conservation Association, organized the protests. From his automobile-dealership office in Fairbanks, Seekins likes to talk "wise use" game management. "The predators are at a point of destroying the game in Alaska," says Seekins. "Wolves end up being a game vacuum cleaner and they have to be shot off."

A crowd of fifteen hundred predominantly bearded and ruddy-faced locals showed up at a drafty ice rink called the Carlson Center. Shivering environmentalists stepped to the microphone and got heckled by Seekins's demonstrators. Pro-wolf-control dinner speakers harangued environmentalists. And Hickel knew well his constituency when he spoke, "I will not

be part of the state of Alaska giving away its sovereignty"—making a crowd of warm, fur-clad hunters jump to their feet and applaud.

When the charismatic Athapaskan chief of Nenana, Mitch Demientieff, came to the microphone, he confessed, "The governor was mad at us because we wouldn't send a large Native delegation to come out here and say, 'We want wolf control!'"

On the last day security guards prevented the fur-heads from parading a still warm and freshly killed wolf into the ice rink. "This state needs to move into the next century," says Cindy Lowry of Greenpeace. "It's barbaric."

"The eco-extremists are not reasonable," says Seekins. "They exaggerate, they lie, they don't use biologically sound facts and they search for wildlife biologists that [sic] are the exception rather than the rule to create myths about wildlife management." U.S. Forest Service moose biologist Dr. Vic Van Vallenberghe says, "After they stopped [direct] wolf control in 1983, every major caribou herd increased and moose populations have sta-

bilized." Independent wolf biologist Dr. Gordon Haber calls ADF&G's wolf control "insulting from a scientific standpoint."

Seekins says, "I think that the battle lines are drawn. If we are going to control the destiny of our wildlife we have to take a proactive position and no longer make any compromises."

After the summit, trappers left warm cabins and rebaited their sets, hunters refueled their Super Cubs, and environmentalists returned to their offices. At Anchorage's three-room Alaska Wildlife Alliance—a grassroots force trying to keep wolves out from under the crosshairs—Steve Wells isn't getting much sleep. "I'm on the verge of burning out," says Wells. "The world doesn't get it: legally or illegally, hunters are going to continue fulfilling the state's agenda by bumping off wolves."

The age-old mythology and global persecution of *Canis lupus* says a lot about Alaska wolf control. In *Of Wolves and Men,* author Barry Lopez wrote about the wolf: "He was the Devil, red-tongued, sulfur breathed, and yellow eyed." Lopez believes that the Latin word for wolf, *lupus*—and for light, *lucis*—suggests Lucifer.

In other texts, the prophet Isaiah called Lucifer "the Son of the Morning." The wolf of the Middle Ages was known as "the devil devourer of man's soul." Undoubtedly these early superstitions influenced citizens and bounty hunters to slaughter millions of wolves during America's westward expansion.

"We killed the wolf in Europe," said the German wolf biologist Eric Zimen, "and we hated the wolf, but it was not anything like what you have done in America."

Then came Alaska. Wolf control officially began with the $10 bounty enacted by the first Territorial Legislature in 1915. The wisdom imported from western ranchers dictated that wolves must be controlled, otherwise Alaska's "livestock"—Dall sheep, moose, and caribou—would be dead meat. For seventy-five years a variety of trapping, poisoning, and aerial gunning techniques may well have created an even warier species of Alaska wolf.

When poisoning began in 1948, wolf hunter Chuck McMahan's dad, Cleo, photographed accidentally poisoned coyotes and grizzlies and ravens, then displayed his pictures throughout

Alaska. Although Cleo spoke out against the inhumanity of poisoning wolves, it also diminished his $50 bounties and his pelt sales. The July 1954 *Alaskan Sportsman* features a photograph of Cleo posing with twenty dead wolves and a story: "Although lack of funds have slowed down the U.S. Fish and Wildlife Service's wolf-control program in Alaska, others are going strong and the fight continues against this enemy of game and fur animals."

Cleo McMahan taught his sons the classic hunting lesson of the Bible, that animals were put on earth for man's dominion, that man could do as he pleased with the animals. But if the rest of the Last Frontier did not see wolves as evil incarnate, they became *Canis non grata* solely by virtue of being predators and competing for the same food that humans ate.

In 1971 Congress passed the Airborne Hunting Act. U.S. Code 16, 742j-1 reads that any person who is airborne and shoots or harasses animals can be fined $5,000, imprisoned up to a year, and have their airplane and firearm confiscated. But Alaska has always sheltered anarchists from the law.

In 1976, ADF&G biologist Vic Van Vallenberghe watched the McMahans violate the Airborne Hunting Act. The biologist happened to be flying in a plane above Cleo's, herding a wounded wolf on the river ice. Cleo banked up on one wing, straightened it out, then stalled the Super Cub and landed forty yards from the wolf on the ice. Cleo's son leapt out. When he saw the biologist's plane circling above, he shrugged his shoulders: they'd been caught. McMahan walked to the wolf lying on the ice, head swaying in the air, and gave the coup de grâce with a .22 pistol.

The judge was kind to a man so respected among the hunting community. Cleo had also done a lot of flying for the ADF&G and, after all, this was Alaska. The state fined him $250, which would be suspended pending good conduct, then confiscated the wolf hide and the .243 rifle. Cleo kept his airplane and his freedom. Two weeks later, Van Vallenberghe saw the McMahans buying a new .243 rifle in an Anchorage gun shop.

Other wolf poaching cases—with evidence that would have slammed cell doors in the

Lower Forty-Eight—reached the Alaska courts. In 1976, hunter John Greybill shot five wolves from the air; the assistant district attorney fumbled his case. Greybill walked.

Hunter Stu Remstead had sixty wolf hides with pellet holes peppering their spines. But a forensic expert's testimony that the wolves had been shot from the air did not wash. Remstead walked.

"If the law is bent or broken with wolves," says Van Vallenberghe, "it's okay with the state." In 1976, a precedent-breaking study was performed in a remote stretch of Alaska surrounded by blackened dwarf spruce and milk-white rivers that stretch like a mirage, further than the best rifle scope. Van Vallenberghe refused to control wolves. He was transferred (and later quit). In his place another biologist eliminated every wolf for three thousand square miles. ADF&G does not advertise this study because moose populations did not increase. Elsewhere, amid a healthy wolf population, the ADF&G collared moose calves and learned that bears, rather than wolves, were responsible for 79 percent of the kills.

The nonpareil of Alaska wolf control is biologist David Kelleyhouse. In 1981, he grew dissatisfied with the efficacy of single-shot rifles or automatic shotguns and requisitioned an American-180 machine gun—capable of holding 177 rounds and firing thirty per second—to be mounted on his Super Cub wing. The regional supervisor, Dick Bishop, approved the order, but when it leaked to the media, the ADF&G squelched the requisition. "Machine-gun Kelleyhouse" (as the Anchorage press called him from then on) and his colleagues still controlled some seventy wolves with shotguns that winter while mollycoddling the area's moose.

The ADF&G's statewide wolf control continued until 1983 at a cost of $824,000 and thirteen hundred dead wolves, not counting hundreds more killed by land-and-shoot hunters. The public furor caused Governor Sheffield to freeze wolf control funding.

State game managers then passed the trigger of wolf control to civilian hunters. In interior Alaska, Machine-gun Kelleyhouse tacked up posters reading: "We encourage you to legally take a bear or a wolf. You'll also be taking an

active part in management of Alaskan wildlife. Do your part."

Then came the feds. Aware of the blatant disregard for the Airborne Hunting Act, Al Crane and a meager staff of eight other U.S. Fish and Wildlife Service agents (versus eighty state fish and wildlife cops) started pursuing convictions. "Finding wolf poachers up here," says Crane, "is like finding needles in a haystack." He knows that divvying up the vast state would give each Alaska or federal game warden 3,490 square miles to patrol.

The cowboy-booted Crane doesn't male bond real well among the state "fish and game cops" because he likes to remind them that "95 percent of all land-and-shoot wolf hunting is illegal."

"Crane sees the regulations a little differently," said Captain Phil Gilson of the state's Fish and Wildlife Protection Division. "He's going to have a hard time proving his case in court." Gilson then whispers conspiratorially, "The goddamned feds have been trying to tell us what to do for years.

"Don't get me wrong," said Gilson, "I don't have anything against the tree huggers, nor do I have anything against wolves."

Al Crane persevered. In 1990, he had accused Anchorage surgeon Jack Frost of violating the Airborne Hunting Act while wolf hunting; a search warrant was served. Anchorage is a small town, and insiders still murmur about the contents of a huge freezer in the respected doctor's home: mixed in with wolf carcasses lay a human leg (inadmissible evidence for the charges). The following summer Frost pled guilty to one misdemeanor of using his aircraft to herd and harass wildlife. He forfeited his Super Cub, paid a $10,000 fine, and served two years of probation. The well-publicized case forced ADF&G to ban land-and-shoot sport hunting in November 1991. Critics say that the ban is little more than semantics; Hickel's suspension of Kelleyhouse's wolf control program for 1993 is likely to change nothing. When the Board of Game takes up the issue next month, according to an ADF&G source, the department will probably recommend reinstitution

Editorials

Never Cry Wolf;
Winning the Climbing Lottery;
Price of Adventure

4

During my brief tenure as an editor at Climbing magazine, I found my first opportunity to inspire readers about ethics. Although I had to leave windy Palmer, Alaska, and move to glitzy Aspen, Colorado, for the job, I found many chances to write about the North or hunt down other Alaskans who could write about climbing.

The forty-hours-per-week job turned into a one-hundred-hours-per-week job in the ten days preceding the monthly publication. I learned the value of deadlines, reshaping rough stories into would-be masterpieces, and how to write a lot of copy—headlines, editorials, features, even ad copy—in record time. More than any single adventure in the wilderness,

these new skills gave me a solid foundation for a successful freelancing career. My boss, Michael Kennedy, espoused the value of no-bullshit, unadorned language and full-bleed photographs uncluttered with type—as per the high bar set by the British editor Ken Wilson at the now defunct Mountain magazine. Kennedy is an accomplished editor and photographer and had a knack for finding and then selecting photographs that improved a story. He spent countless brutal hours hunched over a light table, staring into hundreds of color slides with a magnifying loupe.

Alarmed by the lack of self-sufficiency that I had already experienced while rescuing many climbers in Alaska, I wrote the following "Never Cry Wolf" editorial in hopes of inspiring change. Several years later, I expanded the piece and included it in my popular book, In the Shadow of Denali: Life and Death on Alaska's Mt. McKinley (the prequel to Northern Exposures).

Denali, an incredible 20,320 feet above the winter forest, with the lower angled, upper half of the Cassin Ridge (left of center) beelining to the summit.

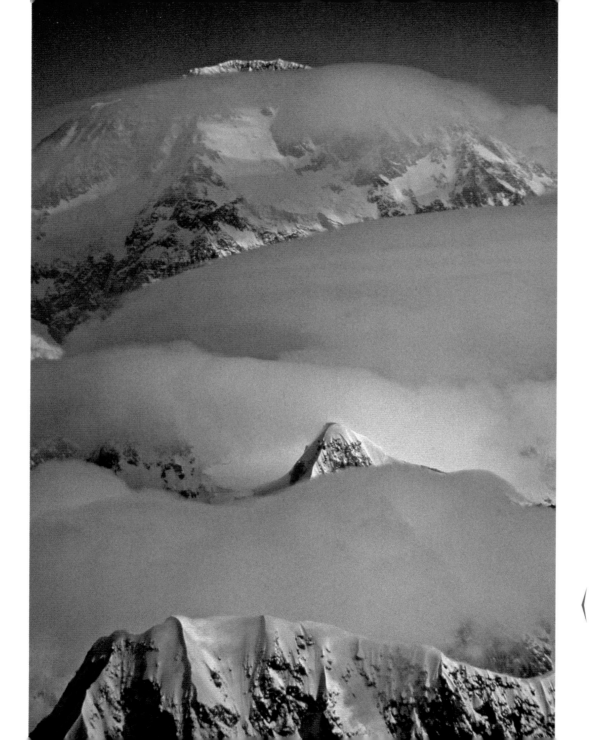

Lenticular clouds blanketing Denali and Mount Huntington, as seen through the rescue helicopter canopy shortly before running out of fuel.

television commercials, and rights to all photo sales from the expedition. His business partner, the French explorer Jean-Louis Etienne, gets to keep the expedition's $3.5 million ship. Although this expedition has charted a new route across the icy continent, the most earth-shattering, record-breaking accomplishment of the International Trans-Antarctica Expedition is its budget: $13 million.

Steger warmed up for this trip in 1986, when he and five companions reached the North Pole—a torturous mission considering the pressure ridges, drifting ice, and open water that had to be crossed by recalcitrant sled dogs. But more important than tagging the pole, Steger had deftly drawn in the media. He was subsequently hailed by an American public eager for real-live ice-bound heroes on dog-sleds, particularly after the fiery deaths of the astronauts in the *Challenger* spacecraft.

Yet who can refuse fame and riches? Perhaps it is largely the bombastic statements of Steger's publicity man, Jeff Blumenfeld, that have stirred the media into a feeding frenzy. As a result of the Antarctica trip, Blumenfeld pre-dicts that Steger will become "a true American hero, a household name by the time this thing is over."

Perhaps the public (and the press) are not so discerning when it comes to real adventurer-explorers and real heroes. Perspective is needed. I, for one, would rather revere someone like the English climber-explorer Roger Mear, who has shunned limelight and riches, clutching his dreams so that no one could ever take them away.

On February 28, 1982, Mear gazed up Denali's Cassin Ridge. The windchill factor was fifty below, and ten thousand feet above, a snow plume wailed a half mile across the sky. Mear mantled over the bergschrund and, after a torturous week of worry about a storm (which would have doomed the team), he and two companions completed the Cassin in winter.

The three had climbed fast and light, with only borrowed equipment and food bought with hard-earned cash, so their satisfaction in terms of climbing by "fair means" (without media hype or airplane support, carrying all their gear on their backs and disdaining fixed ropes)

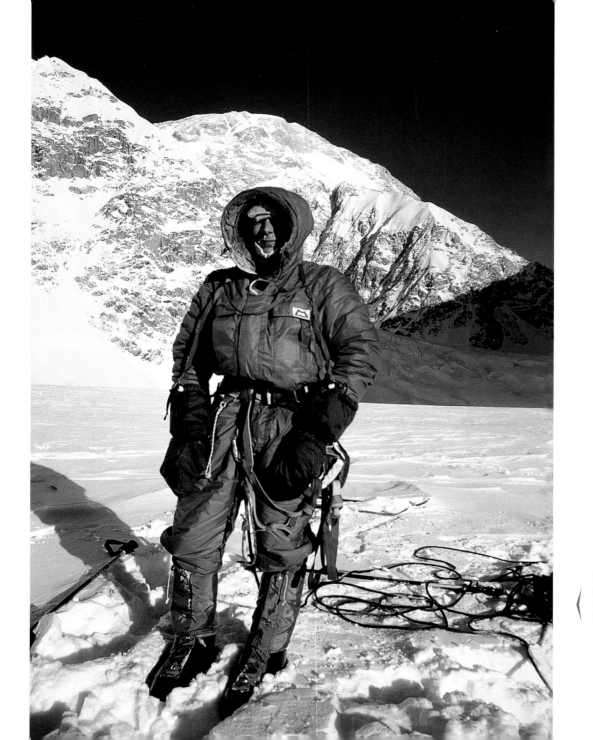

Polar explorer Roger Mear clad in a down suit and two underlying layers against the meat freezer conditions of Denali in winter.

was infinite. The other two became frostbitten, thus when Mear fell into a crevasse and blew out his knee, they weren't there to help him. So he built a sled from his skis, sat down, and poled himself two miles back to their snowcave.

Mear had built his philosophy upon that of the early polar explorers, particularly Captain Robert F. Scott. Indeed, Scott is one of the most esteemed explorers of the century. In 1911, Roald Amundsen beat him to the South Pole by a month, but Scott was lionized because he died while crawling back to the coast, adhering to both science (he painstakingly carried thirty-five pounds of geologic specimens back from the pole) and fair means. While Amundsen was conveyed by fifty-two dogs to the pole, Scott (after his ponies died) man-hauled sledges.

Before he even knew of Amundsen's plans, Scott had written: "No journey made with dogs can approach the height of that fine conception which is realized when a party of men go forth to meet hardships, dangers, and difficulties with their own unaided efforts."

Yet Antarctic exploration has always been an expensive business, and even the most altruistic of early explorers were heavily financed and armored with machines and beasts. Scott's $6 million expedition had some dogs, plenty of ponies (all were eventually shot for food), and malfunctioning tractors. In the end, he renounced all of these contrivances. Other seekers of the pole who couldn't get support from the scientific community were bankrolled by wealthy industrialists. And history shows that many early explorers were motivated by wealth, rather than science.

But some were different. The English Himalayan explorer Eric Shipton shaped the consciousness of several generations with his lightweight, low-budget expedition philosophy. In 1931, before leaving to make the first ascent of Kamet (25,447 feet) in India, Shipton was invited to dig up some gold with his friends. He refused, and his would-be partners became rich. He later wrote in his autobiography, "I was far too dazzled by the glitter of the Himalaya to be much tempted by the lure of gold."

Shipton went on to lead many of the early attempts on Everest, but fell afoul of the gentlemanly British philosophy of expensively

mounted, militaristic sieges. In the ensu-
ing decades, Everest has received consider-
ably more adventurers and media attention
than both the North and South Poles. But
today Blumenfeld, the publicity man, says:
"[Antarctica] is the hot continent now. Mount
Everest is out. It's been done every which way.
It's been trashed."

Further perspective is given by Hugh Carver
of Adventure Network, the company that
has provided air support to Steger and other
Antarctic adventurers during the last five years.
"When we started this business, we thought
people would be interested in doing trips solo
and unsupported," said Carver. "But the pro-
gression is not towards the most difficult. We
found that it really doesn't matter if you have
caches, airplanes, and lots of dogs. The public
doesn't know the difference."

And who are Carver's heroes? Scott of
course. As for modern-day men, while Carver
has a "hell of a lot of respect for what Steger is
doing in the middle of nowhere in horrendous
conditions," he cites Mear, Robert Swan, and
Gareth Wood and their 1985 South Pole expe-

dition. Before that trip, Mear told Swan he'd go
only if they were entirely self-sufficient, man-
hauling all of their gear and using no radio for
the 883-mile march to the pole. Swan agreed.
Their Footsteps of Scott expedition brochure
read:

> …to restore the feelings of adventure,
> isolation and commitment that have
> been lost through the employment of the
> paraphernalia of modern times. Without
> recourse to depots, dogs, air support, or
> outside assistance of any kind.

Mear and company tried to court the pole
with a spartan $350,000, then reluctantly
conceded to buying a ship and the other un-
avoidable excesses involved in Antarctic travel.
Swan doggedly found several million dollars'
worth of support. And during the Antarctic
summer of 1985–1986, the trio walked in to-
tal isolation across the most unspoiled land-
scape in the world. Unbeknownst to them, as
they dragged their sleds to the South Pole, their
support ship was crushed by pack ice and sank.
Finally, following in the footsteps of many other

threadbare adventurers, they arrived back in England bankrupt, holding a six-figure bill for their unplanned flight out of Antarctica.

But the magnitude of Steger's crossing can't be disregarded. ABC's recent television footage of the international team setting up a tent in eighty-mile-per-hour winds on what was called "another moderate day" shows that the six have bitten off a mouthful. But they shall survive, and probably will finish their difficult trek across the most desolate continent on the planet. It's part high adventure, part work, yet the hard-working adventurers are all highly paid. If there's a problem, they'll simply dig in and radio for more air support.

So choose your heroes as you may. Steger would be first to cite Scott of the Antarctic, who stared at infinity, only eleven miles from a food cache, then penned his final words with great dignity: "The causes of the disaster are not due to faulty organization, but to misfortune in all risks which had to be undertaken..."

Then there is Roger Mear. In 1983 he was still limping from his crevasse fall. Still he was vibrant and ecstatic after finishing a wildly corniced and previously unclimbed route on Alaska's little-known Mount Deborah. He looked like a bum and smelled as if he needed a shower. A shopkeeper threatened to have Mear arrested because he counted his own change out of the cash register. His clothes were worn thin, and as we played king of the rolling log, we chatted. He never mentioned his upcoming trip to the pole.

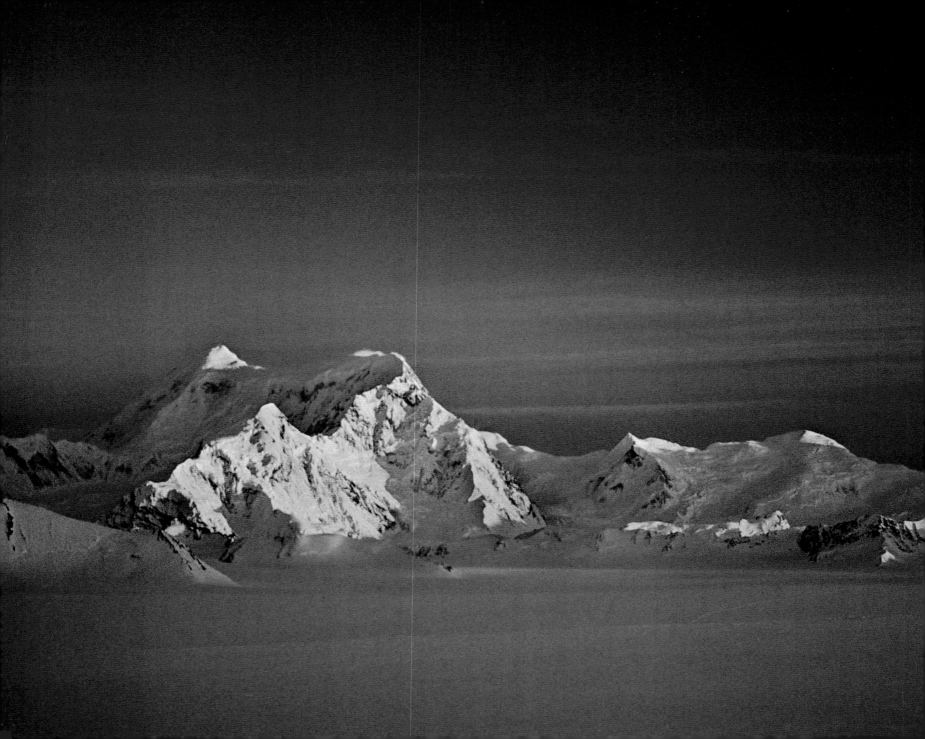

Mount St. Elias was first climbed by the Italian Duke of Abruzzi in 1898, and this rich historical backstory made the expedition a perfect book project. In 1995, on the heels of a divorce that prompted a restorative expedition with plenty of time to rechart my future, I procured an advance royalty from the New York City publisher Henry Holt and, with my sailing partners, split the cost of a thirty-foot sailboat that carried us from Seattle twelve hundred miles north to Mount St. Elias. The first three weeks onboard in tight quarters—in hazardous tidal waters, then out in the open ocean—proved an expedition unto itself. But that was only the prelude to an uncharted and dangerous climb detailed in this story.

My blundering efforts at learning to sail or even pilot an awkward, large-keel-hulled boat

Sunset on the northern façade of Mount St. Elias, 18,008 feet, from the Quintino Sella Glacier.

haunted me until I had the opportunity to sail alone from Prince Rupert to Seattle at the end of the expedition. Those times I put up the sail and found a sense of mastery under the power of the wind that set off a profound longing inside of me and in large part inspired me to rig a kayak to sail much of the Northwest Passage two years later (see Chapter One). The bug still hasn't left me: I often imagine sailing around the world, thanks to this 1995 climbing and sailing trip.

My climbing partner, Jeff Hollenbaugh, embodied the ideal expedition personality. Until the avalanches began, he was unflappable, enthusiastic, and the most easygoing soul you could wish for in the confines of a tiny bivouac tent. He chafed—as everyone does—while being repeatedly interviewed on my video camera, and by the end of the expedition, he wanted nothing to do with the long sail home, but who could blame him? The expedition was a glorious failure, almost doomed from the beginning

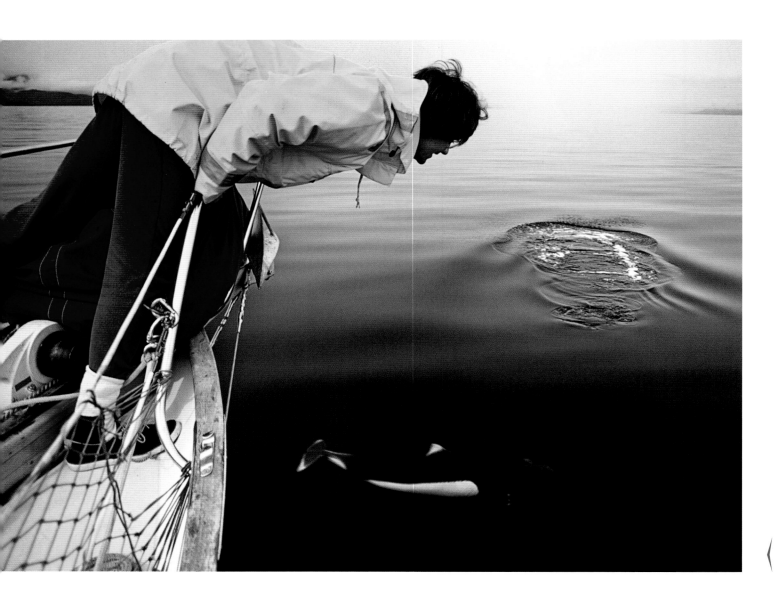

Jeff Hollenbaugh enjoying playful Dall's porpoises, showing us the route twelve hundred miles north from Seattle, Washington, to Icy Bay, Alaska.

for its audacity, and I never bothered making a film. The Most Hostile Mountain: Re-creating the Duke of Abruzzi's Expedition on Mount St. Elias *was published in 1997—oddly, it is the only book of mine that went out of print, but it still earns the most word-of-mouth raves.* Climbing *magazine asked me to write the following story for their September 2000 "Epics" issue.*

IN LATE APRIL 1995, Jeff Hollenbaugh and I began donkeying hundred-pound packs toward the tallest escarpment in North America. We first saw Mount St. Elias as the ultimate seismic tsunami: a product of battered continental plates, thrusting ancient earth and ice three and a half miles above the Gulf of Alaska. Just looking up at the cloud-hung mountain as we walked—knowing of the river crossings, mosquitoes, and blisters—hurt.

For training, we'd spent the last month sailing a small boat twelve hundred miles from Seattle, drinking beer, and fishing in the cold Pacific. Although neither of us were complete strangers to the sort of labors that lay in front of us—18,008 feet of vertical gain through fifty miles of brown bear habitat and slushy glaciers—it did take several days of walking to get our land legs back.

Since Plan A—an unclimbed yet safe Southwest Spur—was blocked by impassible icefalls, we reluctantly switched to the South Face. This steep, two-and-a-half-mile-high, five-mile-wide concavity is overhung with hanging glaciers. Add to this the region's prodigious snowfalls (along with periodic earthquakes), which have a tendency to loosen these hanging edifices of ice and trigger cataclysmic avalanches. A place, in short, where atheists would be forced to review their convictions.

For several days now, as we plodded across the Malaspina Glacier and onto the Libbey Glacier, the roar of avalanches rose from the distant face like thunder. We reassured ourselves that our route was merely getting cleaned off. Therefore, we reasoned, by moving alpine-style quick, as the Nietzschean climbers of our fantasies, we could beat the next cycle of avalanches. Up there, we equivocated, we would also

elude the clutches of yesterday's huge bear, which had horrified us by placidly hopscotching across the maze of crevasses, lured by the smell of our sailboat-ripened long underwear.

After eight days of thankless toil across this frozen white desert, backlit by the Pacific Ocean, we stopped in the avalanche shelter of a snow dome at six thousand feet. The sailboat was over forty miles distant and our packs held eleven days of food and fuel (half of which we would cache at this camp for our descent). As rock fall bombarded Jeff's Plan B couloir up to the double-corniced Southeast Ridge, we turned to Plan C: a contrived and avalanche-swept ramp leading to a small face beneath the eleven-thousand-foot Haydon Col. Plan D—a distinct nonoption—was retreating to seasickness and ignominy.

"You know, Jeff," I tried a voice of elderly wisdom on my partner (fifteen years my junior), "I'm sure the ramp's not as bad as it looks." The trick, I mentioned, would be to sprint through the three obvious debris piles as hastily as our legs could carry us.

Before going to sleep, we watched Big Bertha, emanating from two miles above, avalanching toward the slope we had earlier traversed, simultaneously and slowly mushrooming over toward our present position, chilling the air forty degrees, blocking the sun, fogging our sunglasses, and refrigerating our lungs.

Jeff wrote in his journal: *"Just watched the grandest ice fall collapse I have ever seen, right across the path we will travel tomorrow. The only thing I like about this route is that if I get crushed by the ice it isn't a bad place to check out."*

I shook Jeff awake at three-thirty on May 5. The darkened sky twinkled with distant constellations. Mars glowed red as a stoplight. The face above sparkled phosphorescently and for once it was silent. But as Jeff torched the noisy stove to roaring life, I jumped, thinking the face had let loose again.

We packed up and ran into the bombardment zone. While I stopped by the debris pile, admiring its neat semicircle shape, Jeff yanked on the rope from behind and shouted impa-tiently to keep me moving. We were committed now; we weren't going to stop because of mere crevasses or a few showy avalanches. I felt omnipotent. And in this delusional state, I convinced myself that this was the power of remote mountains—you respond to their overwhelming indestructible magnitude in kind, by feeling similarly invincible.

The main debris pile stretched a square mile and a hundred feet deep. We jumped on board warily and catlike, as if catching a train from an overpass, skipping, jumping, then skating as we tried cramponing into glass-hard ice blocks. Jeff was mute behind me, so I announced the observable good news: "Nice that the avalanche filled in all the crevasses!"

We were off the pile and up the opposite moraine in fifteen minutes. Jeff took over the lead, jumped two crevasses, and started weaving through seracs. After another two hours, we got dead-ended by a half-dozen chasms. But by long end runs and following tight compass bearings in the whiteout—constantly consulting the altimeter—we were determined to wriggle through. An avalanche bellowed

somewhere nearby, too close for comfort. Our nerves were strung so tight that if we stopped, the conversation would naturally turn noodle-backed. I knew that if we just made it across the worst of the run-out zone, we would be too committed to turn back.

After we swam a rotten ice wall, the clouds lifted to reveal more crevasses. I caught my breath and took three running crevasse jumps over the bluest and most bottomless-looking crevasses I had ever seen. Jeff followed speedily.

When the sun triggered the itchy Big Bertha, a mile off, it was hard not to admire the billowing airborne snow, mimicking a cumulus cloud, and roaring with thunder. "Beautiful, huh Jeff?"

He shouted, "LOOK!" Then, with terrible calmness: "We're dead meat." Straight above our heads was another avalanche, a half-mile wide and oddly silent.

We began running just as the roaring noise reached us. After a record-breaking hundred-yard dash, we jumped into a shallow crevasse, sheltered by a semitruck-sized serac. We pulled our suits up as Jeff uncharacteristically intoned,

"Fuck, fuck, fuck." Given his soft-spoken nature, catastrophe seemed imminent.

"We're going to be okay," I lied. I suggested that we both grab our shovels just in case we had to dig our way out. He ripped his shovel off his pack as a sign of consent, as I locked my arm against the side of the crevasse and we both took deep breaths, like you do before diving into a pool to see how long you can hold your breath. Just as I thought about how slowly time was passing, the sky went dark and the roaring engulfed us. I pulled my hood up and it went dark as the wind reached down into our crevasse and up into our suits, spackling behind our sunglasses, licking our eyelids, and retracting my testicles up into my groin as surely as if I had been kicked, stealing all of my self-assurance. Then it stopped as suddenly as it began.

I poked my head up and looked around into a white blanket of ice vapor. It was impossible to see where the avalanche debris had stopped. I clambered out, and looked at Jeff: his snowy white hair (formerly black) was plastered straight up. His eyes were fluttering, but he had not yet spoken. "How do you feel?" I asked.

Jeff Hollenbaugh climbing two vertical miles above the sea, happy to be temporarily out of avalanche and rock-fall range.

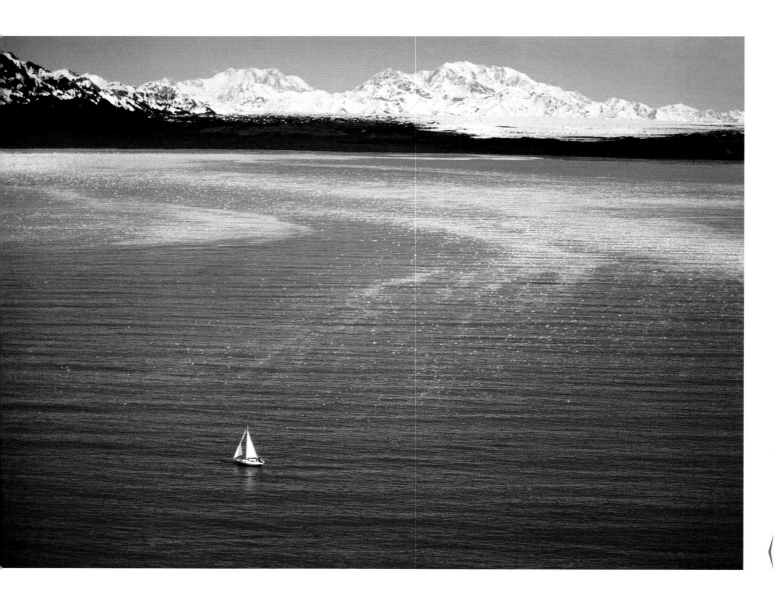

Our boat the *Heaven Sent* in Icy Bay, beneath Mount Cook, 13,766 feet above the sea and the fifteen-hundred-square-mile Malaspina Glacier.

I was determined not to return. I swore that I was through with this sort of suffering.

By the time a Tlingit seal hunter appeared in his skiff as we bushwhacked along the fiord, we had stretched seventeen days of meager freeze-dried rations over twenty-four days—thanks to the molded-over salmon. Seven days had passed without a single bowel movement, let alone a digestive note of flatulence. I couldn't get my pack belt tight around my diminishing waist.

We joined Jeff's dad, Gary, in our boat, the *Heaven Sent*, and sailed back out into the Pacific toward the village of Yakutat. We were all seasick in the twenty-foot swells; I had never sailed before this trip. But looking back at the mountain, and the memory it represented, allowed us to cope.

Nothing would persuade Jeff to accompany me any further than Yakutat (he caught a one-way flight back to Seattle for a week of peaceful rock climbing), let alone Gary (he flew out of Juneau). In the inexorable pattern of most epics, I had twice reached that point where it seemed as if the difficulties were behind and the rest of the voyage would offer smooth sailing. Now I merely had to single-hand the thirty-foot schooner a thousand miles back to Seattle—crashing into an uncharted reef, getting caught in a tidal whirlpool, and transiting thick fogs (sans radar or a GPS) whilst sailing across a half-dozen large sounds.

As a bit of final confession, I was not disappointed when Jeff didn't reply to my letter containing his invitation to return to St. Elias that winter of 1996. We have managed to steer clear of it ever since.

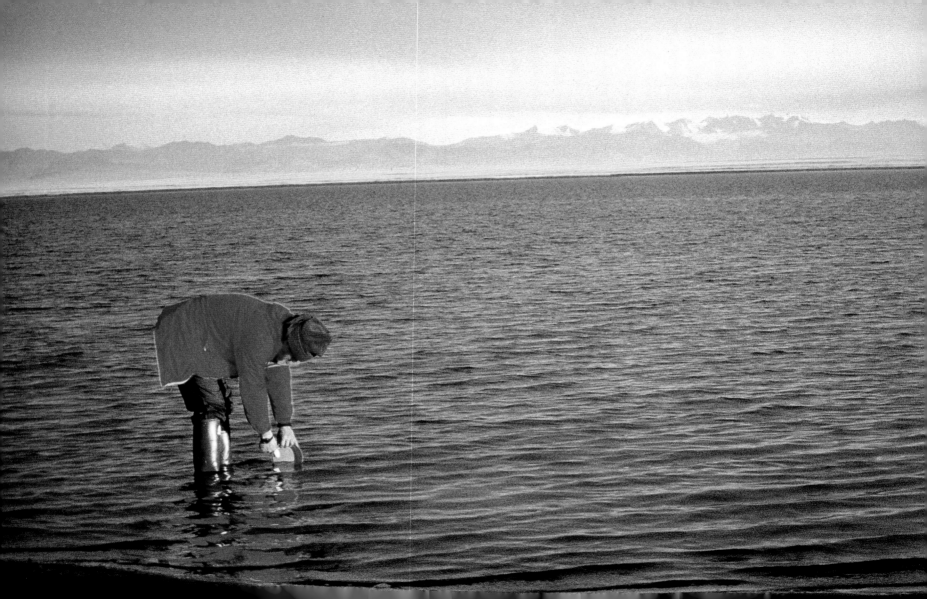

Arctic Refuge Essays

Sacred Place;

Musk Oxen;

What We Would Lose

Although I had written longer narratives centered on adventures I took in the Arctic National Wildlife Refuge, the following three stories served as op-eds to alert the world to the price we would pay for oil drilling in the refuge: destruction of its hallowed coastal plain. During the previous decades of adventuring, I had seen enough of our shrinking natural resources and compromised wilderness to realize that it was time to make a stand. I had recently become a father, and it seemed likely—in the face of fossil-fuel and other wilderness exploitations—that the next generation might lose the opportunity to explore or even take comfort in knowing that these wild places simply exist for their own sake.

The "Sacred Place" essay fleetingly sketched my three weeks with George Schaller, the re-nowned wildlife biologist, who took his first field trips in northern Alaska before I was born. Our 2006 trip comprised endless logistics and meetings with other scientists who explained how global warming had already altered the Arctic. Amid the many detailed parts of our itinerary, I singlehandedly videoed the expedition for a five-minute PBS documentary, Arctic Warming (two of the three graduate students uncooperatively ducked out of almost every interview I shot), kept a journal, and took photographs.

The Patagonia company (which published "Sacred Place" and "Musk Oxen" in their 2007 catalogs) had long ago become a model for sustainable manufacturing, admired and imitated by most outdoor retailer companies. Their seasonal catalogs, with a circulation of up to two million, are collector's pieces, filled with photographs depicting so-called Patagoniacs playing hard-core while dressed in environmentally constructed threads sporting the

Looking south to the glowing coastal plain of the Arctic Refuge—known by Gwich'in Natives as the Sacred Place Where Life Begins—in midnight light.

famous logo. Although I felt at home publishing in Patagonia, *and they paid rates commensurate with any East Coast journal, my "What We Would Lose" editorial in the June 6, 2005,* Washington Post *might have been more important for effecting change, if only because that paper, by comparison, doesn't sing to such a knowledgeable choir.*

Sacred Place

Snowmelt pushed us through the limestone folds and shale backs of the Brooks Range, down the Marsh Fork of the Canning River, toward the sandstone legs of the Sadlerochit Mountains and the fertile-footed coastal plain. We heaved our raft through the shallow headwaters as birds erupted from the willows and Dall sheep bolted off salt licks. An icy sea wind sat down so hard in the valleys that it blurred our vision and stirred the vast landscape into a strange and dusty pandemonium.

The six of us had come to celebrate this place, the Arctic National Wildlife Refuge, and learn from our companion, George Schaller. He visited the Arctic as a graduate student in 1956 as part of a scientific survey. Led and inspired by the wildlife biologist Olaus Murie, they documented diverse habitats and plentiful wildlife, allowing them to convince the Eisenhower administration to legislate a nine-million-acre range. Until now, George had been too busy making other wildlife reserves in far-flung corners of the world to return here. Exactly half a century had passed since he first set foot in the sanctuary that now represents the most symbolic wilderness battle of modern times.

It all began in 1980, when the Carter administration doubled the range into a 19.5-million-acre refuge, and Congress mandated a study of the 1.5-million-acre slice of coastal plain. The results would determine if the plain should be opened for oil leasing or protected as wilderness. The Gwich'in people refer to the coastal plain, which is underlain by billions of barrels of what petroleum geologists refer to as "sweet, light crude," as the Sacred Place Where Life Begins.

If they develop the plain, the United States would gain perhaps a meager one-year supply

of fuel over an expected half century of drilling, while oil contractors would strike it rich. In turn, the Sacred Place Where Life Begins would go bankrupt. Caribou would be driven from their calving grounds along with scores of bird species and an already-shrinking population of musk oxen. This remote wilderness that draws fewer than a thousand people a year would then be lit by the reek of gas flares, the clang of oil rigs, and the shimmer of pipelines.

We hoped for something different. Working through the Wildlife Conservation Society, along with the National Geographic Society and Patagonia, George came back so that this fiftieth-anniversary trip would bring needed attention to saving the Arctic Refuge that he helped create. Fifty years after mentoring with Olaus, George, seventy-three, began passing the torch to a new generation of Alaska and Wyoming graduate students paddling our rafts. By the time we splashed through the swirling Canning River confluence, George showed us all—scientists, a teacher, and a journalist—how we could find the same moral compass, along with the courage to speak out, that Olaus Murie had given him.

When we crashed through the narrow and braided headwaters, the river broke into George's kit. His prized 1956 field journal and his first edition of *Animal Tracks*, personally inscribed to him by Olaus, soaked up the water like sponges. No sooner had we turned the perforated raft up into a windbreak each evening than the unflappable George would hang out his soggy books, wet gear, and valuables, then excuse himself to explore. Armed with a newer field journal, he searched for voles, measured small trees, and discovered nests of plovers, rough-legged hawks, swallows, and peregrines. Identifying and further defining this place—inhabited by nine species of marine mammals, thirty-six species of land mammals, and 180 bird species—seemed the least we could do to show why this refuge needs congressional protection.

Swept out of the mountains, we pirouetted up onto yet another gravel bar. Clad in leather boots, George jumped into ice water

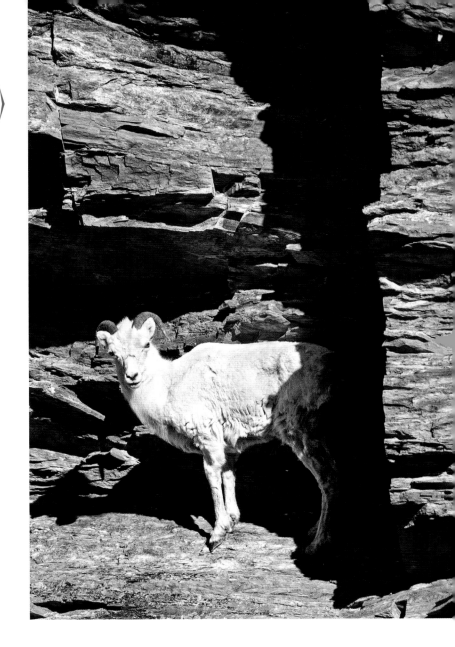

One of an estimated 20,000 Dall sheep that ply the river cliffs, mineral licks, and mountainsides of the Arctic Refuge.

and, before heaving us back into the current, he balanced over the paddle, cupping his hand for a teeth-numbing drink. He gazed around for more Dall sheep, dotting distant hillsides like summer snow.

Each morning, he awoke at five, inspected the tundra, and then arrived back in time to start paddling. Each evening, after long days shivering on the river and boot-sucking jaunts across the tundra, he'd arrive in time to eat dinner and scrub our dirty dishes. We'd talk then about how we might each make a difference. Many nights, George would peel apart the soggy pages of his journal and read to us from a time when they thought of wilderness as a resource more valuable than oil.

Out on the coastal plain, a wet Beaufort Sea breeze plunged us into the freezer. We stepped from the leaking raft one last time. Through airborne river silt that lined our eyes like sleep, thousands of caribou appeared, undulating up and down, pushed above the visible horizon by mirage, as the herd worried the tundra for protein-filled plants against their coming migration. George praised the chill that quelled

the mosquitoes. Then he walked off beneath caterwauling pomarine jaegers, where he photographed whistling ground squirrels, followed tracks, and pulled apart scats to check animal diets—out into the Sacred Place Where Life Begins.

Musk Oxen

The chocolate, blonde-tipped musk-oxen fur flies horizontal in the wind as if they had hung their shaggy jackets to dry in a subzero blizzard. They roam this half-mile-long narrow island of turf, surrounded by the Beaufort Sea shallows, in the 19.5-million-acre Arctic National Wildlife Refuge. In my fingers I hold a tuft of their *qiviut* (pronounced *kiv-ee-yut*) undergarments, softer than the finest sweater, eight times warmer than sheep's wool. No wonder musk oxen can survive the winters here.

From a stone's toss away, I can smell their ripened old hay–and–wet sweaters body odor. The five adults look as happy and unperturbed as hairy cows but circle protectively around a calf and a lush carpet of food. The ancient

Iñupiat Eskimo hunting camp on this islet has fertilized the soil into a rich garden of grass and sedges that could feed the small herd for months. The placid musk oxen stand no higher than my chest. They look to be half yak, half water buffalo, with horns waving up either side of their heads like the hairdo of a 1960s receptionist. The Iñupiat know them as *oomingmak*, the bearded one, but to most people they are the strangest and least-seen megafauna of our continent.

More goat than ox, musk oxen belong to the family of sheep and domestic cattle. Their ancestors first crossed the Bering Land Bridge to North America a million years ago. They grazed with woolly mammoths and rhinoceroses, from the plains of the Midwest to the forested East Coast and across the high Arctic. While their huge coats and an ability to go months without food allowed them to withstand seventy-below-zero tempests, standing on bluffs like icy statues, these survivors of the last Ice Age could not survive human hunters.

They regard me, the intruder on their islet, with an indifference that cost them extinction in

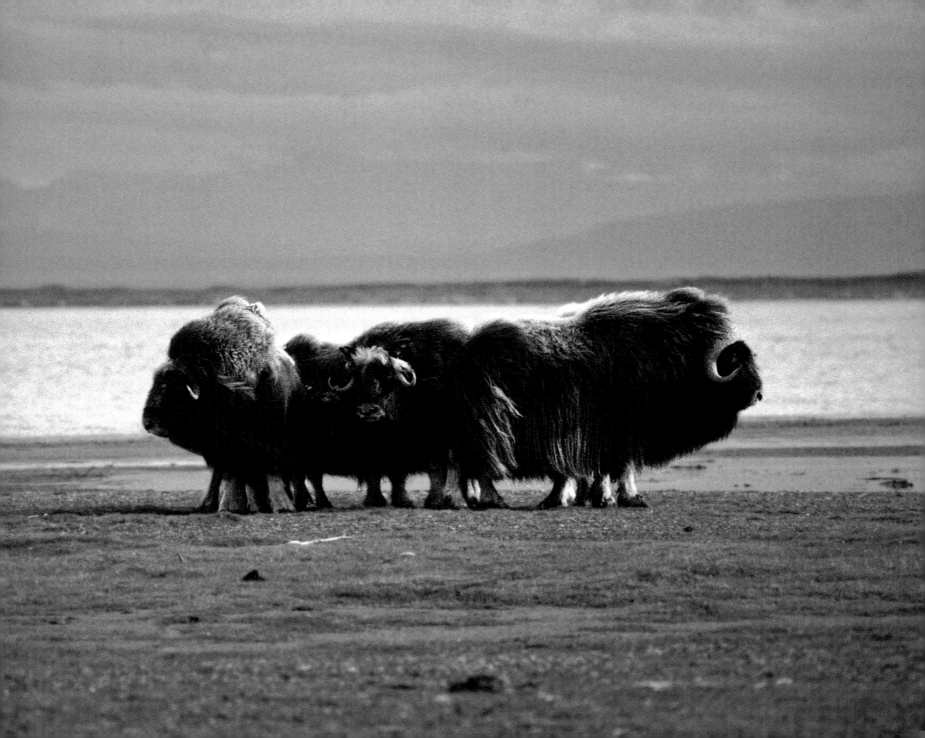

Alaska by refusing to run from hunters' guns a century ago. In 1969, a dozen musk oxen from Greenland were airlifted to a neighboring island. When they fled out onto the sea ice, the Iñupiat, who had not seen the animals for decades, gently herded them back to land. By 1985, 450 musk oxen had spread throughout the refuge. In recent years, their population has dwindled from grizzly attacks and icy climate conditions that prevent them from digging out their winter food. Amid this global warming and the proposed oil drilling in the Arctic National Wildlife Refuge, despite the thickest robes and the warmest cashmere on earth, their future remains fragile.

What We Would Lose

In the northeastern corner of Alaska is a strange polygonal-patterned plain that the local Gwich'in people call Vadzaii Googii Vi Dehk'it Gwanlii, or the Sacred Place Where Life Begins. At this cold ocean edge a caribou herd calves, polar bears den, and millions of migratory birds roost. Snowy mountains come booming up out of the sea, surrounded by sandy spits and lagoons. The unscarred landscape turns and locks in your eyes. It looks limitless. It also happens to be one of the last places where we can cup our hands to drink pure water, gaze across a skyline uninterrupted by commerce, and meet primeval nature. Congress, which calls this protected coastal plain the Arctic National Wildlife Refuge, or ANWR, is close to opening 1.5 million of its acres to oil leasing. Pro-oil politicians, who travel north on weekend delegations to shake the hands of a few Natives and glance at the tundra, often denigrate this alien-looking landscape to serve their agendas.

I've been going to the refuge for twenty years, and I know that the cold and bugs can blind you to the real value of the place, particularly if you're accompanying a congressional delegation keen to reduce our dependence on foreign oil. Since Congress is now operating on a fast track that overlooks and seeks to subdue one of our greatest national treasures, the public needs to know what's really at stake.

Nothing compares to the refuge. Even while kayaking seventeen hundred miles across the

A Walk Across Mount Logan

This story from the July–August 1980 Climbing *magazine brought me my first paycheck as a writer and photographer. At the time, climbing mountains and the expedition life seemed infinitely more important than whatever career I might embark upon, even though I often wondered if I could be a writer. Since the unclimbed West Ridge didn't particularly stretch our limits as climbers, and I was keenly aware that these journeys offered no redeeming value to the rest of humankind, I constructed a narrative that made light of a grueling and dangerous plow up a mountain hammered by snowstorms. As the second-highest mountain in North America, Logan—a more challenging mountain than Denali—has had fewer ascents in its entire mountaineering history than Denali has each year!*

Steve Davis breaking trail on Mount Logan's West Ridge, following our flagged, bamboo garden stakes that helped us find our route in whiteouts or identify thin crevasse bridges.

I kept a journal during the climb and took many photographs. When the magazine went to print, I was chagrined (as I would be again and again) by the editorial selection of pictures. Eventually I came to learn that adventure-driven magazines have small interest in sunset or beauty shots. Action and movement—muscular men swinging ice axes, honed women slotting fist cracks—sells copy. My favorite photographs (often unpublished) showed soft light on serac walls, a sea of clouds, and otherworldly shaped cornices.

In the intervening decades since we completed this first ascent, no one has set foot on this ridge again, and in all probability no climber will make its second ascent because of the distance and time involved in reaching the summit. Also in recent years, mountaineers have shown a new aversion to tackling the St. Elias Range's dangerous and unstable cornices—responsible for the deaths of several talented alpinists. The most memorable part of our climb, despite

frequent cornice collapses, is that Steve Davis, Roger Hirt, George Seivwright, and I began and ended the trip as good friends.

I AWOKE TO THE SOUND of churning gravel, as Roger Hirt's Volvo shuddered through another hairpin turn on the Alcan Highway. I counted twelve empty beer cans choking the brake and clutch pedals beneath Roger's feet, then fastened my seatbelt. His eyes were swimming in red pools behind his coke-bottle-lens glasses and a maniacal smile contorted his face as he steered the car towards the guardrail on the next turn. I felt thankful that we were just a few miles from Whitehorse.

In the Whitehorse airport we had no trouble locating Steve Davis. He looked like the Jolly Green Giant, a full two heads above the normal people in the incoming passenger line. George Seivwright trailed in his wake, with a death grip on the flask of Yukon Jack that he thought was well hidden beneath his jacket.

The four of us were familiar with Mount Logan's sobering history, which began fifty-three years ago when eight men marched in over one hundred miles of desolate glacier. They made the first ascent in a storm, then staggered back down the broken glacier, haggard and frostbitten, terribly overextended. This tour de force is heralded in the annals of North American mountaineering history as an epic, sterling achievement.

I winced as I remembered my epic trying to recruit climbers before the trip. Bradford Washburn's photograph of the oversized West Ridge elicited mixed enthusiasm from potential expedition members. Disenchanted replies, such as "Sorry, I've just decided I'll be roadside climbing in June," were as commonplace as the excuse "Looks nice, but uhh…I have to go to school this summer." A wealthy friend's faux pas was "I'd love to go, if I could afford it." It occurred to me that my peers found something unpleasant about Mount Logan's West Ridge.

With renewed vigor I pressed promising companions relentlessly for the answer

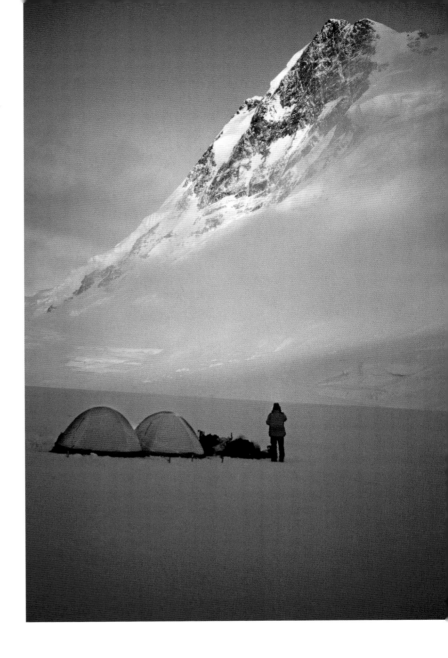

Base camp, 10,000 feet, in the King Trench Route below King Peak (16,972 feet), a satellite peak of the Mount Logan Massif.

to the problem. A rock jock admitted, "I'm not interested; it's too much bloody work." A marathon runner observed, "Looks too long for me. No wonder it hasn't been climbed." Finally, George wondered, "How are we going to carry all of our gear ten miles across the plateau after climbing this three-mile ridge?" I suddenly remembered the intrepid band of hard men from fifty-three years ago who took turns dragging sleds, so I frantically replied, "We'll take turns dragging sleds," and George's eyebrows rose as I continued, "in the spirit of the pioneers fifty-three years ago, who..."

"Spirit of the pioneers, eh?" said George caustically, as we flew effortlessly above the broken-up glacier, nervously picking pills from synthetic pile clothing underneath Gore-Tex. The Helio Courier landed us at ninety-five hundred feet on the King Trench and we began scouting for a route up to the ridge crest. Armed to the teeth with Terrordactyl metal-shafted hand axes, the slightly longer laminated bamboo axes, tubular screws, and chrome-nickel-plated crampons, we clambered up and

down a twenty-five-hundred-foot couloir, until three successive snowstorms left us sitting complacently in the tents, munching fruitcake. We had brought sixty pounds of fruitcake to supplement our gas-producing, freeze-dried diet. The ensuing pollution drove Steve and Roger to their own tent, and without a word we had decided on tentmates. Our rationality began to crumble as avalanches roared down the couloir, and we lay listlessly in the tents and got to know one another better.

I first met Steve when he was mildly hypothermic, wandering around in an ice climber's cabin with his crampons on. He was an aspiring marine biologist from Seattle. Feeling a bit of tent fever, he flicked on the two-way radio, assumed a French accent when he contacted a glaciologist at 17,500 feet, and inquired, "Have you seen my son Philippe in zee hot-air balloon?" With shocking gravity he raved, "He is helping us to search for zee legendaire ice feesh on zee sum-eet plateau." The return transmission was filled with incredulous laughter.

Steve swapped lies with Roger, who we learned was a former racecar driver. Roger, a dilettante mountaineer, was game for anything and had an impressive repertoire of jokes. He began to smirk as mysterious pictures, neatly clipped out from *Gourmet* magazine (crêpes Suzette, beef Wellington, glasses of wine, and bowls of fruit), began appearing amongst our supply of freeze-dried food. At the height of his humor he presented me with a menu from my favorite restaurant on my birthday.

George toasted our three passing birthdays with assorted spirits. The last time George and I climbed together, we had failed miserably because of our reliance on the "Yukon Jack courage" carried in George's rucksack. He spent most of the storm ingeniously concocting two crossword puzzles entitled "Sexual Terminology" and "Sex and Climbing." Steve and Roger retorted with a "Deviant Behavior" puzzle near the end of the storm.

At first the crossword puzzles and escapist novels were satisfactory escapism. Then, in boredom on the fifth day of the storm, I began staring for hours on end at the patterns of our tent ceiling, which eventually became a whirling myriad of colors turning round and round in my

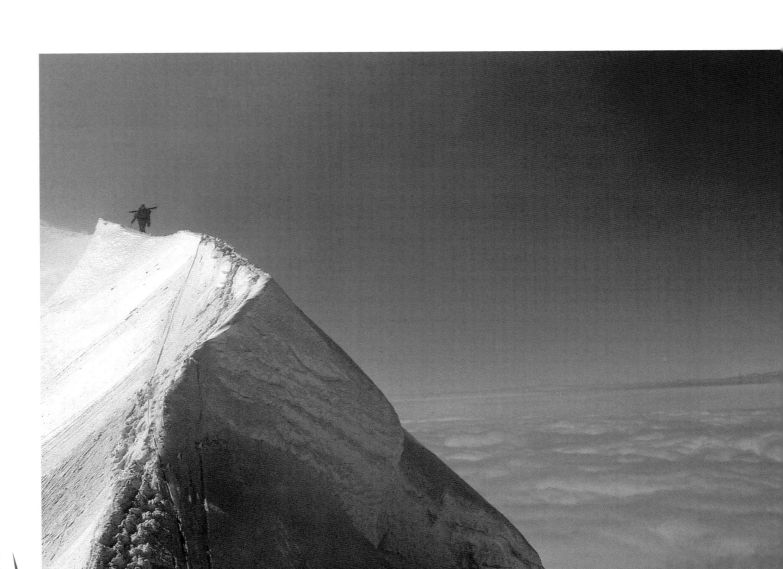

Beneath the sea of clouds, we were surrounded by an oceanic glacier system: the Wrangell St. Elias Range is the largest nonpolar ice field in the world.

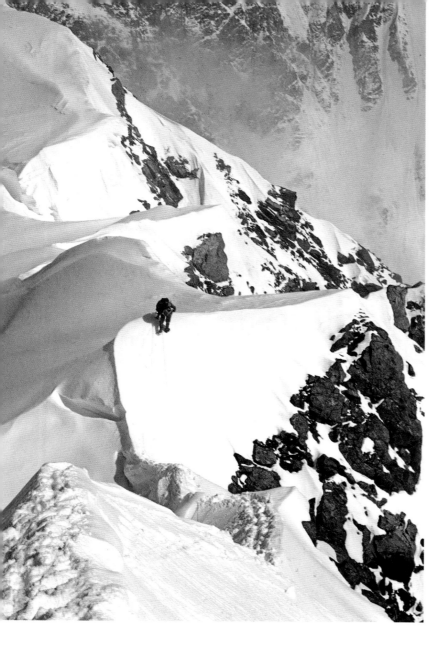

George Seivwright climbing ice, previously untouched by other humans, on the serpentine and elegantly corniced West Ridge.

head...George shook me out of a dizzy nap as the storm ended. My patience had reached its tether. Steve discoursed in nonsensical terms on the ice fish's behavior and territorial instincts as we started up the couloir.

Two days later at the top of the couloir, Roger cursed roundly in the midst of another gale. Twelve hundred feet of fixed line hung in a messy tangle from his harness. He was precariously stranded on sixty-degree ice just below the ridge crest, yelling at the ropes that had caught on a rock projection below.

Meanwhile, George was preparing hors d'oeuvres with the last of the cheese and pilot biscuits to celebrate our arrival on the crest. In twelve days of floundering, we had made scant progress on the long ridge. Our stove and shovel were broken, and one of the tents had begun to rip in the wind. After extricating Roger, George mixed up some Yukon Jack and Gatorade, and we toasted to progress in the shelter of the tents.

Anxiety and bad jokes drove us out to pack loads in the wind. We all marveled at how the northern slope of the razor-edged ridge

fractured and shifted underneath our body weight. During a rest break I admired the awesome North Face of King Peak, then watched horror-stricken as an avalanche inundated our former base camp site with tons of snow. I remembered my trust in the Logan expert from Vermont as he told me, "Your base camp is perfectly safe from avalanches." In the following days we moved our camp to the corniced midpoint of the ridge and dug a snow cave.

Steve and Roger came back later on the eighteenth day after fixing rope across the water ice cornices. Roger announced that an entire section of cornice had collapsed beneath Steve. After Steve changed into his second clean pair of underwear he told the story with a blow-by-blow description. He finished sarcastically, "You guys are going to love fixing those final cornices tomorrow; it's a pity that Roger and I will have to carry loads instead." Roger mumbled, "I'm not sure how you're going to get around that last cornice, though…"

Steve and Roger slept soundly that night in the snow cave. George and I slept fitfully and absconded early the next morning with Roger's

axe. I felt a boundless freedom, front-pointing across the frozen wave of ice, poised several thousand feet above the King Trench. I laughed with George and sang Judy Collins songs as we waltzed across blue ice in a whiteout. I saw the broken cornice and gingerly downclimbed beneath the fracture line. I stopped singing as I imagined Steve too high on the cornice, probably looking for his ice fish. In sobriety at the top of the last cornice, I hammered in Roger's axe and tied the strangely knotted quarter-inch line to it.

As Roger scrambled up the final cornice his eyes squinted in a mixture of wonderment and concern when he realized he was hanging from his missing axe on the quarter-inch line. He said that the knots were tied over the badly frayed sections of polypropylene in an attempt to keep the line from breaking when we hung from it. I groaned inwardly and thought of an obscure expeditionary law that states, "When you have a bunch of clowns you're going to have a circus."

On day twenty-one, Roger accidentally hit Steve in the head with the shovel and sent him sprawling onto a crevasse bridge,

which promptly broke underneath his weight. Suspended from his outspread arms, he contemplated the space beneath his feet and quipped, "I found a good place to dump the garbage, guys!" We tiptoed across a labyrinth of crevasses and set up our tents on a windy spot near the knife edge.

While stormed in at the knife edge, I wrote in my journal:

> Day 23 July 2: Woke up at 9 A.M. and shoveled the snow away from the tent. It has been so windy we've been wearing our wind gear inside the tent. Woke up later at 2 p.m. and the wind was still blowing fiercely as we cooked breakfast inside....We couldn't go anywhere last night or yesterday because of the vicious wind. Last night it blew the snow wall down onto the tent, hit me in the head and woke me up.
>
> I was sure the tent had ripped. The gusts would come and go. Between gusts we could hear a roaring up on the plateau, which got closer and closer; then it would hit the tent. George was holding the tent during these blasts to lend it support. I had resigned myself to fate, consolidating my gear in case the tent ripped open, so I could bring everything to the other tent.

Roger dozed off and dreamed he was inside a washing machine during the spin cycle, as Steve's dirty underwear and socks bounced violently back and forth from a cord on the inside of their tent.

The sun rose brightly into the tents through calm, clear skies, but morale sank to a new low when we finished the last loaf of fruitcake. In silence we raced one another out of camp, all vying to be first across an unstable snow bridge. The tenuous crossing was punched through with foot holes that glowed blue from the light of the crevasse bottom two hundred feet below. We all knew, from a competitive survival instinct, that the last person stood the least chance of crossing.

I screamed to George for tension as my leg punched through into the dark void of the crevasse. In wide-eyed desperation I lunged to the snow wall bordering the crevasse and clawed up out of the hole. Everyone looked on with grins from the far side of the crevasse, and we

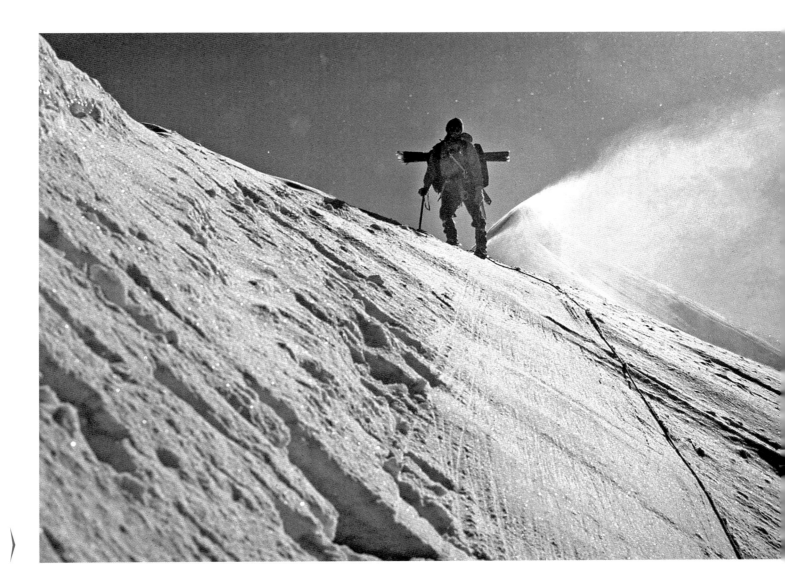

George Seivwright load carrying on a brisk day with wind-carried snow forming another large snow cornice—a characteristic feature of St. Elias Range ridges.

balanced along the crest of the exposed knife edge toward some steep ice.

While George was climbing on the ice beneath the Rock Towers, his crampon broke. Roger and Steve laughed as the front eight points fell from George's foot and sailed down the Japanese Gully to the bottom of the mountain. I watched in distress from the top of the pitch as "four-point George" continued on, unperturbed.

George belayed me up the next lead. Without warning, a cornice broke at my toes—I jumped back and hollered "HELP!" against the roar of wind from the monster cornice as it avalanched to the trench four thousand feet below. I felt lost teetering on the edge in a cloud of spindrift, listening to my heart pounding wildly. I dropped my load, downclimbed very carefully to George, and we retreated to the tents for a brew.

Steve and I gulped hot tea before leaving to fix the final difficulties over three rotten rock towers. It was our twenty-fifth night out.

Rock climbing in fifteen below, our crampons sounded like fingernails scraping a blackboard as we traversed above the night-marish snow slope. I stayed warm on the last belay by kicking rocks off into the abyss. Steve finished bulldozing up fifty-five-degree depth hoar snow and shouted down an unintelligible phrase. With distinct emphasis on each syllable I yelled into the wind, "AM I ON BELAY?" The wind abated momentarily and I heard a faint, "You're off belay." I looked at the wobbly snow picket I had for a belay and shouted wrathfully, "PUT ME ON BELAY; I'M FREEZING; I WANT TO GET OFF THIS AVALANCHE SLOPE!"

A muffled cry came from above and twenty feet of slack dropped at my feet. I grabbed hold of the dubiously anchored fixed line and floundered up the slope to find Steve attending urgent toilet matters in a crevasse at the end of the ridge. We climbed back to the broken cornice and spent the following day in snow holes as our gear hung like a laundered wash on the frayed fixed line above us.

That night George cleaned the fixed line and dragged it behind. Scared shitless, we crossed the exposed avalanche slope for the third time, and Steve changed into his last clean pair of underwear. We wove our way through

seracs that seemed like gargoyles guarding the entranceway to the plateau, and the sun rose in a great golden glow through the chaotic jumble of the hanging glacier. We made camp in the shelter of two seracs.

Stormbound at our serac camp, we played gin rummy with cards that George had cut out from a granola box. Summarizing everyone's thoughts, Roger asked, "How do we find the high-altitude plateau?" I thought of the Vermont expert's advice and recounted, "The northwest col is unmistakable and leads to the high-altitude plateau." Roger nodded and I continued with uncertainty, "You can't possibly miss the col if you just keep heading across the lower plateau."

The next morning, we prepared to leave for the col. Steve stunned everyone when he broadcasted on the radio, "On zee twenty-eighth day we continue our search for zee leg-endaire ice feesh." We wrapped all of the gear that we couldn't fit into our packs with plastic sheets, like giant burritos, making two snow-boat sleds to haul behind us. Steve christened them "Calypso I and II," and we set off, feeling

like mangy beasts of burden, postholing across the vast sixteen-thousand-foot-high plateau.

After two days of wandering around, we still couldn't find the northwest col. We consulted our five-hundred-foot-interval contour map and decided we were probably lost. I cursed the Vermont ne'er-do-well's lousy advice and our esprit de corps faltered. The situation was grim; if another storm moved in we'd be in trouble. We were in the middle of high-altitude no-where, our food was running low, and we were burned out from thirty days on the hill. I looked at my friends.

Steve's fingers were cracked open, and he spoke in descriptive terms about junk food and beer, in lieu of the ice fish. His huge frame had become painfully skinny and his ribs were sticking out.

Roger was half delirious with dehydration, and his face looked like a jigsaw puzzle of sun-burned and peeling skin. He'd had a long day trying to match Steve's giant stride across miles of barren plateau.

George was stoically nursing raw sores on his hips from dragging the sled. As I sat

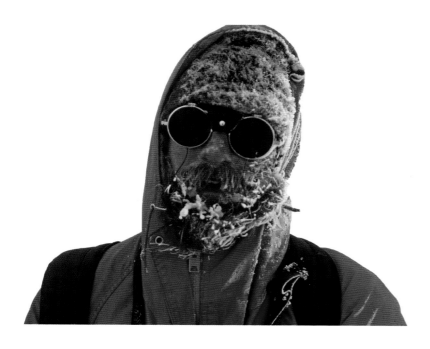

added ballast of the sleds behind us. We took turns breaking trail above the northwest col at eighteen thousand feet and I suppressed an oxygen-deprived urge to cut the sled loose and ride it down the mountain. For consolation, I pretended to be at twenty-eight thousand feet, moving with three breaths to a step. I crawled into our high-altitude plateau camp, and we prepared for an early-morning departure for the summit.

In typical stormy weather, Roger broke trail to the West Summit. On top we braced ourselves against the wind, our clothes encrusted with rime ice. It had taken us thirty-two days to reach this point, and as I watched George, Steve, and Roger, I realized how important our camaraderie was. Roger was sitting down, grinning from ear to ear in rapture, and Steve laughed as his hat blew off and he looked through his camera at George, smiling with the bottle of Yukon Jack.

We groped our way down through the storm to the high-altitude plateau, traded a summit rock to the glaciologists for bacon and eggs, then glutted ourselves. We wondered how long

apathetically with a headache, George cajoled, "Let's go climb that ridge and find out where the high-altitude plateau is!"

I followed George up the ridge. Three hours later the sunset blushed red on the high-altitude plateau beneath us—we'd found it! In our groggy state of mind, we realized that we were standing on top of the North Peak. We staggered back down to the tents and told Steve and Roger of our discovery. We forced down beef Stroganoff gruel and aspirin, then collapsed.

Slogging up a snow slope the next morning, we fought to keep our balance with the

the descent down the trench would take. One of the glaciologists theorized, "It would take you four hours…," and we all brightened up, until he finished, "if you had skis." We thanked them and stumbled off, feeling a bit queasy from the bacon grease.

I got tired of postholing along below the 18,200-foot col and sat down on the loaded-up trash bag I was dragging. After a brief rest, I pulled up my feet and started sliding down the King Trench, using my axe as a rudder. Two hours and seven thousand feet later, at the bottom of the King Trench route, I brushed off the wet snow that I had picked up on the speedy trash-bag descent.

United later on in the trench, we called the bush pilot and asked what our chances were for a flight out. He replied, "The weather is being dominated by quasistationary upper trough." He paused and we looked at each other dumbfounded. Then the radio crackled and he asked, "What are you boys gonna eat if the weather turns bad and I can't fly in?"

"Our boots," we answered.

Miraculously, the clouds lifted three days later, and the bush pilot appeared in the middle of our discussion on the nutritive value of boot leather. After the obligatory posed photographs, Roger and I climbed into the plane. Phil Upton lit up a cigarette and gunned his engine while Steve and George shook the tail loose. A familiar smile lit Roger's face, and I fastened my seatbelt as the plane shuddered down the glacier, heading out to the Alcan Highway.

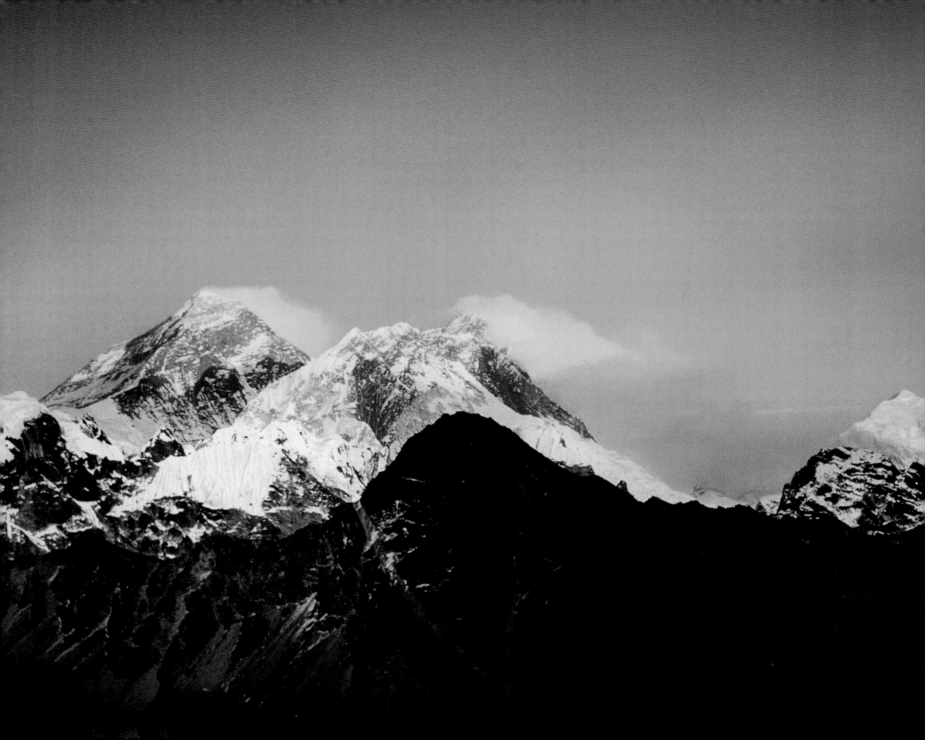

Book Reviews

All Fourteen Eight-Thousanders;
Mount McKinley;
The Horizontal Everest

Over the three decades that I have smithed words for a career, I have published scores of book reviews, often about the North. Even though most writers aren't paid for these reviews, I couldn't say no to free books and I rarely turned down an opportunity to build my burgeoning adventure library. Besides, if I couldn't stay abreast of others' ideas or trends in this genre, I had no business being an adventure writer.

Writing book reviews also offers an opportunity to stay practiced in the short narrative form, and I strove to include my own first-person experiences to make my reviews more readable than the turgid Publishers Weekly *reviews that are the standard-bearer of the book reviewing world. The* American Alpine Journal *is renowned for its book reviews, usually written by those climbers at the top of their game and frequently displaying a subjective and creative flare—to the chagrin of those authors (including me) whose books are lambasted as often as they are praised.*

I steadfastly avoided writing book reviews for friends because I wanted to be a fair and objective critic. When it came to reviewing the book about the landmark Himalayan achievement of Reinhold Messner (now an author of at least sixty-three adventure books) I wanted to tell the story, warts and all. At the same time, I made light of myself as an inexperienced Boy Scout fawning to the überalpinist on Denali.

All Fourteen Eight-Thousanders

Messner has come a long way since I met him in 1976. I was then a shell-shocked dilettante on Alaska's Kahiltna Glacier, marveling

Nepalese sunset on (from left to right): Everest, Lhotse, and Makalu—three of the fourteen tallest peaks of the world.

at the huge peaks surrounding our slightly smaller mountain of food and equipment, when Reinhold Messner skied into Base Camp. He had just soloed Denali.

He was generous, gave us his sled and left-over food, and seemed eager to chat. But I was awestruck and dim-tongued beside the shining protagonist and author of *The Seventh Grade* and that brilliant treatise on climbing ethics, "The Murder of the Impossible," whose prose was as direct and hard-hitting as the routes he'd put up.

Messner shook his head as he saw our pyramid of supplies that had demanded an extra flight from our pissed-off bush pilot. Eventually he walked on, muttering sotto voce as he departed our overindulgent company: "You Americans disgust me."

Of course, he was right; our ethics were obscene. The next week our young team littered the well-worn West Buttress trail with caches of unneeded food and equipment. Never since have I deserved his disgust. The simplistic and lightweight Messnerian climbing style shaped my generation.

Most of his subsequent books have been milestones. *The Challenge* debunked the myth of expedition tactics with his cleverly juxtaposed siege-style failure on Lhotse, followed by his brilliant alpine-style success on Hidden Peak. *Everest* and *Nanga Parbat* furthered his critique of large assaults and the use of bottled oxygen. With each volume his prose grew more self-centered, even purplish. I myopically wrote off these misgivings to faulty translations, for who could question one who had given up everything—brother, wife, family—for an ideal strung high above the clouds?

After *Everest* and *Nanga Parbat* were published, the man behind the books appeared to be less the messiah and more the martyr. He lived in a castle. His profile in *Time* was titled "King of the Mountain." His success had become contingent upon an ever-burgeoning mountain of books and a dynamic media machine of his own creation. Could it be that my hero was turning into a parallel of the Ugly American?

Nonetheless, one hundred years from now Messner's name and lessons will stand out in Himalayan climbing. He was the first forthrightly

to pronounce that the secret to climbing longevity and survival lies in listening to your intuition. Furthermore, he will be remembered because he has shown mountaineers how to utilize little gear and thus better to appreciate the mountain itself.

His latest book, *All Fourteen Eight-Thousanders*, is haunted by a climber scarcely mentioned, whose achievements and ethical rigor seem to outshine Messner's stardom. I refer of course to Jerzy Kukuczka and his completion of all fourteen: eight new routes, four winter ascents, one solo, and one ski descent. Although several of Messner's climbs were new routes and solos, many were repeats of established lines. Furthermore, the unassuming Kukuczka—fond of vodka blowouts and living in a cramped tenement with his family in Poland—has never written any books about his eight-thousand-meter peaks. To be sure, Messner crossed the finish line first, but this great achievement is a little sullied by a hyped-out media machine in need of constant feeding.

Otherwise, the structure of *All Fourteen* is simple and serviceable. The chronologically ordered stories are well illustrated. Incredible that he could even gasp his way up these peaks, let alone take good photographs, which are often more interesting than the rehashed stories from his previous books.

One interesting sidelight of the book is the short commentaries from such Himalayan masters as Kurt Diemberger, Hans Kammerlander, Oswald Oelz, and Chris Bonington. These give perspective and help to explain the author's immense contribution. Sidebars from Riccardo Cassin and Doug Scott don't pay homage to the grand master, a welcome relief. But most readers will guffaw at the commentary from Messner's waifish young companion, Sabine Stehle ("to base camp on three eight thousander expeditions"). She tells the reader that her boyfriend gets too much heat from the critics, and the accusations that she is Messner's *dolce vita* are maligned gossip. Objectivity is thrown into the deepest crevasse here.

Otherwise, the appendix has interesting statistics of climbers who have climbed at least four eight-thousand-meter peaks. The charts concerning success rates, number of

expeditions, nationalities, and fatalities on the eight-thousand-meter peaks are fascinating.

In the end, Messner's respect of the mountains is a thematic pillar. For example, every chapter heading provides the original and indigenous mountain name, rather than surveyors' more recent and canned label. Nor is Messner entirely blind to the contradiction and limitations of racing up all eight-thousand-meter peaks. He writes: "Our generation, as I have often said, is not going to be measured by how many eight-thousanders we bagged and how fast we made the climbs; we will be remembered for how intact we leave these mountains as places of opportunity for the next generation."

The antecedent Messner—who was hero-worshipped by a generation—would have disavowed the race to climb the fourteen biggest and focused instead upon the overlooked difficulties of the six-thousand- and seven-thousand-meter gems. Nonetheless, he could surprise us again. His recent advocacy of protecting the "white wilderness" and his secretive search for the Yeti might eventually show us more of the original goods.

More than a dozen years have passed since the author shared his finest philosophy, not only with the mountaineering community at large, but with some Boy Scouts on their first expedition. I've had thirteen years to work up a riposte to Messner's parting shot on the Kahiltna.

"What is it about us that disgusts you, Reinhold?" I'd ask the next time.

"You are self-indulgent, technophilic, and materialistic," he might reply.

"Alas, Reinhold, that sums up your latest book."

————————————————

I had first met author, renowned cartographer, and aerial photographer Bradford Washburn in 1975 as a Boy Scout preparing to climb Denali. I was one of hundreds who sought his counsel about that mountain, and for another three decades, I enjoyed many chats with this exacting man and his ebullient wife, Barbara. One of the finest honors in my difficult path as a photographer came when Brad asked if he could use my photograph of a lone climber on the West Buttress above a sea of clouds for his coffee-table book.

This gesture (accompanied by a small but hugely appreciated check from Random House) spoke leagues to Brad's character: although supremely confident of himself, he believed his photography to be part of a larger continuum of Denali images. But most critics would agree that his precision-oriented, large-format aerial photographs have no peer in the world of mountain photography. His coauthor for Mount McKinley, David Roberts, brought much of the narrative alive. In his recent biography of Washburn, David (Brad's longtime friend and admirer but also the undisputed prose master of modern mountaineering literature) conceded to the difficulties of meeting Brad's standards of perfection throughout the book's long gestation. This review appeared in 1991, in the British Mountain; the magazine folded later that year.

Mount McKinley: The Conquest of Denali

Mount McKinley: The Conquest of Denali is an unmatched literary commemoration of the mountain. On yet another level, it celebrates one man's sixty-year liaison with it. Through the insight of historical text, accompanied by 120 stunning photographs and maps, the careers of both McKinley and Bradford Washburn are sounded a twenty-one-gun salute.

Surprisingly, this is the first time that North America's highest mountain has been given the coffee-table-book treatment—even though Alaska is already alkaloid with the genre. Forty years ago, long before such books became popular, Washburn conceived it as a sort of guidebook; innumerable museum

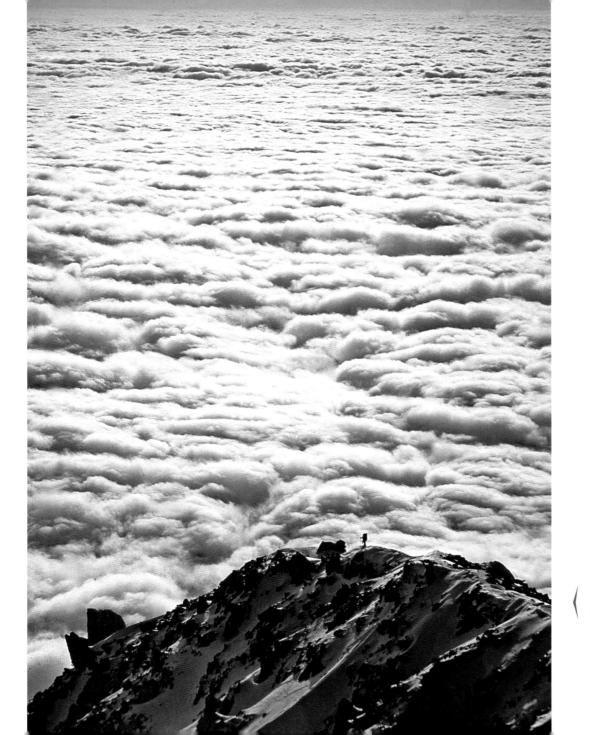

Looking down from 17,200 feet at the West Buttress route and Washburn's Thumb, the rock tower left of center.

Given my interest in both mountaineering and arctic journeys, Jerry Kobalenko's work proved essential reading. Along with his ear for the historical anecdote, he took artful pictures, so I devoured his book. Recently, during the Banff Book Festival in Canada, I had a chance to get to know the author and quickly discovered that too much time in the North can irrevocably mark one's soul. Jerry is a true eccentric and monk of the solitary spaces (characterizations that also apply to me).

The Horizontal Everest: Extreme Journeys on Ellesmere Island

The Horizontal Everest shows that a consummate adventurer can also aspire to illuminated historical writing. Jerry Kobalenko, a talented storyteller, is no stranger to epic sufferfests, breaking over four thousand miles of trail on Ellesmere Island while retracing the routes of explorers or famous Mounties.

Three caveats: (1) Don't be led astray by the title of the book. Whatever marketing chutzpah or lack of poetry are created by *The Horizontal Everest: Extreme Journeys on Ellesmere Island*, the title works once you pick up the author's tongue-in-cheek-glance askance at the world's highest mountain.

(2) The cover photograph has an unusual, almost familiar beauty that often speaks of high art—but it was inspired by a more famous photograph. Some readers will recognize the mimicry of the author jumping ice floes with Jim Brandenburg's famous 1991 photograph from the cover of his book *White Wolf*, showing that animal jumping ice floes alongside Ellesmere Island. Kobalenko even briefly introduces the reader to that wolf photographer within *Horizontal Everest*. But once you get to know Kobalenko, whose wry personality fills his book, you can imagine him chuckling in his sled's slipstream about his spoofed photo, which shows that the book is about the human—rather than the wolf—stories of Ellesmere Island. Although he has underwritten his trips to Canada's northernmost island by exposing the carefully posed photographs that appear in the book's color insert, to my eye, this adventurer's writing is his real talent. And isn't

it true that most artists stand on the shoulders of giants?

(3) This is an arctic exploration rather than a climbing book. Many alpinists will agree with the author's statement that pulling a sled for weeks on end takes a different sort of athleticism than a several-day push in the mountains. Historians within the 101-year-old American Alpine Club will remind us that the early membership cut their teeth in arctic exploration, through some of the very epics that Kobalenko describes in his alluring narrative. The equipment we now accept as de rigueur, or derived from Europe's Golden Age alpinists—crampons, snow goggles, igloos, or snowshoes—actually came from the Inuit dwellers of the Arctic. The techniques and food and sponsorship campaigns of modern climbing were also refined from nineteenth-century polar expeditions.

Even if you'll never pull a sled in the Arctic, Kobalenko's self-deprecating narrative has a way of pulling you along for a ride. Rather than focusing upon his considerable Ellesmere Island journeys, his experiences are merely jumping-off points for rich tales about other northern adventurers. In what outwardly appears to be an expedition book, there is a refreshing lack of chronologically structured itinerary or first-person narrative. He has an ability to cut through the macrohistory hyperbole that less experienced arctic adventurers create whole books out of, and by using his skeptical investigative eye, Kobalenko paints one of the most convincing and entertaining portraits of northern exploration that I've ever read.

In compressed chapters, he candidly shows the reader his troubles with partners lacking motivation, unveils his polar bear encounters with refreshing and respectful candor, recounts the techniques and over-the-top sponsorships involved in North Pole expeditions (started by the lying Cook and the racist Peary), follows Krüger's disappearing trail across Ellesmere, lionizes Hattersley-Smith and the Inuit, and deftly analyzes other forgotten players of arctic exploration. This is original ground here, and all the more stimulating because Kobalenko is no stranger to adventure.

However, the author mentions but does not properly credit the Reinhold Messner of polar

travel, Børge Ousland. Kobalenko also strangely avoids using the kites that are revolutionizing sled travel in polar regions, but his miles logged behind the sled harness against the wind probably gives him more empathy for the explorers he's following. And while the "Selected Reading" appendix leaves out several arctic gems related to his stories, he lists more than a few books that could be arcane classics.

Without equivocation, Kobalenko's book deserves to be read because of its playful yet compulsive curiosity about a landscape inhabited by rabbit herds and sailor ghosts. Through subtle turns of phrase and seamless transitions, he transports the reader to old explorers' homes, dusty arctic museums, and back to the radiant island. "I needed the wild landscape under my feet," he writes in the beginning of the book from an icebreaker. While others "stalked about the ship with the all-consumed air of those for whom every second has meaning, I gazed through binoculars at the distant coast of Ellesmere and recalled the many times its extremes had gripped me with similar magnificent obsession."

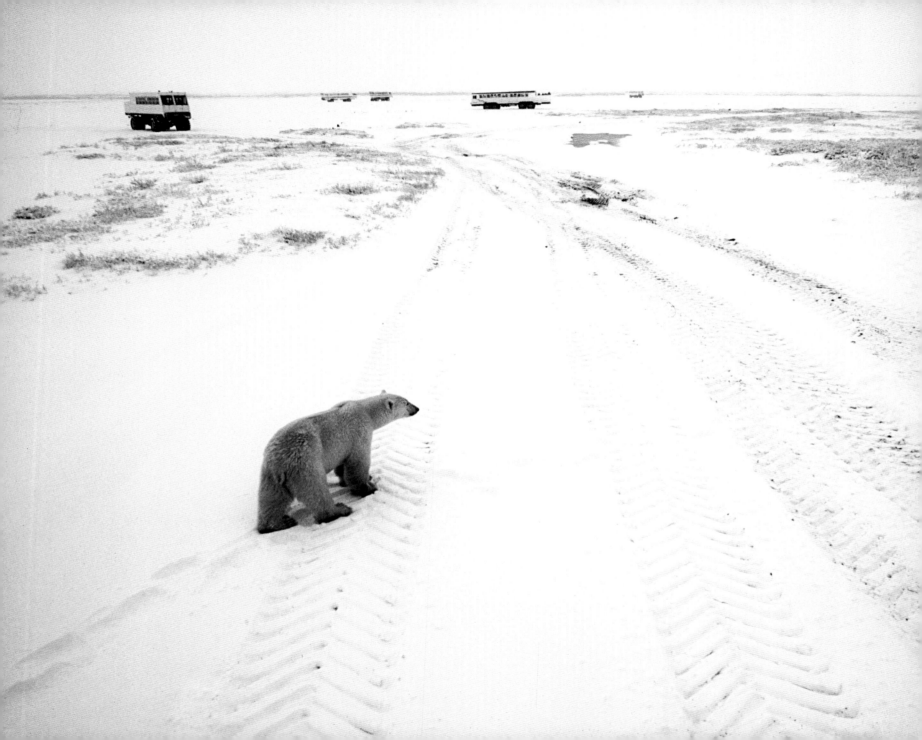

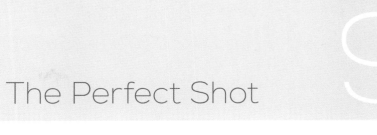

The Perfect Shot

Seeing the Arctic from the safety of a tundra buggy, after having crossed the Northwest Passage a half-dozen years before, allowed me a new perspective on polar bears. In retrospect, the safe and cushy experience did not allow me to improve upon the photography, contrary to the assigned story title. Still, I remain indebted to the Hooked on the Outdoors *editor and writer Doug Schnitzspahn (now editor-in-chief of* Elevation Outdoors*), with whom I have long commiserated over the challenges of our writing careers. The images I captured from this assignment (which were published in the September 2005 issue) were journalistically solid. But when I compare them to my grainy images of a polar bear swimming toward me or challenging me from an iceberg in 1999, I* can feel the difference. Shortly after this trip I stopped shooting film in favor of the instant feedback of a digital camera.

One could argue that the comfort and efficiency of traveling in a heated tundra buggy insulates an artist from the light that defines great photography. And now that changing climate is melting the polar bear's sea ice hunting platforms and putting the species at risk, it might be best—for sake of the polar bear—to keep photographers and polar bears safely separated from one another. There is now evidence to show that both polar and grizzly bears, with their food sources removed by changing climate, are much more likely to be preying on humans. While grizzlies are nothing to be trifled with, when you see a polar bear up close and personal, tending to myriad daily obstacles—capable of swimming all day long at six miles per hour or sprinting on shore at up to twenty-five miles per hour—there is no question that this species stands atop the food chain.

More than 10,000 tourists a year visit Churchill, Manitoba, to observe polar bears, mostly from the safety of elevated tundra buggies.

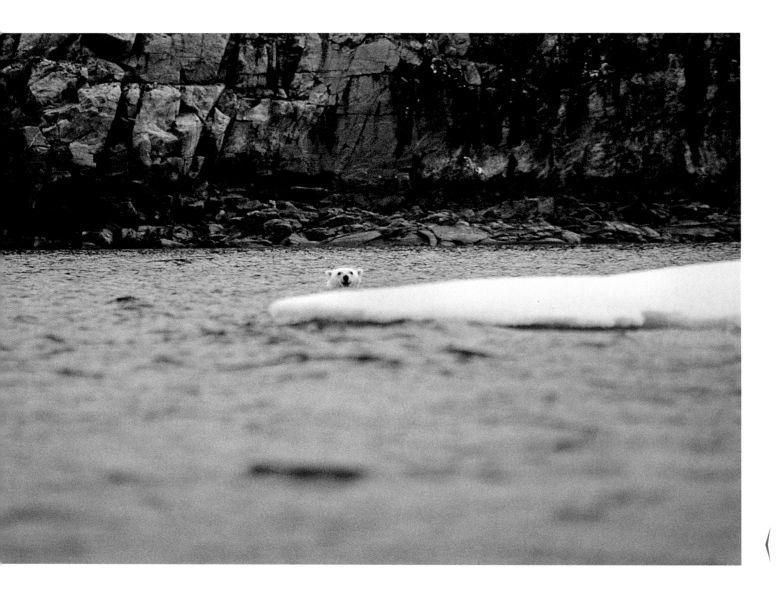

The shaky but unforgettable kind of image you produce when a polar bear starts swimming after your kayak, Gulf of Boothia, Canada.

A POLAR BEAR swam straight at me during a great photographic opportunity—freighted with fear—in the Canadian Arctic. I had solo kayaked twenty-two hundred miles across the Northwest Passage, and this was my first chance to capture an image of the big white bear known to the Inuit as *Tornarssuk*, the One Who Gives Power. I snapped off a couple of quick shots, but the low light and icy waves bouncing against my kayak didn't promote artful composition. Nor did being chased by the largest land-sea carnivore on the planet. Panic began to pound in my throat. Polar bears can easily outswim a paddler, so I pumped my rudder and spun the fourteen-foot-long bow of my flimsy canvas-and-rubber kayak to confront a half ton of the world's supreme all-terrain predator. With the camera forgotten and the bear's breath frothing the black sea as she gained on me, I tried to send forth all of my respect by facing the bear—a technique, I'll admit, that had failed me previously, from the safety of a warm and crowded spot behind the Denver Zoo's Plexiglas.

Yet, amazingly, it worked in the remote Arctic. She stopped swimming after me.

Tornarssuk clambered onto a flat pan of cobalt-colored ice and, as waves pulsed against boulders on the shore, the bear and I regarded each other. In all likelihood, she had never seen a person before; I had certainly never been this close to a wild polar bear. I held my breath, hoping she wouldn't smell the seal meat I'd eaten for dinner. Saltwater misted the air as she shook herself like an immense sheep hound. Unable to resist her beauty, I quickly released the shutter again but then realized that I had to put the camera away. No sense pushing my luck.

Encountering a bear in the wild shakes you (and your shutter finger) to the core, as if for several fleeting minutes, you and the bear are sharing a primal spark that makes you kin. I had seen a skinned polar bear hung out to dry in an Inuit village, and, lacking fur and claws, its resemblance to a muscular human was a revelation. But to meet a live beast in the wilderness stunned me. Stealing another photograph would have broken the spell.

Besides, I had risked enough on this journey. I gave a final bow of respect and turned my kayak east, toward the last village, toward home. The monochromatic day and my reluctance to press for a good image would yield only a few softly blurred photographs.

Five years later, I shuffle after my fellow tourists out of the subzero arctic day into a too-warm tundra buggy in Churchill, Manitoba, the polar bear capital of the world. I have journeyed here to once again try to photograph a wild bear, and this time I feel prepared to properly document it. Ninety-five percent of the polar bear pictures you see in photo galleries, books, magazines, and television specials come from these souped-up bus tours no more than two dozen miles out of Churchill. To the uninitiated, these images appear to have been exposed by pros risking life and limb in the frozen wilderness. Yet the great draw of this place is that amateur photographers can often safely obtain the same stellar photos.

What I crave is just a few minutes of the prerequisite autumn tundra sunshine, or God's light, with the dark ocean as background. Then the alabaster of a polar bear in the foreground will be mine forever. It doesn't matter that the One Who Gives Power is permanently printed in the emulsion sheets of my subconscious. This time I want to blow up a slide from *my* camera, frame it, and place it above the living room mantel. Then I could more accurately recount my close-encounter story of the arctic kind, point to the photograph, and show everyone the otherworldly power of Tornarssuk. If I respect the subject of my portrait, I reason, why wouldn't the bear be fair game?

In the buggy, I compare my traditional film camera with the newfangled collection of digital equipment carried by my excited companions—amateurs, pros, and even scientists, many of whom are affiliated with zoos.

Helen Coe, a blonde extrovert from Portland, had been drawn to photographing wildlife after an African safari. Lenka Tresnakova, our rugged Czech-Canadian guide, spent a decade photographing all kinds of bears. She generously hands me her state-of-the-art Canon digital.

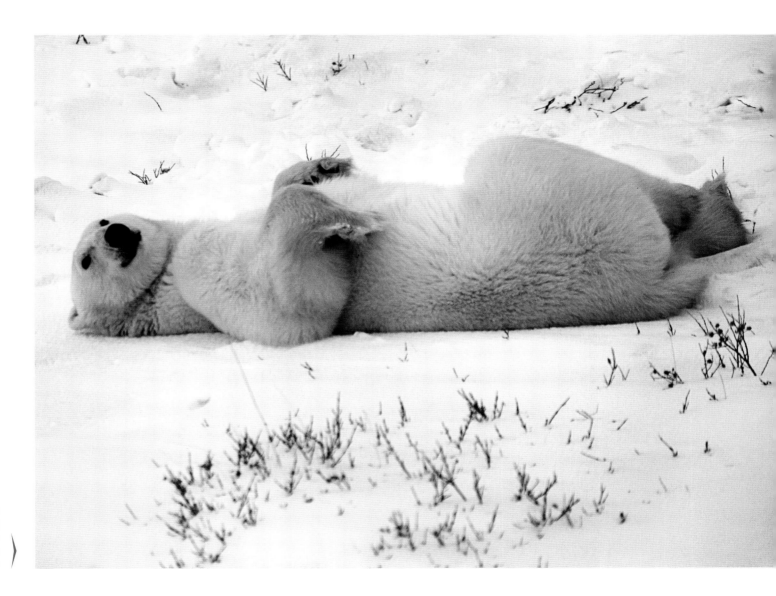

One of many hungry "sea bears" waiting for the ice to freeze to facilitate seal hunting on Hudson Bay.

charge—the officer substitutes a tranquilizer for rubber bullets.

"Then we transport them to D-20," Romaniuk said.

"You mean the bear jail?" I asked.

"No, we call it D-20, the bear compound."

To follow the officers out to the landfill on the west edge of town to check their traps, I had to find a backup "chase car" in case the emergency phone line called the officers away. No sense leaving any unarmed journalists out on foot for bait.

"Eight hundred, nine hundred pounds' worth of animal is a lot of work," Romaniuk reminded me while wrestling with a huge trap, stuck open by the recent spate of frozen rain.

But you can't knock that which succeeds. "For twenty-one years," Romaniuk revealed, "there hasn't been a single serious bear incident in Churchill."

By serious he was referring, undoubtedly, to the case of the stolen pork chops.

On our second night in the tundra buggy lodge, we feast on arctic char. A half-dozen hungry bears circle outside, growling, yowling, and prowling on the other side of reinforced-Plexiglas windows, pretending not to watch us eat. "The roles are finally reversed," Helen Coe—a patron of the Oregon Zoo—announces. "This is the way it should be." By the time I crawl into the snoring back bunkroom, I have burned three rolls of film, shooting the passing "zoo visitors" with my flash.

In the morning, it's cloudy. We drive out in a tundra buggy until we find sparring bears. Windows pop down and camera shutters click. Despite the lack of sunshine, Bob loans out his long lens and launches into another soliloquy: "They're not really fighting, this is just training for when they get out on the ice and find the seals again. Then things'll get exciting." The two males, like albino sumo wrestlers, knock one another down to the ground, where they play bite and roll and then stand up again. After fifteen minutes, they quit and fall asleep, to avoid overheating. Outside the temperature stands at eighteen degrees, not counting the stiff breeze.

Gordon Point pokes into Hudson Bay a dozen miles east of Churchill and is as photogenic as an abandoned military rocket base. Lacking

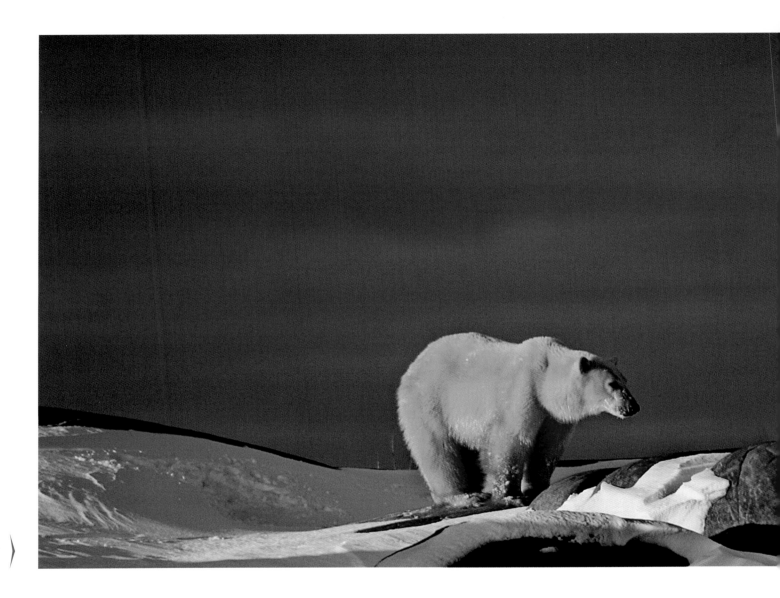

A polar bear lingers in rare fall sunshine near Churchill, Manitoba.

bears, the colorless, bombed-out landscape would be ideally suited for the neon splendor of a NASCAR racecourse. It would take at least two of the skeletal and wind-blasted spruce to make one Christmas tree. The wildlife looks equally thin.

The following days are pretty much the same. Through the gloom, we repeatedly aim and shoot at dozens of three-hundred to six-hundred-pound, starving, subadult male bears. Sows with cubs remain hidden, I learn, so that the males won't prey on the youngsters.

The ocean stretches languorously indifferent and ice floats free in front of this legion of bears similarly disinterested in resuming their swim time until the solid pack ice arrives with seals. Above the clanking, jumping, jerking tundra buggy, a late October low-pressure system collides with the descending jet stream and masses against the refrigerated salt air of Hudson Bay, throwing up and drawing down moisture.

Read: clouds and snow. Read: terrible photography weather.

Still—as the bears wrestle, gnaw kelp, sleep, dream of pork chops, saunter past, shit kelp,

run, pose, box, play on their backs, lick their paws, open their mouths, roll in kelp, and blink their eyes—the fourteen photographers in our buggy, including me, excitedly expose thousands of mostly worthless images. Shooting slides, I can't help feeling annoyed that the gang of digital photographers can simply erase the pictures they don't like.

Often the bears come so close that a telephoto lens becomes a handicap. The ten-foot-high railings on the buggy's back outdoor decks are the only sane opportunity to get outside amid the many hungry polar bears several feet below. It takes just two minutes in the glacial breeze before my fingers feel like sticks tapping the shutter button.

After five days of exposing several dozen rolls of film in mediocre light, I reach new limits of endurance. I guzzle innumerable glasses of wine, listen to a dozen enthralling lectures by renowned bear scientists and bear photographers, begin to feel more caged than the starving species I came to photograph, and get no exercise beyond lifting a camera lens. Nonetheless, as we finally roll and bump our

way back toward town, I vow to stay another week to get the shot that is evading me. If only I had the film.

Churchill's five-million-bushel grain elevator shines like a swollen thumb in the distant and alluring sunshine. A fox shows off, prancing back and forth alongside the buggy with a weasel in its mouth, as the lodge fades into a distant white bus station, guarded by the profiles of a half-dozen polar bears. Then, under clearing skies, my four-hundred millimeter inexplicably locks up as I focus on a snowy owl perching cooperatively alongside the road, undeterred by all the machine-gunning shutters.

Several miles further on, we trade our tundra buggy for a school bus. A German film crew jostles past, along with an influx of anxious photographers who are waiting to take our place at the lodge. I load my broken camera gear into its protective case outside and on top of the bus. Then I fall asleep, soundly as a bear.

Somewhere within town limits, within bear zone three, back on the pavement, the windows drop open with a collective bang as the driver slams on the brakes. I sit straight up in my seat. Outside, for the first time in a week, the sun breaks through the clouds and the ocean stretches into a textured canvas of wind and ice. And there, posing in the foreground not fifty yards away, stands Tornarssuk, the great pork chop eater, glowing golden in God's light astride the black Churchill quartzite, his fur riffling in the breeze.

"Here it is," Bob says. "*National Geographic!*"

My companions aboard the bus certainly must feel what I've always gotten from Tornarssuk: the indelible knowledge, almost a power, that bear and human have the same souls, neither prey to each other nor preying on each other. This animal is as implacable, regal, hungry, and self-sufficient as I once wanted to be. No wonder the sea bear created such an industry.

Everyone senses my pain. As I grit my teeth and begin complaining about my broken telephoto lens, about how I am now missing the best light of the trip, Helen, Lenka, and Bob each pass me their digital cameras, inviting me to take the photograph I have traveled so far to find and waited so long to expose.

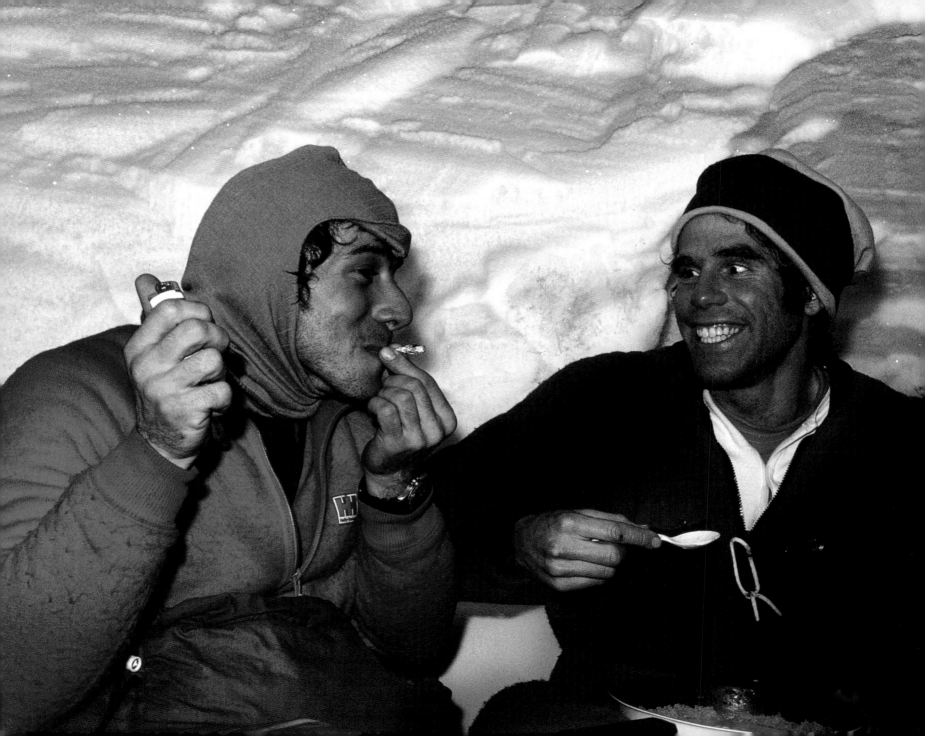

It's unlikely that I could have found the courage to cross the Arctic and face down polar bears if I hadn't climbed Denali's Cassin Ridge in March 1982. A lifetime of successful expeditions is all about building a foundation and assimilating new skills and confidence to successfully tackle similar or greater challenges.

Still, the Cassin in winter was the most dangerous outing of my life. My partners and I coped with the usual avalanches, crevasses, rock fall, frostbite, and storms. Amid these perils, the subzero cold stalked us like a predator. We couldn't even pee without putting future generations at risk.

While I took pains to solicit food and free equipment, we were largely unsponsored with the exception of oatmeal, herbal tea, and trapdoor-underwear suits. After breakfast one morning, the tunnel entrance to our snow cave blew shut with tightly compacted snow, and it took me a precious half hour to dig my way back out to the glacier toilet area, fighting a burgeoning peristalsis. I made it out in time but my fingers had grown so wooden with cold while shoveling up into a subzero ground blizzard that I lacked the tactile sensation to know that the underwear trapdoor was still closed while I moved my bowels.

Humiliated back in the cave, I spent hours trying to boil my white underwear suit clean. Later that year, I published a nuanced story about this fall from grace, causing the underwear company—Damart—to contact me and let me know that I had soiled all chances of future sponsorship.

Our accomplishment and all its close calls still, I imagine, raise eyebrows. Until global warming lifts the subzero blanket off North America's highest mountain, this particular route will only be repeated in winter by fanatics.

Dessert inside one of four snow caves dug during the Cassin winter ascent; Roger Mear with foil pipe and Mike Young eating cheesecake.

Adventurers usually write about their jour-
neys once. Not so for a story about Denali's
legendary Cassin Ridge in winter. For this, the
last version (originally titled "Absolute Zero"),
published in 2004, Duane Raleigh, publisher
of Rock and Ice, *tried to photograph me out-*
side my snowy home in Colorado standing
over a block of fog-emitting dry ice to add at-
mosphere to my story. But in the end, Duane
wisely led with the photograph I shot of my two
companions digging a snow hole—the same
one that blew in the next morning—during a
subzero blizzard at eighty-five hundred feet on
the Kahiltna Glacier. One good image from the
heart of extremis, at least in this writer's mem-
ory, adds tension, timelessness, and dimension
to the words that follow.

OUR BICKERING TRIO had turned into invalids, waiting for deliverance from our base camp snow cave at seventy-two hundred feet on Denali, winter, 1982. Roger Mear could not walk after severing his knee ligament in a forty-foot crevasse fall. And while Mike Young and I suffered only minor frostbite during our successful climb, our spirits had plunged to critical levels in the subzero temperatures.

Two days before, a bush pilot landed, dropped off three Mount Hunter climbers, walked up to our empty-looking cave, and tried to shout in to its potential inhabitants. The cave's twenty-foot-long entrance tunnel, covered with several feet of new snow, muffled all sound. Thinking that the mountain had claimed three more victims, the pilot jumped back into his warm plane and flew away. I crawled out later that evening only to discover the fresh tracks of his ski plane and hoped that our obsession with climbing Denali in winter would not be our undoing.

Obsession certainly stoked the first and only previous winter ascent prior to our attempt. In winter 1967, the Frenchman Jacques Batkin died in an unroped crevasse fall. His surviving teammates, Dave Johnston, Art Davidson, and Ray Genet, carried on, single-mindedly pushing to the summit, surviving a six-day, 18,200-foot bivouac with forty-eight-below-zero windchill. A helicopter, searching for the overdue climbers, found them walking down and plucked them off

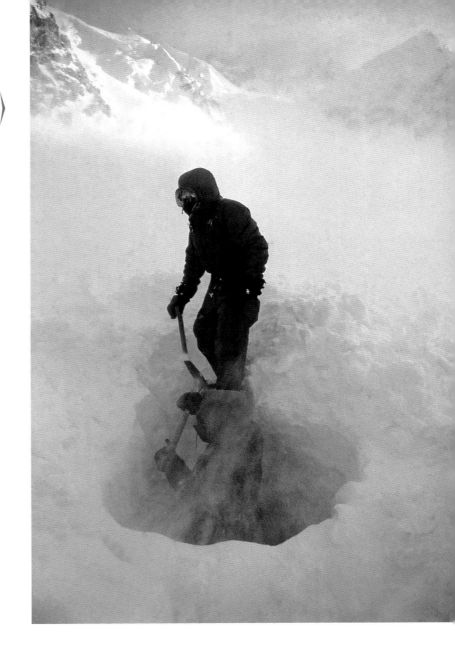

Roger Mear (front) and Mike Young shoveling to stay warm; once the trench was five feet deep, we dug horizontally to make a snow cave.

the mountain. All three were treated for frostbite, including partial amputation of toes.

Two decades later, Johnston actually returned. He skied in solo, fifty miles from his remote cabin, for a rematch against the Gods of Winter but wisely called it quits at thirteen thousand feet, afraid of having his toes further edited.

The remaining winter history is short…and tragic. In March 1983, Robert Frank fell seven thousand feet down the West Rib—spraying flecks of flesh and bone—while he and Charlie Sassara were descending from the summit. The following February, the celebrated Japanese soloist Naomi Uemura disappeared while descending the West Buttress. In February 1988, hearty Alaskan Vern Tejas survived the first winter solo, via the West Buttress, inspiring another Denali guide, Dave Staeheli, who soloed the West Rib in March 1989. That same winter, three Austrians made it up the West Buttress, two days before three Japanese—famous for conquering Everest in winter—were blown to their deaths by tornado winds above 18,200 feet. And in 1998, two Russians upped the

West Buttress ante by tagging the summit in January's shortened days (with less than six hours of daylight), followed two months later by another Japanese soloist.

Of these canny twenty wintermen to have climbed above eighteen thousand feet on Denali, five (not counting Batkin) have died—a disquieting 25 percent death rate. Sixteen have tagged the top. This 8 percent winter success rate contrasts dramatically with the 52 percent success rate in summer (with 14,167 summiteers and counting). In winter, you are exactly ten times more likely to become what the park service mountaineering brochure refers to as "flash frozen!" And, should you join the unlucky percentile who die during the darkened three months preceding the vernal equinox, chances are that it will happen during the descent, when a lenticular hurricane begins and your lungs battle tropospheric depression, an anomalism of low-pressure atmosphere that descends over Alaska in winter, making the oxygen level at the 20,320-foot summit feel like breathing at twenty-five thousand feet.

Our climb on Denali's Cassin Ridge took place twenty years ago. On the eleven-mile approach from the base camp landing strip, ferocious winds made simple skiing a struggle—it took nine days just to shuttle loads to the Cassin. Several times we had to dig ourselves out of our snow cave or be buried alive by the ground blizzards. On the tenth day, when the skies cleared, our pulses quickened when we turned the corner and ogled the Cassin.

Things were looking up: the wind had dropped and the temperature freshened to twenty below. We stood amid the dubious shelter of SUV-sized ice blocks—recently disgorged from a distant hanging glacier—and watched an incalculably large plume of summit spindrift brush-stroke the blue canvas of sky two miles aloft.

After the legendary Italian mountaineer Ricardo Cassin first climbed the route in three weeks of July 1961, the Cassin became sought after for its pleasing architecture of solid granite and fluted ice. Unlike other Denali routes, which follow indirect buttresses or dangerous

faces, the Cassin is a natural nine-thousand-foot transect to North America's highest point. During the normal summer climbing season, when the storms subside and the snow stops falling—*if* subsequent high pressures don't pull in hurricane winds—the mountain allows several climbers to sneak up the Cassin. Most memorably, fifteen years after Cassin's twenty-two-day first ascent, the soloist Charlie Porter performed a two-day blitz.

We climbed then creaked to a halt at a sheltering bergschrund at twelve thousand feet. Overhead, at fourteen thousand feet, we could see the two rock bands: the supposed crux with several 5.5 moves. Seemingly easy enough terrain, but on this route, on this subarctic mountain, quick-brewing storms turn even the most cruiser terrain into the most sporting mountain real estate in the world. With winter winds regularly exceeding one hundred miles per hour, we rightly feared for our lives.

In winter, speed would equal our survival. A storm up high on the route could pin us down for days. Even in fair conditions the best way off the enormous and difficult route was up and over, linking with the standard West Buttress then down that route. Retreat down the Cassin itself in a storm was out of the question. We either climbed quickly and made it to the summit before an arctic front caught up with us or we got caught, waited in our snow holes, and hoped our meager supplies would outlast Mother Nature.

Sucking in subterranean Denali air through my cinched-up sleeping bag, I reassured myself that the differences in our personalities would provide competitive fire to get us up the route. Although we shared an irreverent bonhomie, we were an unlikely "team" of loners. Snoring beside me was the six-foot-three doctor Mike Young, a fiercely independent New Englander. Mike—an Ivy League scholar and basketball player—courted the Cassin in May 1980, but was turned back after a bad crevasse fall. Roger Mear—an English mountaineer and clowning veteran of the Eiger's legendary Nordwand in winter—was a five-foot-eight devotee of the Meerschaum pipe.

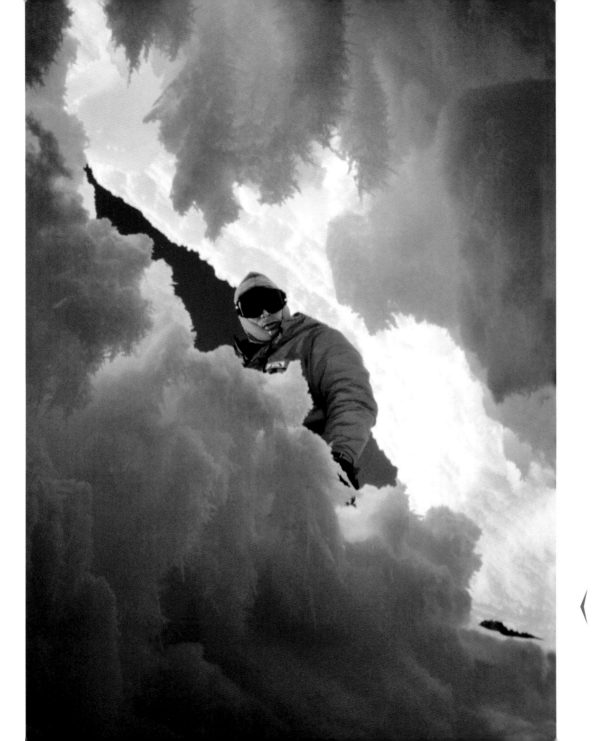

Roger Mear peering into the bergschrund bivouac below the Japanese Couloir.

Before bedtime, the straight-laced Mike made him promise not to toke up once we started climbing. I was the twenty-three-year-old naïve youth seeking more adventure than I'd already found on Denali's West Buttress and West Rib. We all three thrived on extended subzero expeditions, we had all climbed in the Himalaya, and, to a person, we all despised crowded mountain routes. The Cassin in winter was the perfect prescription for our offbeat trio.

An hour after dawn on February 24, 1982, we wriggled out of our bergschrund bivy, squinting like emerging ice worms. The sky had gone as white as the glacier. Roger stood atop a pack half his size, planted his axes in the ice above the 'schrund, and gracefully levered himself up into the twelve-hundred-foot Japanese Couloir.

"Want a push?" I asked.

"Bugger off!"

"Say what?"

Cursing poured down with the sugary snow as Roger established himself on the ice, then pulled up his pack. Mike and I quickly followed, crabbing simultaneously up snot-colored dinner-plating ice, until the awkwardness of our huge loads demanded that we belay. As we climbed, or belayed, the subzero cold forced us to continually pit-warm our hands and to prevent our fingers from going wooden.

Six hours later, frustrated to be moving so slowly over ground that we ordinarily would have blitzed, we tumbled onto a rock ledge and laid out our sleeping bags head to toe.

Just after dawn, Roger stemmed up the first rock band, cursing stridently—"Fuck me"—to demonstrate how easy down-sloping 5.8 felt with a seventy-pound pack [not until thirty years later did I find a climber's topo map that shows a hidden yet easy snow couloir bypass to the first rock band]. After another tedious belay, we began simul-climbing across the glorious corniced arête, a one-thousand-foot ice fin that leads to the route's only horizontal section. The aerated and snow-covered ice wouldn't hold screws. Instead, we buried snow flukes and quick-chopped bollards as flying-saucer clouds whipped across the horizon. At 13,500 feet, we flopped out of the wind and into a crevasse. Salvation at last.

In that tomb-like bivy, and in the evenings to follow, shivering and silently repeating the word *please*, I prayed for our lives. *Why am I here*, I wondered, with the same tone I'd save for later entries in my journal. *Please, if you let me live, I'll never do anything so asinine again*. The wind ate away at the roof of the crevasse, thumping and wailing as if some primordial beast demanded entrance. In the cerulean crevasse light of dawn, we found our sleeping bags coated with frothy rime that looked, at least to my anxious eyes, like frozen spittle.

The wind continued to howl all morning, nearly knocking us off our feet. Aside from the breeze, however, the weather smiled on us— high-pressure cobalt skies displaced the dangerous lenticular clouds, signaling a few days of stormfree sailing to the summit. Time to bolt.

Roger led a mixed pitch, swinging an axe in one hand and pinching granite in the other. What fun this would be in summer with light loads!

By dusk, having negotiated the first rock band, we chopped out a tent ledge at 15,500 feet, a full two grand above our last camp.

While Roger and Mike crawled inside the two-man tent, I drew the short straw and spent an hour hacking another frozen waterbed; we toiled for two hours more to melt enough snow for our water bottles and some tepid drinks.

Above us, the northern lights appeared as green-and-red curtains of glowing trace elements strewn about by the solar winds. Such beauty caused even three atheists to contemplate the existence of a Creator. "My God, look at this you guys!" One hundred and twenty miles away to the south, Anchorage glowed yellow, just as an enormous orange orb breached the eastern horizon, bigger than any moon I'd ever seen—a flaming asteroid subsuming the earth. I played the movie director, shouting for "more Technicolor." Roger poked his head out of the tent and giggled, then Mike took his turn, sighing in admiration.

Sadly, though the three of us were bound by a common passion for cold places, we lacked the proper respect for one another to remain friends. The mounting precariousness of our position on the mountain made us violate the protocols of even ordinary good manners. We

barked orders at one another and competitively egged each other on. From my perspective as the odd man out, our team chemistry had merely sparked an aggressive fire, one that could, on a whim, turn into an every-man-for-himself catastrophe.

The next day we climbed sluggishly through the second rock band. Altitude was taking its toll on our lungs, rendering our feet leaden, our minds lethargic.

In a long chimney, Roger moved with a spidery, tilted-back grace, his arms held below his heart for balance. Halfway up, Roger barely brushed a frost-shattered granite corner, sending a boulder crashing past our heads, filling the air with stinking cordite. Mike screamed. Adrenaline steamed from the hood holes of our Michelin Man suits.

The last pair of our Footfang crampons screeched up the last rock pitch of the second rock band; we still had an hour of light. Thankful, we flopped down where the ridge flattens onto the upper south face and pitched the tent above a dizzying abyss. I had never felt so naked. A good wind could simply lift us up, suck the air out of our lungs, and drop us like clipped birds to the glacier five thousand feet below. As the low winter sun dipped once again below the horizon, Mike and I dove into the tent, bending our knees to shoehorn into its tight quarters. Roger took his turn sleeping outside in the fifty below.

"You okay out there buddy?" I shouted through the tent's vent hole.

"Bloody balmy out here, what you think, *mate*?" replied Roger.

By morning of our fifth day, a good night's sleep had shored up our spirits, pushing back our previous afternoon's fears, making our position seem more like a miraculous perch than death row. Beside us, the groaning, mile-wide expanse of hanging glacier menaced the dizzying south face. A falling rock clacked on and on, as a stone might fall into a bottomless well. Above us, four thousand feet of alluring white snow beckoned.

We moved unroped up this concrete-hard, fifty-degree slope, lumpy with snowdrifts. I broke trail for the first thousand feet of erratic drifts, lost in the endless rhythm of step

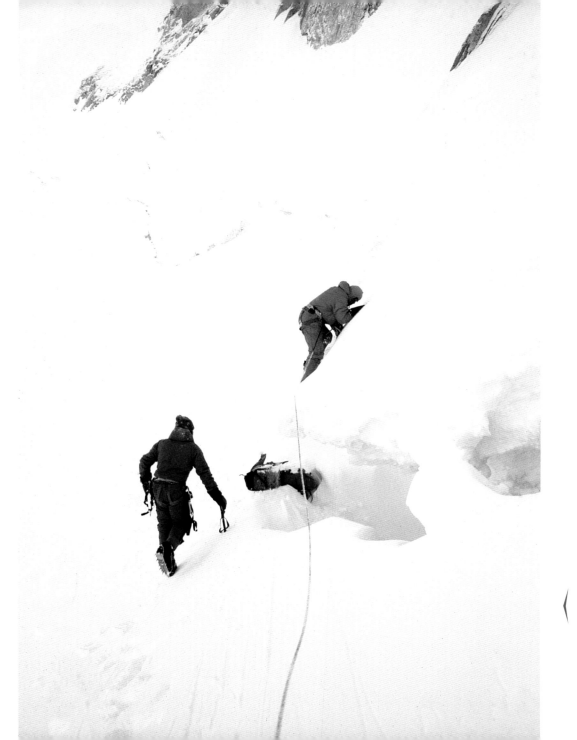

Roger climbed over the bergschrund using his pack as a step and we moved quickly up hard snow that turned into brittle, black ice.

kicking and French footing, constantly looking over my shoulder to assess the weather, wondering when it would change and burst our brazen dreams.

It was thirty below and calm. Twenty miles away, the legendary Mounts Hunter and Foraker shrunk into mere islands above a sea of clouds while the sun hung wanly in the south, utterly devoid of radiant heat. Hoar frost protruded from rocks like daggers, while the steel-cold air whittled away at our lungs.

I stopped repeatedly to cough, trying to clear my congested chest. Somewhere above seventeen thousand feet, I felt my reserves leaking out into the sky as if I'd opened a vein. I was all used up; Mike and Roger passed me. As I resumed the march, a patch of slab from a wind drift silently broke loose beneath my feet—*OhGodnotherenotnowsoclosetothetop*—and before my slide could gain any momentum, I jammed in my axe and stopped. Pissed at losing fifty feet of hard-won distance, I let my anger spur me back into the rhythm: swing the axe, breathe, kick, kick, swing the axe. Mike and

Roger, oblivious to my near demise, had by now disappeared from view.

I caught up to them hours later at eighteen thousand feet, pitching the tent. The wind gusted to twenty miles per hour, and my lungs felt so congested and my head so squeezed, I imagined the wind as a blast of Armageddon. The three of us crowded into the tent and started the stove—its fumes made me even sicker. Mike handed me a bowl of cocoa, and as the heat rewarmed my gloved hands, he splashed in a frozen clump of caloric margarine. "Drink!" he said. Dehydration is the bane of high-altitude mountaineers everywhere.

During a nightmare in the ensuing darkness, I rolled onto Roger, who punched me through our padded sleeping bags until I woke. By morning, my tired and jangled companions merely looked hungover, while I looked, and seemed, still drunk. My spastic, cramping legs nearly kicked over the stove and pot, but I was too sick to care. Someone—I was having trouble discerning the difference between Mike and Roger—helped me load my pack. We wasted

four hours getting our gear squared away. I tripped and fell twice just trying to stand. Finally, someone put the pack on my shoulders.

We climbed. Five hundred feet higher, Mike and Roger waited patiently, clomping their cold feet. When I at last arrived, they angrily ripped food and clothing from my pack, stuffed it in theirs, and screamed, "C'mon Jon, move!"

I gave them the finger, ineffectively, through three layers of gloves and mittens.

By the time I staggered to 19,500 feet, now just eight hundred or so feet shy of the summit, Mike and Roger had already finished digging a tent. The air held still, as it so rarely does in winter, while we lay on our sides and spooned together like submariners in a tight berth. By dawn I could no longer breathe lying down. At dawn, Mike changed his socks and briefly unveiled several frostbite-blackened toes. The message was clear: I had to move faster.

I couldn't keep my balance standing up. Roger tied my boots—which took half an hour in the cold—then Mike pulled on my overboots. A soft blanket of clouds covered the peaks below us; I shut my eyes against the nightmare.

Someone clipped on my crampons, someone shouted, "Go, go!" They pulled down the tent, turned it inside out, and beat it on a rock to shed several pounds of frost. I started up alone, flexing my ankles and exaggerating crampon placements to penetrate the squeaking, wind-blasted terrain. I took five steps at a time, then hunched over for several minutes trying to refill my lungs. More than anything else, I wanted to sleep. Mike and Roger quickly caught and passed me, and sprinted for the summit. I crawled after them. After forty-five minutes, I managed two hundred feet.

Returning from the summit, Mike thoughtfully came down and took my pack. I topped out on the Cassin Ridge, at its convergence with the West Buttress and the beginning of Denali's final ridge—several hundred yards laterally and two hundred feet vertically below the summit. I had finished the Cassin, and since I had lounged two hours on top the previous summer, climbing to the summit again under my present condition would have been pointless and foolhardy. At sixty below, my toes felt remarkably warm and stiff. I pushed aside my face mask

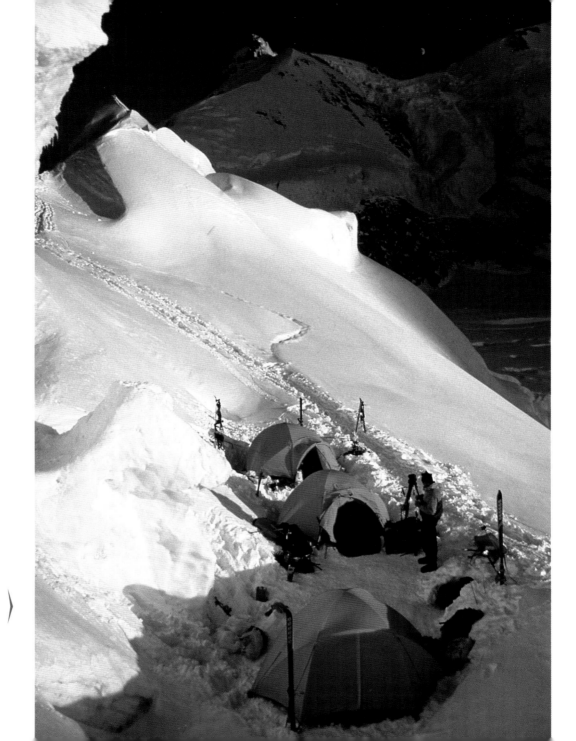

Karstens Ridge camp on the traditional Muldrow Glacier route on Denali; Browns Tower in sunlight above.

and attempted to spit: the drool instantly froze solid, with the startling crackle of a mosquito hitting a bug zapper. Then I joked about how it might be quicker from here if we just jumped.

Roger and Mike looked at one another and shook their heads in sympathy, like doctors surveying a dying patient. Then they shouted something unintelligible and shot out of sight. Alone, I stumbled to the 18,200-foot Denali Pass, then followed the beam of my headlamp across the exposed traverse—known as the Autobahn—where innumerable climbers, many of them Germans, have slipped and fallen. Through a head-spinning hypoxia, I forced myself to perform the proper footwork.

Down on the seventeen-thousand-foot plateau of the West Buttress, the winter wind had unearthed a minefield of desiccated turds and a macabre two-foot-high sidewalk—compressed by the madding crowds of summer—leading all the way to the summit. Out on the bare blue ice lay Roger, inert in his mummy bag. In the cramped tent, Mike waited up with a steaming brew. [With thirty years of hind-

sight, I'll never forget the small acts of kindness that Mike Young was capable of.] Still, we didn't speak.

In the morning we raced lenticular clouds down the ridge. At the thick atmosphere of 14,300 feet, my lungs reopened like flowers under the life-giving sun.

It took another day to descend to our base camp snow cave at seventy-two hundred feet, where we started crossing off the days in our journals. The first bush pilot came and went. Mike practiced mental telepathy in hopes of reviving our irresponsible bush pilot in Talkeetna. To kill time waiting for another hoped-for bush pilot to appear, I scrounged a bit of cardboard and used it to write about my desire to become a writer, life versus death, and the climber's eternal struggle: the longing for a steady girlfriend and a home contrasted with the eternal pining for adventure. Roger just smoked silently, nursing his knee; he'd torn a ligament in a crevasse fall while on a foray to retrieve a distant food cache.

In the soot-walled cave, we didn't talk much. On the eighth day, another pilot, Cliff Hudson,

happened to be out sightseeing and saw our thirty-foot-long "OUT" boot-stomped into the snow. So he landed his ski plane. He flew Roger directly to the Anchorage hospital, where his playful sense of humor at last returned and made him a huge hit with the nurses.

Two years after our second winter ascent, Mike climbed the giant Annapurna South in the Himalayas. Then, while descending Les Droites in the French Alps, an avalanche swept him off and broke his leg, necessitating a helicopter rescue.

In 1988, Roger attempted K2 in winter. Three years later, he and his partner pulled off the amazing first alpine-style ascent of Nanga Parbat's Diamir Face. In 1995—ten years after he and his two partners reached the South Pole—Roger tried to solo across Antarctica, only to be hobbled by a debilitating foot injury.

I worked at Denali from 1982 to 1984 as a rescue ranger. While analyzing the mistakes I'd made during the winter ascent, along with the patterns of other ambitious accident victims, I wrote my first book—*Surviving Denali: A Study of Accidents on Mount McKinley*—in hopes of minimizing rescues. In 1993, to show respect to the mountain that, by all rights, should have buried me during the winter ascent, I deliberately stopped two feet below the top while ski and kayak traversing 120 miles over Denali from Kantishna to Talkeetna. After all, mountains can be spiritual places, rather than inert objects that we subjugate by standing on top of them. Like my partners, I ran a gauntlet of epics on other expeditions, although no trip ever approached the communal dysfunction that I'd fallen into on Denali in winter.

No one has repeated the Cassin during the dark days of winter, and it seems unlikely that anyone would court such risks again. Roger, Mike, and I were relegated to primitive cavemen in our struggle to survive. Whatever recognition we might have gained by this expeditionary brazenness was negated by our inability to thrive as friends.

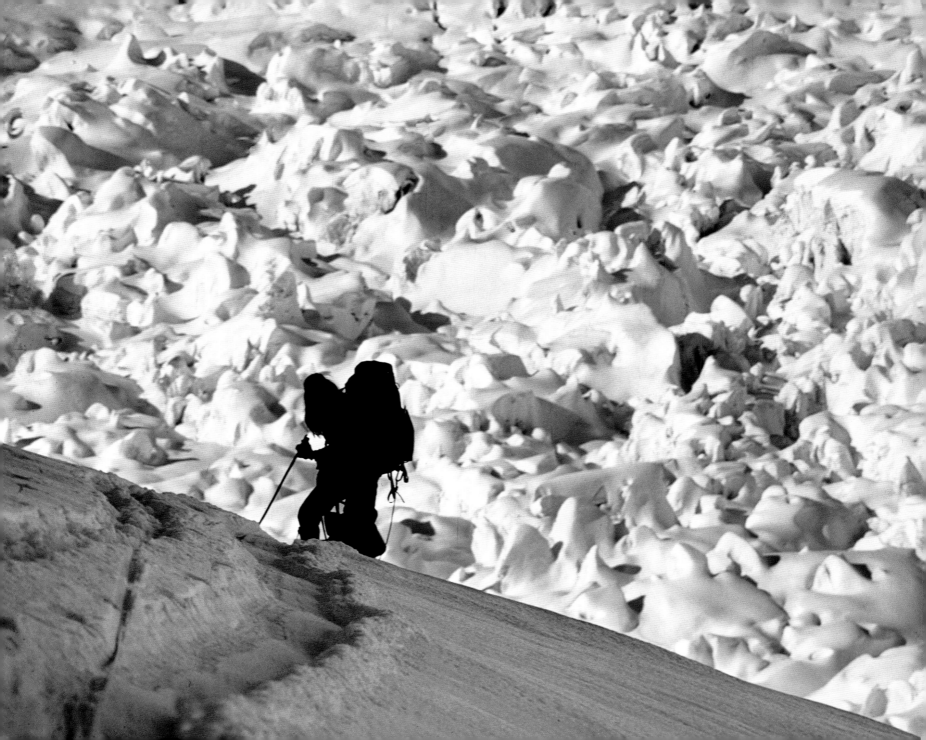

In this story, I employed an unusual second-person narrative in hopes of giving readers a virtual feel for the trip. Although I thought that I had sworn off subzero mountaineering after the Denali Cassin climb six years earlier, going with my girlfriend to Mount Fairweather, in southeast Alaska, seemed at the time like an exception to the usual Alaska winter climb. After all, Nancy Pfeiffer and I were a communicative team, and we liked taking trips with one another. But in hindsight, even the happiest couples are taxed to the limit during big adventures. On this expedition, I learned the hard way that any loose threads in a relationship will unravel against the pressure of avalanches, getting lost, or any number of mishaps that commonly occur on expeditions. Unlike climbing with a competitive male teammate, repeatedly putting your lover at risk does not readily inspire the requisite sacrificial-minded drive it takes to reach a difficult summit. Still, Nancy earned my respect then and now—the woman's skilled reputation precedes her. Plus, she still lives in the North; I left a long time ago.

It's one thing to take an Alaska expedition, but another entirely to live in rural Alaska in wintertime with little daylight. This is the context that most stateside climbers lack about the northern lifestyle. According to one of many myths about being a true Alaskan, you couldn't ascribe to "sourdough" status unless you had peed in the Yukon, faced down a polar bear, and lived in a cabin through the dark winters. Prone to seasonal affective disorder during the winters (as well as frequent bronchitis from training in the cold air), I suffered from depression and worked hard to offset this cabin-fever malaise by skiing and climbing as much as possible. Hence the trip to Fairweather.

As we skiied in deep powder snow, our sleds acted as anchors in the jumbled, crevasse-torn Fairweather Glacier.

Like most of the stories I wrote about Alaska in the 1980s, I didn't take this trip as an assignment; I took it because I had always wanted to visit that 15,300-foot mountain above the sea. A year later, I wrote this story (published in November 1988) for Backpacker *magazine. Typically authors must accept whatever dramatic title magazine editors assign to the story for the sake of selling more magazines. Although it was true that we "missed" the summit, our lives were never in great danger— contrary to the title. Despite the compromises implicit in magazine freelancing, I was pleased that they ran my cover photo portrait of Nancy, smiling high on Mount Fairweather above the clouds, an uncharacteristic shot for a magazine that normally leads with garden-variety backpacking landscapes.*

YOU ARE SICK, coughing, your lungs idling as if the Alaska winter has crept within. Your head is filled with the roar of the tiny airplane that is bouncing you through the Alaska sky, until the giant Mount Fairweather appears out the cockpit window. Sunlight bounces off the ocean in a great blinding blue light, and you shield your eyes against the glare, your heart pounding.

Until now, it has been a twisted, dark winter. Back where you live in a cabin north of Anchorage, glacial winds tore through the chinks in the walls. To get by, you'd dream, and in your dreams there would appear the ideal mountain. You'd be moving smoothly, gracefully, on a tremendous peak surrounded by azure Pacific waters and a sea of white glaciers. Below, the flanks of Fairweather embody all you dreamed about.

To train for it, you had run three thousand vertical feet from the cabin to Hatcher Pass with skis on your back, all the while dreaming of that climb. Up at the lodge, the long Alaska nights often found you shivering in gamey running clothes by the woodstove, tallying the bar tab. Afterwards, you carved crooked turns back to your cabin behind the wavering beam of a headlamp, down past sleeping bears and along the snow-muffled river with the stars above sharp as miniature suns.

By January, stateside friends were writing sympathetic letters, and you wondered if

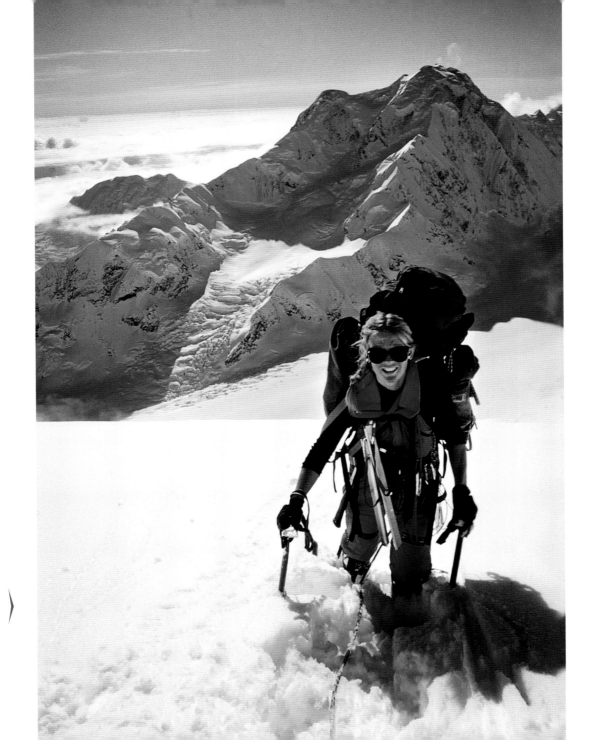

Nancy Pfeiffer high on the Carpé Ridge, emerging from a steep section onto a low-angled snowfield and reveling in winter sun.

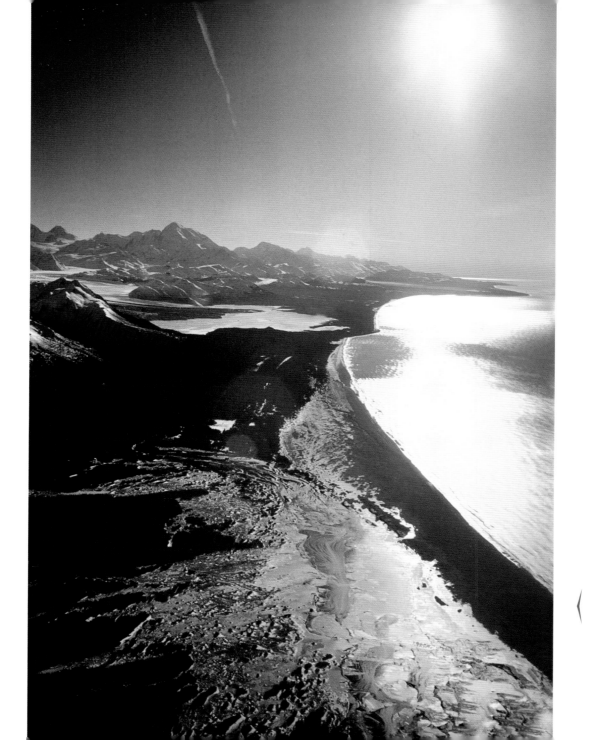

Flying south along the uninhabited Pacific Ocean coast from the Alsek River toward Mount Fairweather.

previous correspondence revealed too much of your cabin fever. It was no fun blowing on your fingers as you typed. The novelty had gone from jump-starting the car, pouring antifreeze down the cabin drain pipes, and restuffing the fiberglass insulation between logs. To warm up, you had to split firewood, pretending that each swing of the maul was an ice-axe placement on your dream peak.

In February, the daylight had returned all too slowly. You hefted the chainsaw with a glint in your eyes, imagining bay windows ripped out of the dark log corners and skylights riven from the leaky roof. Daylight deprivation carries immeasurable costs to cabin dwellers during Alaska winters, and although you may have escaped the absolute depths of depression with many backcountry trips, another winter of seasonal affective disorder might do you in.

But it's all behind you now as you stare out the cockpit window. The ocean stretches to Japan, while to port, partner Nancy Pfeiffer gawks at the mile-wide mouth of the Alsek River. The breakers beat on the coastline, and you imagine sea lions baying amid the surf.

The pilot hugs the coastline. You grimace at the thickness of the forest, then spy a river that should provide an exit off the Fairweather Glacier. The route through the icefall looks like a tray of jumbled, frosted-blue ice cubes. Nancy demands to know where and how you'll get through it. "Trust me, trust me," you say, half wondering just how much to trust yourself.

The Cessna lands with a jolt. The pilot twirls the plane around and shuts down abruptly, five thousand feet high on the Fairweather Glacier. You jump out the door and snow fluffs over your shins. Nancy muscles gear out of the plane while you stroll the glacier, craning your neck up at Fairweather like a tourist beneath a fabulous city's skyline.

The pilot restarts the Cessna, and the prop wash from takeoff blasts stinging snow as you cower behind several weeks' worth of food and gear. Being dropped on a remote glacier brings on a sense of awe and abandonment as dazzling as the sun. You've felt this many times before. This one hits hardest, though, because now it's just two of you, it's winter, and your intended route, the Carpé Ridge—as yet

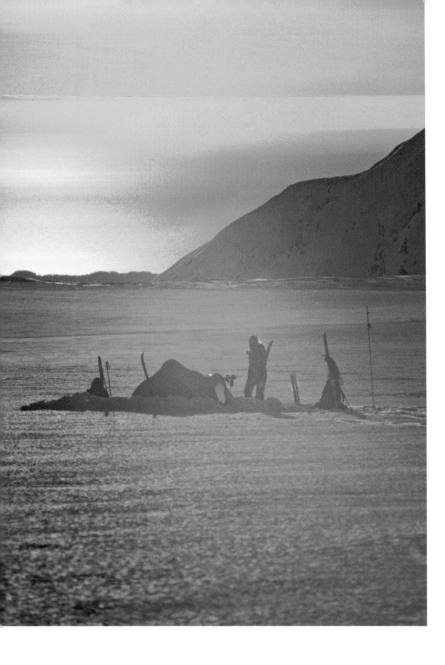

Camp on the Fairweather Glacier with the sun
setting over the Pacific Ocean, 5,000 feet below.

unclimbed in winter—soars ten thousand feet above. Legend has it that the French explorer La Perouse named the mountain *Beautemps* (Fairweather) as a sarcastic joke. You want to shoulder this commitment properly, but it shakes you up good.

Both of you lift and grunt and pull the gear down glacier, all the while gazing up the bristling arc of the Carpé Ridge rising toward the summit. It was first climbed in 1931, the third attempt in four years. Allen Carpé and Terris Moore were two of the most brilliant alpinists and adventurers of the day, and their route set a standard that made a quantum leap beyond contemporary Alaska glacier outings.

But you wonder if the mountain has changed since then, for the route now appears to include unavoidable and ominously active icefall zones beneath two gargantuan glaciers hanging high on the wall. To further weight the odds against you, the Desolation Valley fault line—only ten miles away—rocks this place with more than two hundred tremors a year. At home, you shrugged off the earthquakes. Now, you shudder at the thought, because a big one might

fast enough. Your limbs carry you upward, your mind lost in a stupor.

At the belays, you gaze down at the white line of surf crashing on the coast for hundreds of miles in either direction, with no boats or towns or people. Mount St. Elias looms to the north, but instead of the usual pulse-quickening climber's desire to have it beneath your boots, you see it framed in a canvas that you are happy to simply admire. Then the blue waters of Glacier Bay appear to the east, surrounding you in a pastiche of ocean and glaciers and peaks.

Cold reality intrudes at the next belay. The ice turns hollow and rotten. The tool placements are tedious, and each semisecure step takes a half-dozen kicks. The only way you can make the summit is by moving together without protection or bivouacking without gear—foolhardy options at best. The dream is running out of gas, and facing this new vulnerability becomes painful.

Nancy listens halfheartedly, but her eyes say the summit is still possible. She wants it more than anything, and broaching the inevitable is received like a knife in her chest. Maybe retreat would be best decided if the mountain spoke for itself.

Up you go.

Clouds build in the west as the afternoon advances. You reach a tightrope walker's ridge with fantastic exposure, a rotten ice cake with brittle sugar-snow frosting, and it all comes clear. The thing is climbable but will surely involve a night in the open, which may well cost you some toes.

Down you go. You read one another's mind on this and there are no words, just an understanding that the summit is not in the cards.

The ocean is mesmerizing. You watch until you can imagine its breakers crashing on the cape. The wind sprays spindrift over the ridge. The sun dips seaward and spreads a golden band of light wider than the Rockies, linking ocean to mountains. You both stumble down, suffused by this precious light. The sun finally drops into the water and Nancy stands silent, her hair wild and wind-tousled, backlit against this vast golden Pacific.

In the tent there is nothing to say. Nancy is haunted by the failure, but takes heart when

she realizes that the exit to the coast will prove an adventure in itself. For that matter, you still have to cross the dangerous hanging glacier.

In the morning, you hustle down to beat the late-day rush-hour traffic of this crumbling mountain. You swoop effortlessly down snow-fields that had cost you hours of sweat during your ascent. You awkwardly downclimb rock bands that you had sped over on the way up. You rappel off hastily made doorknob-shaped snow bollards, chopped with an ice axe.

Nancy forgets her axe at the last rappel and comes down red-faced, sputtering mad. There's no time to retrieve it, so she takes your spare. She is pissed and vents her anger on the snow, violently step-kicking down a couloir.

Gravity and lightened packs aid the descent. You sprint across a blue-ice highway harder than asphalt and littered with serac shards that crunch beneath the crampons, then skitter away like discs on a shuffleboard. When you reach the flat glacier, mounded with avalanche debris, you slow to a trot and keep your neck craned up at the hanging glaciers. Once out of their reach, you mock the big, ugly SOBs.

Time to excavate the buried camp and pitch the big tent. Later, you both ski up a side glacier and carve dozens of turns through champagne powder. But the dominating presence of the mountain rekindles depressing memories of failure.

You have less than a week until the bush pilot expects to rendezvous on the coast, so you shove off early in the morning. There's no looking back. You ski down the icefall, kicking your sled when it trips you, sweating across two feet of new snow on precarious avalanche slopes. And so it goes, feeling your way down this scarcely trodden glacier, in constant anticipation of the vista around every corner.

At Desolation Valley, wolverine tracks cross the trail and you suddenly realize that you haven't seen another living thing for weeks. You both race to meet the bush pilot, skating down a frozen glacial river, laughing and singing.

The fun ends when you reach a cul-de-sac of crevasses that run in every direction, blocking the route out. You try two more escapes, until you are forced onto boulder-strewn ice, cloven by more crevasses. The jumbled terrain makes

you weave back and forth like drunks. Nancy curses this lousy luck, while you suggest that the lake at the glacier's snout, if still frozen, will avoid the thick forest and provide a quick exit to the coast.

The next day, Nancy throws a rock down a cliff and onto the lake. The ice splinters and a spout of water shoots skyward as the rock sinks. You're both speechless. The only option is to flail around the lake through the tangled forest, with packs becoming one-hundred-pound loads since you can no longer ski or drag the sleds.

A freezing rain soaks through the seams of your leaky raingear, and a gale shrieks through spruces draped with banners of moss. You beat between dense alders and ease past prickly devil's club, skirting glacier tongues that dump rubble into the lake. After covering a half mile in ten hours, you are too tired to crawl any further out of this tangle, so you make your bed on two feet of sphagnum moss underlain by tree roots. All night long the tent rocks as the tree and its root sway in the wind.

In the morning, the rain resumes. As you push further into this squalid jungle, you're

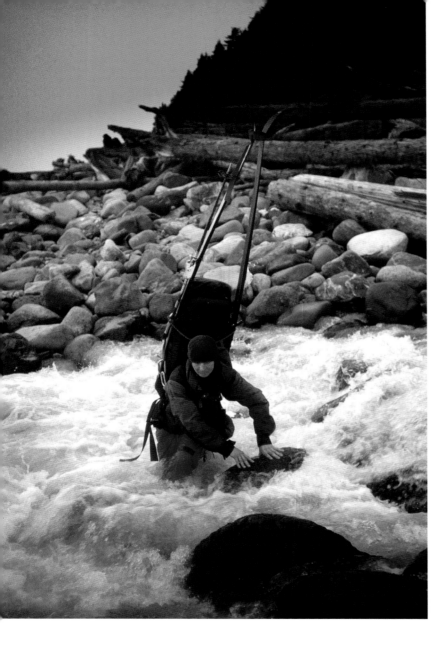

convinced that you'll never make the coast be-
fore the midday rendezvous with the bush pilot.
As you worm through the dense undergrowth,
you step gently across the foot-thick moss-
carpeted moraine. Nancy falls into the mossy
holes between boulders three, then four times
and punctuates each plunge with a stream
of profanity. Each fall sends a shudder down
your spine, because if you break a leg here, the
trees and brush would make an evacuation into
an epic.

Giant cliffs and a maze of spruce blow-
downs force you away from the lake, and you
move deeper into the flora, due west on the
compass. Fortunately, the jungle relents to
penetrable forest. You cross a swamp on fallen
tree trunks, and when Nancy pulls out the map
for orientation, you realize that you are lost.
You wring the water out of the map and argue
about which direction to go. Nancy, thoroughly
frazzled by these route-finding fiascoes, points
ninety degrees off your choice route.

When the argument subsides, the sound
of a distant stream breaks the silence. Then
there's another noise, like a dog kennel beneath

the full moon. Wolves? "No," Nancy says, "sea lions." You've never heard such a wonderful sound: escape from bushwhacking purgatory. It is life and light and the end of the tough sledding. You listen again, carefully: the "stream" is the surf crashing on the coast, and in the lulls between waves, the sea lions howl.

The rain has stopped. You smell salt air and see a searing white light beyond the last trees. When you wander out of the woods and drop onto the sand, the power of earth, sky, and sea moves you to utter speechlessness. You've been delivered from the jumbled glaciers and the dank jungle into a brilliant, sun-lit landscape. Suddenly the Cessna buzzes overhead, wings wagging, after you emerge onto the beach. You wonder at the timely perfection of it all.

Nancy walks alone, her face lit by a smile just sunny enough to hide her fierce independence. She's a climber and carries heavy packs; a tireless skier; an expert avalanche forecaster. You don't know what she's thinking, but at this moment through the camera lens, as she tromps ankle-deep in the surf, a blonde braid beating against her back, this picturesque woman is surely one of the most skilled adventurers in all of Alaska.

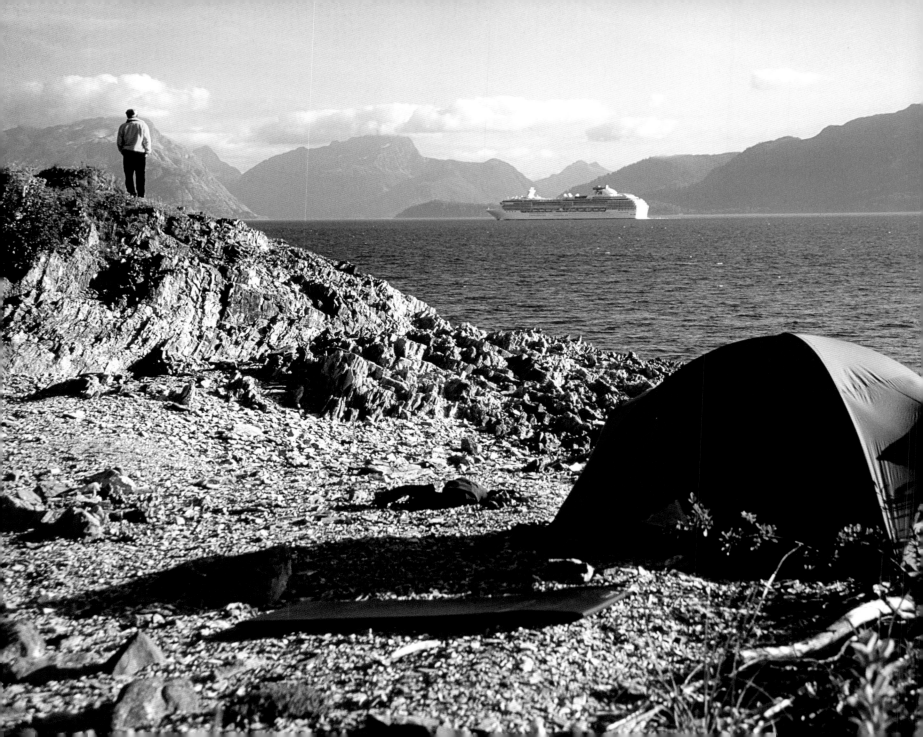

Although I was psyched to spend more time again near Mount Fairweather, I would have had trouble looking in the mirror if I wrote a whitewashed story for the Holland America company. Most southeast Alaskans know that the cruise-ship industry damages the coast by dumping oily bilges and spewing diesel smokestacks while boosting coastal tourist town economies a hundredfold for three months, then sinking them back into economic depression for the rest of the year. So I counterproposed to Hooked on the Outdoors editor Doug Schnitzspahn that we should include a sea kayaker's perspective of Glacier Bay before I boarded any cruise ship. (Doug repeatedly gave me assignments and allowed me to write stories about the North that often doubled the conventional twenty-five-hundred-word story

Will Wood, on a shoreline rife with grizzly signs, watches yet another cruise ship steaming into Glacier Bay.

length.) Still, even after finishing the kayaking research trip for the story, I was skeptical about returning to this glacial Eden aboard a cruise ship, but I relented when Holland America extended free tickets to my wife, June, and our one-year-old son, Nicholas. I did keep an objective point of view, and it turned out that the cruise-ship captain—a bona fide environmentalist—won me over. At least for traveling aboard his ship.

My kayaking companion Will Wood, who had a lifelong dream of taking an Alaska expedition, flew me to Glacier Bay in exchange for guiding him in a sea kayak. Like most photographic subjects, Will grew impatient as I shot hundreds of time-consuming photographs. By capturing stellar images, I had an opportunity to grab the attention of thousands of readers and get them to gaze at the pictures and maybe even read some of the story so that they might feel moved enough to advocate for better protections of wild Alaska against similar motorized

exploitations and unnatural incursions. The story (published in the little-known Hooked on the Outdoors *in August 2004) won the San Francisco Honorary Magazine Award for "Best Feature Article" (that city allows only temporary docking for limited cruise ships).*

OUR WILDERNESS idyll suddenly turned sour after a dozen miles of paddling into America's most storied park. As I shut my eyes to better hear yodeling loons and gasping whales, a foghorn blasted across the waters—like an unwanted farter at the tea party.

I blinked to behold a ten-story cruise ship. In its swift and disconnected rumble past virgin stands of hemlock, horrified humpbacks, and glassine seas, I felt yanked out of the primeval and back into the twenty-first century I had come to escape.

Through the binoculars the insignia read "Princess Tours." This buoyant city block and its hundreds of ant-sized passengers lolled motionless at the railings, looking like—as the diehard paddlers say in these parts—almost deads, newlyweds, and over-

feds. Strange laughter, the clinking of china, and discombobulated music reverberated off the still waters. Then the white leviathan faded into its own cloud of smoke, and unlike the whales' breaths, the smog remained as a black smudge against the skyline.

As the wake hit us in the calm-water sanctity of the Beardslee Islands, we were forced to turn east and paddle into two-foot-high waves to avoid capsizing. "Damned cruiseship," my partner said.

"Well," I said, wondering if Will had just sounded the trip mantra, here on the first day of our weeklong trip, "at least their waves make the paddling more interesting."

We had come to Glacier Bay partly through the praise of our favorite nineteenth-century conservationist who wrote, "The Master Builder chose for a tool, not the thunder and lightning to rend and split asunder, not the stormy torrent nor the eroding rain, but the tender snowflake, noiselessly falling through unnumbered generations."

Naturally, times have changed since John Muir's day. But we had also come to see the

North before the travel tourism business—indirectly created by Muir and prospering with terrorism jitters abroad—further overcrowded or damaged Alaska.

Will, an adept athlete and jack of all trades, had paddled a sea kayak twice. I was no stranger to kayaks or Alaska, but I didn't know Glacier Bay. Will built fine homes around San Francisco while I hammered out adventure books in Colorado.

With Will's skepticism balancing my blithe optimism, we saw ourselves as an ideal modern-day team. But in our slapdash naiveté and unfamiliarity with this bay, judging from the cocked eyebrows of local watermen, we may have appeared more Laurel and Hardy.

After twice grounding out in nonexistent passages between islands, we paddled further into a seventy-mile-deep and double-armed waterway, more protected than Prince William Sound. Glacier Bay was also newer, greener, warmer, and more startling than any Alaska seacoast. This snowflake-carved seascape housed one of the richest marine sanctuaries on earth.

That afternoon the tide dropped, temporarily trapping us between the mud bars and spitting clams of two islets. We lugged our kayaks fifty yards north through the postcoital fragrance of the littoral and started boiling water for pasta. A few steps away, in the shadowed forest, the undercanopy bristled with oversize ferns and thick green moss and raptor whistles and the bouquet of life and death amid the bustling rot and burst of the regenerative nitrogen cycle. The sensory abundance of this Tolkienesque jungle was enough to stimulate anyone's appetite.

We finished cleaning our parmesan-crusted bowls a dozen yards down the sloping shore, where the incoming tide would cover up smells and dissuade the bears from ransacking our campsite. As we stuffed food packages back into the locking black plastic bear barrels, Will grumbled about the dearth of mosquitoes: "How can I go back home without a few war stories about the legendary attack birds of Alaska?"

The mysterious booming echoed, again, across the waters. Muir first described as many

Will Wood packing bear-proof
food barrels before another day of
paddling. Sturgess Island.

as sixty-nine glacier collapses per hour into the sea, like "a perpetual thunderstorm easily heard three or four miles away." Yet according to our maps, we were still fifty miles from the nearest glacier. We didn't know what we were hearing.

Fox and black bear tracks ambled along the sand. We set up our tent out on the high beach with the best exposure to mountains and sea. After traveling all the way to Alaska, we weren't going to hide in the forest, but we were still incredulous that the National Park Service wanted motorboat tourists to gaze out over the pristine wilderness with no sign of people or tents. During our morning's check-in with the ranger, he pointed out that the cruise-ship companies had complained about seeing bright-colored tents pitched along the shores of Glacier Bay's supposedly unspoiled cornucopia. Hence the new park regulation: backcountry users must hide their tents from passing boats.

Every summer, over several hundred thousand tourists penetrate the wildest reaches of this park in large motorboats, balanced by fewer than two thousand kayakers and overnight campers. The *Anchorage Daily News* reported that the cruise-ship industry had recently given the Alaska Republican party $75,000 to try loosening cruise-ship regulations in Glacier Bay National Park.

I gave my partner an earful about how this recent phenomenon of "access for all" has subjugated many of our greatest national treasures—Yellowstone, Arches, even Denali—into motorized theme parks for airplanes, snowmachines, and automobiles. "A large segment of our population believes," I said, while staking our tent into the most prime-looking real estate, "that it's a constitutional privilege to view the natural world from behind the safety of heated glass, as if traveling to an aquarium."

Those of us who choose to physically "earn" the quiet sanctity of wilderness—by letting, as John Muir wrote, "nature's peace flow into us as sunshine into trees"—are supposed to abide the noisy wake of motor vehicles. By traveling in kayaks, Will and I felt demoted to second-class citizens, at least in the eyes of park service administrators.

The ranger had also asked if we were carrying a compass, and although we shook our

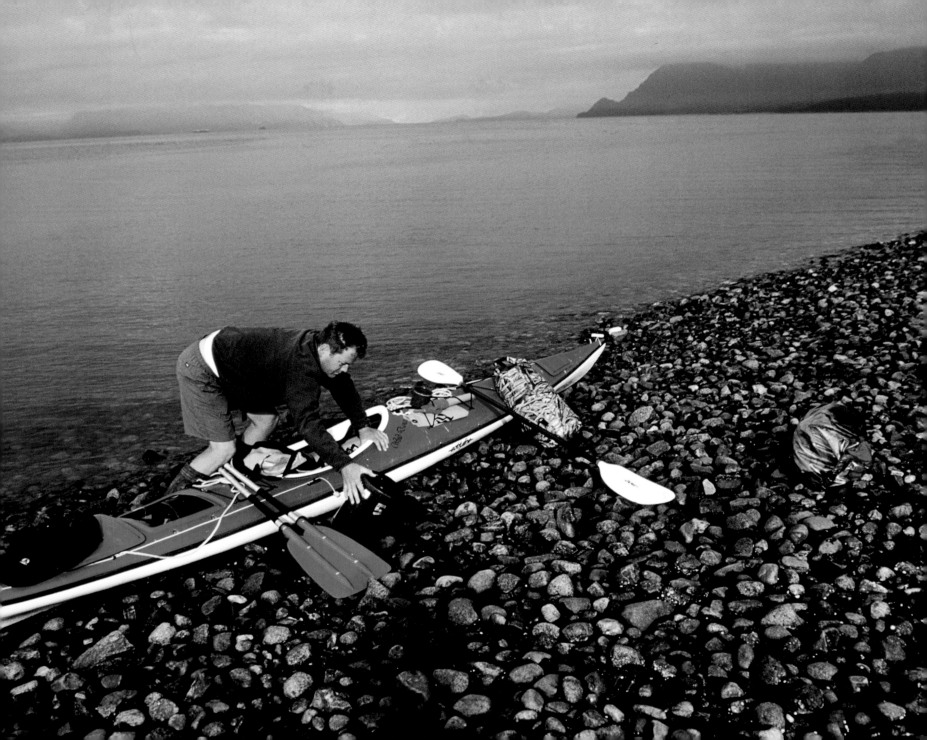

heads "no," he didn't ask if were carrying maps or a GPS. He inquired about the color of our boats, how much food we were carrying, then issued us the bear barrels to protect our food—and, ultimately, to protect the bears from learning bad behavior. Although the ranger had been courteous, his stiffness gave him away. During my tenure as an Alaska mountaineering ranger in the 1980s, my colleagues and I quickly learned the difference between reading off the government equipment checklist versus asking spontaneous questions to determine a backcountry user's experience level. Although our Glacier Bay ranger had pressed his uniform and obtained a law enforcement degree, his lack of familiarity with the maps showed that he'd spent more time goosing the throttle of a Lund skiff than feathering the paddle of a sea kayak.

Will and I politely thanked him for the canned information and filled up our water jugs. Before shoving off, a local friend pressed a bound folder from the Ocean Conservancy in my hands and opened this sixty-four-page "Cruise Control" report to a pertinent section:

[T]he National Parks Conservation Association listed Glacier Bay as one of the ten most endangered national parks in the United States, primarily because of cruise ship air emissions, the killing of a pregnant humpback whale by a cruise ship in 2001, and legislation sponsored by Alaskan Senator Ted Stevens requiring the National Park Service to allow an increase in cruise ship traffic in the park…

In 1996, the National Park Service had allowed an increase in Glacier Bay cruise ships, so the National Parks Conservation Association took the government to court and, surprisingly, won. In August 2001, a federal judge ordered that the number of cruise ships entering the park each year would be reduced from 139 to 107, the pre-1996 level. For the park service, this meant losing nearly a half-million dollars in concessionaire fees. For sea kayakers, this meant that we would only see two cruise ships per day, each emitting several thousand automobiles' worth of pollutants into the air.

Once we were able to escape park headquarters with the requisite check-in nuisance, we could concentrate on resuming the journey.

Our weeklong paddle back into time would follow the four-thousand-year-old Little Ice Age and its retreat 250 years ago. Past the forests and new alder thickets and tree stumps—petrified beneath the cold centuries of glacial weight—and polished granite mountainsides. Then onto the shrinking glaciers of the park's creation.

That night the light—bombarding off the bay and a sea of reflective icefields—clung to the horizon like a paystreak of gold brightening a streambed. We read from a copy of John Muir's posthumous book, *Travels in Alaska*. America's most celebrated mountaineering writer had turned forty-one when he first came to Glacier Bay in 1879 and took credit for its discovery—even though Vancouver originally charted this coastline in 1794.

Muir observed that Vancouver's ice cliffs had receded fifty miles up into a newly made bay. Muir's studies of these tidewater glaciers over the next two decades allowed him to make lucid deductions about how ancient ice carved out California's Sierras.

In 1879, Muir claimed this newer Alaska glacial landscape contained more ice than all of Switzerland. His part-scientific and largely promotional descriptions of the icebound paradise were presented in a series of public lectures and illustrated articles such as that year's June issue of *Century* magazine. Unlike the European cities surrounded by glaciated Alps, most Americans—living in cities isolated from their mountains—had never seen ice flowing like rivers. In a decade's time, the mountaineer-cum-prose stylist brought Glacier Bay into the garden rooms of thousands of wilderness-loving Americans, and in so doing, planted the seeds for a new national park. Unwittingly, Muir also created a tsunami of tourism.

By 1890, scores of steamships hauled tourists through the islands named after him, for two-week cruises (the first modern cruise ships carrying thousands of passengers each started in 1953, as an adjunct to warmer Caribbean destinations). The highlight of the tours up Alaska's famed Inside Passage were here, in these whale-spouted waters that Will

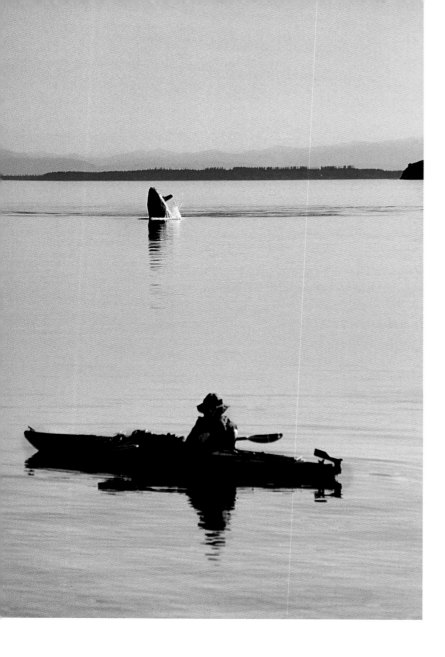

and I were paddling, where ordinary Americans could come face to face with ice exploding into the ocean, while crewmen hacked apart the smaller bergs and served their excursionists chilled cocktails.

In 1925, president Coolidge created Glacier Bay National Monument. Fourteen years later, Roosevelt doubled its acreage, and for forty years, it remained the largest national park in the country. But as the park grew, so did strain from increasing tourists. Visitation grew from 58,280 people in 1976 to 96,151 in 1980 when Glacier Bay National Park and Preserve expanded to 3.3 million acres. By the 1990s, a quarter of a million people, mostly cruise-ship tourists, visited the park each summer, begging the question: could one still experience the same splendor that Muir had described when a steamship dropped him off in 1890? One hundred and seventy-eight incredulous passengers limp-wristedly waved their handkerchiefs goodbye, as the wild-eyed and cerebral naturalist rolled up his sleeves and set out exploring.

At dawn, repeated booming woke both Will and me. Now we had no doubt of the source:

forty-foot-long humpback whales—not seen in these waters by Muir—were breaching into the air and slamming their thirty tons of blubber and bone back down into the sea. Abundant schools of tiny capelin had drawn an unprecedented bevy of whales. For hours, from our illegal campsite next to the sea, we watched.

They spy hopped, poking their heads above water. They lob tailed, splashing the sea with their tail. And they pec waved, waggling their sixteen-foot-long pectoral fins like a greeting: their audience on shore waved back.

Our jaws stayed open in awe, as Will listed more startling facts from the park service booklet: "the most acrobatic of all whales....Only 7 percent [or about ten thousand] of their pre-whaling numbers remain....The park's humpbacks migrate as far as Hawaii each winter."

Each performance closed with an arcing curve of their backs, a long "poofff" of watery vapor shot out of their blowholes, and with their dorsal fins pushed out, the whales dove back into their cafeteria. Down there—clouded by billowing plankton, vast schools of wriggling fish, and slimy tentacles of emerald algae and bubbled seaweed—they sounded hundreds of feet. Like bulbous submarines, they sounded into a blackened abyss carved by the inexorable weight of countless snowflakes, then taken over by the sea.

All day long, with the nearest kayakers dozens of miles away, we put down our paddles to watch this endangered species surface and blow, jump and lunge, wave and sound. The afternoon heated into the eighties, so we stayed offshore to keep cool. As two agnostics reveling in the infinity of nature, we felt more interactively involved than in any zoo, aquarium, or church of our memories.

"Hey, Jon," Will asked. "One flick of a tail beneath a kayak and it'll be a long swim to shore. I mean," he added, "just hypothetically speaking?"

"I don't believe a whale has ever been so clumsy," I replied.

"Well, hypothetically speaking, how long would a kayaker last swimming in this icy water?"

"Ten minutes." I added cheerfully, "Hypothermically speaking. Still, hypothermia is

supposed to be the easiest way to check out: like taking a nap."

We chose the most conspicuous tent site and dove into the cold sea screaming lung-bursting oaths. As another cruise ship passed, we flashed our moons back at the sun glint of hundreds of binoculars aimed toward our prominent yellow tent.

Tufted puffins and peeping oystercatchers rafted alongside the blowing whales, swimming back and forth with us as we strolled back and forth along the beach. A bald eagle flew directly overhead, and a moment later, a cottonwood leaf fallen from its talons drifted past my face. Once it finally got dark, the distant baying of a sea lion colony lullabied us to sleep.

We would learn over the coming days, as motorboats and cruise ships passed and rocked the waters, to pull our kayaks to high ground or throw down our paddles in a supportive brace. Mostly, we focused away from intrusions by marveling at clear streams rife with salmon, the pattern of diamonds sparkling on the water, and sandy shores dented with brown bear and wolf prints.

On the third night out, as Will took a final bathroom break ten feet behind our tent, he tripped onto a three-foot-wide trail, stacked with elephantine fecal matter, below a wall of alders—suspiciously broken off at chest height. "That would be just my luck," Will said, as he kicked one of the piles, "to finish my days as Alaska alder fertilizer."

"They're not interested in us," I tried to reassure my partner, "because salmon are easier to catch."

"What would you do if a griz came into camp?" Will asked.

"Run," I said.

"Isn't that the worst thing you could do?"

"Not if you're the fastest runner."

We finished our ceremonial passing of the Glenlivet scotch. After Will took a last eager look out the door to the forest, I looked out to the sea, and we retired to our respective dreams: glossy/furry creatures sounding/running through the dark with their baleened/toothed mouths opened like front-end loaders.

On the fourth day, alongside an eleven-story Princess Tours cruise ship, the scenery suddenly

The intersection of sea and icy mountains makes Glacier Bay one of the most surreal and beautiful places in all of the North.

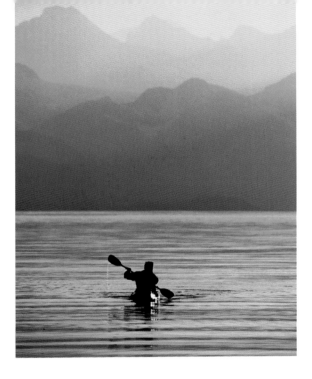

improved as we paddled around a corner to greet Mount Fairweather, rising 15,300 feet above the sea, amid a convoluted layer cake of vanilla-chiffon peaks. We pulled on our sunglasses. Sixteen winters ago, while panting in subzero air, dangerous snow conditions had forced my retreat within three thousand feet of Fairweather's summit—amazing how a rousing defeat improves your admiration of a mountain view.

One hundred and twenty-four years ago, my favorite mountaineering writer paddled a Tlingit dugout canoe in this West Arm of Glacier Bay, here at the former ice edge. The glaciers have now receded another thirty miles up the bay. Muir described "the ineffably chaste and spiritual heights of the Fairweather Range, which were now hidden, now partly revealed, the whole making a picture of icy wildness unspeakably pure and sublime."

Muir's writings often stressed the gain to be found by sleeping out on the ground, the enjoyment of munching a single cracker after tramping a dozen miles, and how we should "climb the mountains and get their good tidings." Yet this God-fearing, white-bearded pilgrim was not a doe-eyed transcendentalist, blind to human nature. As early as 1890, from his camp near the glacier that would soon bear his name, he wrote about the arrival of the steamship *Queen* "with two hundred and thirty tourists. What a show they made with their ribbons and kodaks. All seemed happy and enthusiastic, though it was curious to see how promptly all of them ceased gazing when the dinner bell rang, and how many turned from the great thundering crystal world of ice."

I couldn't help speculating that, if Muir was alive today, he'd feel angered about cruise ships black-clouding and foghorning alongside the amazing glaciers of the West Arm. So, would he take consolation in knowing that the East Arm waters surrounding his relatively tiny Muir Glacier (once the largest ice field within Glacier Bay) are closed to motorized boat traffic in summer?

That afternoon we were glad of the fog hiding the boat traffic as we fought two miles across the wind-corduroyed West Arm and into calm, protected waters. Skidmore Bay is closed to motorized travel, along with five of thirteen inlets—restricting travel within one tenth of Glacier Bay's 327,000 marine acres.

After the heat, we were also glad of the light rain: sizzling amid the dried-out cottonwood leaves and magically unleavening the sea. We rode the flood tide north. Riffles swung our bows back and forth as we tapped our rudder pedals and aimed into the smooth tongue of ocean mimicking river.

We fell back into bliss as the landscape unfolded before us with more lucidity than any natural history museum. Clam shells spiked grizzly dung. Goshawks guarded a boulder field. All sign or sound of humankind had faded from memory—until another ship sounded its foghorn: a dominating blast from over the horizon.

"Damned cruise ship!"

Our focus returned to the route finding. This mission was complicated by the fog and the necessity of finding our escape creek out of the three-mile bay before the tide changed, drying up the creek until next month's spring moon flooded it again. If we missed this lone exit, we'd have to retrace our route south and then turn back north into the main bay. At first, frantically studying our tide charts and map, we couldn't see the creek through the fog. We scanned the shore with our binoculars. Then, just as the tide switched, we aimed into a subtle current flashing against the still bay and showing the high tide rushing out of the creek. The narrow passageway would only fit one kayak at a time. We power stroked in, fought the current for a hundred yards, then caught the back flow of tide, which carried us another half mile out

into the main bay, just as the creek ran dry. We whooped with joy.

"Try finding that kind of mastery aboard a cruise ship," I said, now turned skeptic.

"C'mon," Will asked, in a reversal of roles, "you mean to tell me you wouldn't accept a cruise under any circumstances?"

"Not for all the ice in Glacier Bay," I replied, "would I leave my family to go on a magazine assignment and get fat aboard one of those love boats."

A month later, my family and I joined a press tour on Holland America's thirteen-story, 780-foot-long MS *Volendam*, steaming from Vancouver to Glacier Bay. Historically speaking, it seemed serendipitous that Holland America Tours had been founded in Fairbanks a half century ago, picking up steamship tourists and transporting them throughout the North. Their cruise ships started coming to Glacier Bay before most other companies, predisposing Holland America to looking after the place (e.g., they burned a higher-octane fuel to minimize air pollution), as well as being grandfathered in as a park concessionaire.

They also had a worldwide reputation for first-class service. Even a wilderness Visigoth couldn't help but admire the floral theme—on the carpets and etched on enormous vases with fresh flower arrangements. Walls were decked with red velvet, a half-dozen delicate Italian chandeliers hung from the 747-seat ballroom, and courteous Indonesian stewards stood at every corner. Best of all, Audubon prints hung in our oversize stateroom—Holland America wanted its passengers to relate to natural beauty. And a bottle of champagne in a bucket of ice sat next to our veranda, with a card, "Compliments of the Captain." That night, for our first meal, the fresh fish and precisely steamed vegetables and sculpted cakes mimicked the textured horizons of the Fairweather Range.

Initially, I had trouble understanding that I couldn't come into the stern ballroom during formal dinners while wearing running shoes and blue jeans under a sport coat. But like shrugging into my Gore-Tex dry top each day for the kayak, I quickly learned to make the sacrifices to survive the *Volendam*. Nor could I forget that the company had generously invited

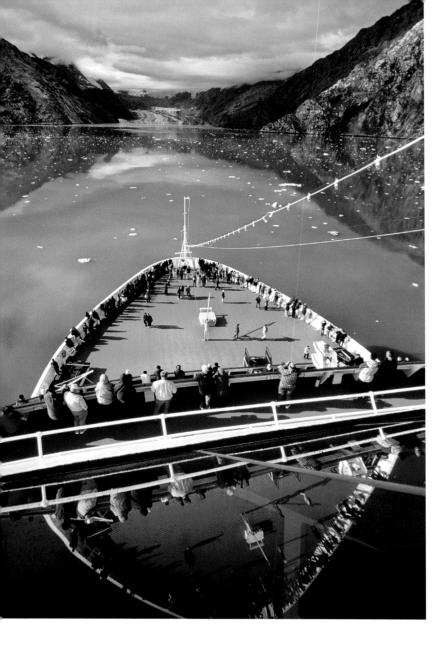

John Hopkins Glacier from the glass reflection on the MS *Volendam*'s foredeck.

my whole family. Holland America had made special dispensation by allowing me to bring Will's cousin, June (my wife), our ten-month-old son, Nicholas, and my mother-in-law, Carol. Although not nearly dead, newlywed, or over-fed, accompanying one another in sea kayaks would have left us barely fed, no longer wed, and quite possibly dead.

My spiritual guide, Muir, had not refrained from trading the hardships of paddling a dug-out canoe for being feted aboard steamships. Some of the most entertaining prose from his *Travels in Alaska* were observations of fellow passengers "strangely ignorant on the subject of earth sculpture and landscape-making."

Muir asked one elderly Scandinavian if he knew what a glacier was. "A big mountain all covered up with ice," he replied.

"Then a river," said Muir, "must be a big mountain all covered with water." Muir told him he "must reform, for a man who neither be-lieved in God nor glaciers must be very bad, in-deed the worst of all unbelievers."

Like Muir, I had also returned to see how my Glacier Bay experience would differ with over a

thousand passengers, aboard a comfortable and dry ship. After all, the trip with Will had ended wetly. For the last two nights, our sleeping bags had become sponges, we battled wind and surf, and although we paddled speechless alongside the towering Lamplugh and Johns Hopkins Glaciers, the cold rain—reddening the cottonwoods and alders overnight—prevented us from lingering.

Still, every minute that Will and I didn't love would be cherished through a gift given to all adventurers: faulty memory. The Alaska wilderness had put a forgettable ache in our paddling shoulders, showing us all the unpredictability, largesse, and wildlife that it's famous for.

Despite the park service's generous loan of bear barrels, Will and I had been made to feel like chopped liver compared to the paying boat passengers. Glacier Bay National Park and Preserve is clearly catering to tourists who prefer warm beds over ground pads, staterooms over tents, interpretation over discovery, and safe protection from the adverse elements of Alaska. Since I couldn't beat the cruise ships, maybe I would learn something by joining them.

Each time the *Volendam* docked with other cruise ships in Ketchikan, Juneau, or Skagway, a crush of passengers—blue haired and flaxen, thin and overweight, riding baby carriages or wheelchairs—bowed the gangplanks. Contrary to legend, these credit-card-carrying passengers were not all almost dead or newlywed because the cruise-ship companies had effectively extended their nets to include every conceivable age, race, or social class.

Southeast Alaska has been transformed by the cruise-ship economy. An industry of seasonal "Alaskana" tee-shirt and tourist shops had enlarged each port into a shopping mall, replete with espresso stands and ice cream stalls, borrowed fresh from the touristy heartland of Middle America, with the bric-a-brac bizarrely plopped alongside some of our greatest wilderness.

Yet none of this was new. As Muir reported about one Alaska port in 1890, "The shops were jammed and mobbed, high prices paid of shabby stuff manufactured expressly for tourist trade. Silver bracelets hammered out of dollars and half dollars by Indian smiths are the most

Sheltering from the rain for a cup of tea in moraine recently covered by the Lamplugh Glacier—all of Glacier Bay is in a rapid glacial retreat.

popular articles, then baskets, yellow cedar toy canoes, paddles, etc."

I had visited these towns repeatedly over the last three decades. In 1995, while single handing a thirty-foot sailboat—capable of running six knots in a gale—I had explored the Inside Passage. The difference, cruising at 19.7 knots on the *Volendam*, was in losing all sense of challenge or sensory input: the molar-rattling bounce of incoming tide against wind, the rage of whirlpools, or the head-tingling adaptation known as getting your sea legs. Seasickness is miraculously negated by the cruise ship's port and starboard thrusters.

On the roofed third-level walkway, beneath a "Please no jogging" sign, as several dozen other passengers and I halfheartedly attempted to work off the cordon bleu before yet another five-course meal, Alaska looked as distant as a promotional video, rolling innocuously and harmlessly unfelt over the rail.

At each port, Carol, June, Nicholas, and I were escorted by capable guides on whale-watching boats, raft rides, hikes, and glacial tours. As our guides led the way, fed us (again),

or paddled the rafts, we never got wet, broke a sweat, shivered, or felt the connection that Will and I had earned. Still, I could plainly observe my fellow passengers engaged in the adventures of their lives. Seeing orcas and humpback whales north of Juneau made everyone's eyes mist up, just as Muir complained in those same waters about his fellow steamship passengers being more interested in the "small whales" than in the larger geology.

Muir was also one of the first to write about the wilderness spirituality of Alaska. He described "dancing down the mountain" back to camp in Glacier Bay, his "mind glowing like the sun-beaten glaciers." Indeed, his writing about the joys of physical hardship had half convinced me that steamships, let alone cruise ships, were not what he had in mind as the ideal viewing point for glaciers.

Or so I thought until I met the Dutch captain of the *Volendam*. At the initial press briefing, I couldn't help interrogating Jeroen van Donselaar. Yet the more I pressed him, the more sympathetic he became to my environmental concerns. He explained that Holland America contributed generously to the Alaska Raptor Center, the Alaska SeaLife Center, the Woodland Park Zoo in Seattle, the Yukon Wildlife Preserve, the American Oceans Campaign [now Oceana], and the Seattle Aquarium. And he didn't have to tell me that if these fourteen hundred passengers spent their time camping out in Glacier Bay, the impacts (feces, denuded vegetation, and overfed grizzlies) would cause irreparable damage to America's greatest marine park.

Unlike most cruise ships, he said, "the *Volendam*, at a cost of $2.5 million, installed a wastewater treatment plant to purify sewage, sink, and shower water to near-drinking-water quality—cleaner than the treated wastewater of most Alaska towns. We then discharge *dis* water," he said, blurring his "th"s into "d"s like all Dutchmen, "*wid* a slight saline content, if the ship is out in *de* open ocean."

While in port however, the ship must have its sewage removed and treated on land. Cans and bottles were recycled. And I had already noticed the deliberate lack of plastic—which can cause irreparable damage to sea creatures when accidentally disposed overboard.

Jeroen was thirty-five, shy, and strangely fit for a cruise ship captain. As I spent more time in his company, he spoke graciously and maintained eye contact with subalterns and passengers alike. He also had a fondness for whales. "It would be impossible," he said softly over dinner that night, "for a *healthy* whale, with functional sonar, to get hit by a cruise ship."

Over a glass of wine, I asked him about how he perceived his mission as captain of this seven-day cruise. He made it clear, with a conspiratorial whisper, that he didn't understand the mind-set of many of his grape-shaped passengers. "But I own this goal," Jeroen said, "to get people out of their staterooms and standing on deck when we arrive in Glacier Bay next to the ice. *Der* excitement about *de* power of nature *dere* makes everything worthwhile for me."

The next morning, day five, 1,130 miles out from Vancouver (the same time it took Will and me to paddle fifty miles from park headquarters to the ice), I stood on the bridge with the captain as we reached Glacier Bay's Lamplugh Glacier. Through my binoculars, two kayakers appeared microbial size amid the ice cliffs and the vastness of the seascape.

Unlike the paddling trip, I now had a completely different perspective of these glaciers. I was no longer worrying about collapsing ice cliffs, rolling bergs, upsetting wakes, or my comfort levels. On a cruise ship, a passenger could absorb the scenery without distraction while being served on the foredeck two levels below with what appeared (through my binoculars) as split pea soup.

Black-legged kittiwakes wheeled and swirled in the distance like a snowstorm. Harbor seals reclined and slept on floating bergs shaped as Barcaloungers.

I refocused on the glacier. Patterns of light appeared on the glacial wall like a shimmering drive-in movie screen lit by an ultraviolet projector. A hundred yards west and halfway up the ice face, a prodigious and omniscient-looking blue eye—clutching a black boulder as its pupil—hinted of an animate force field.

About his 1890 experience in a crowded steamship, John Muir similarly concluded, "All the tourists are delighted at seeing a grand

glacier in the flesh"—recalling that era's artistic renderings of glaciers as alligators, snakes, or sleeping giants.

I felt no less awestruck as we pulled around Jaw Point to worship the Johns Hopkins Glacier. If anything, the immensity of the mile-wide, 250-foot-high glacier made even the 110-foot-high, 105-foot-wide cruise ship seem as shrunken as the pants on my burgeoning gut. Torrents of chocolate-colored, mostly digested rock water rushed out from the bowels of the glaciers and into the bay. I flinched when the Lamplugh shifted behind us and several thousand tons of ice creaked, swayed, and exploded into the sea with a resounding splash. Strangely enough, the resounding disorientation matched my perspective from the kayak.

Jeroen feathered the bow thruster lever as if it were a paddle, spinning the boat from starboard to port, avoiding the bigger bergs: a sapphire regatta berthing a third of the turquoise-tinted sea, mixed in with the suspended glacial till. "It used to be that cruise ships would blow their horns to try and collapse these ice walls, but this is a new era. Besides,"

Passengers become oblivious to the Margerie Glacier when lunch was served on the MS *Volendam*.

he gestured to the kayakers (now invisible to the naked eye, yet somehow he'd spotted them without using binoculars), "we have other people to think about here aside from those on board."

Captain van Donselaar smiled like the boy holding his country above the waters with a thumb in the great dike. He nodded toward the aft window to show me why: the railings were lined with passengers. The casino and theaters and stores and tennis court and spa and exercise bikes and bingo hall (but not the cafeterias) had been abandoned. Passengers stood pointing and photographing and holding up their children. To commemorate this climatic arrival, the chefs proudly grilled silver salmon in the glass-walled upper deck, alongside roosting guillemots, carved from ice. No one would miss the view as they ate.

Over the ship's intercom, the naturalist—sold to Holland America by the park service for the day rate of $1 per passenger—sermonized in hushed tones over the intercom, as if we stood before the alter at some primordial church. She explained how tightly packed ice acts like

a prism, transmitting the high-energy blue light, while loosely packed ice absorbs the high-energy light and appears white. Everyone listened intently. "Newly minted environmentalists," Jeroen called them. Fourteen hundred passengers, and many of the seven hundred crew, ogled what Muir called "a magnificent picture of nature's power and industry and love of beauty."

America's natural history prophet had fathered his first child, Wanda, by the time he made his third trip to Glacier Bay in 1890. Over the last six months, I too felt the distinctive mellowing ascribed to adventurers who become parents. Once you have a child, you get this urge to share the wilderness. I had never expected that riding this love boat with my toddler and wife and mother-in-law—let alone hundreds of other awestruck passengers—would have been such an aesthetic experience. History doesn't tell us if Muir ever brought his daughters north on the steamships to see the ice, but his last book opens, "I care to live only to entice people to look at the Nature's loveliness." And, here in the heart of Glacier Bay, I now felt certain that he would have approved of this cruise ship's mission.

As Jeroen spun the boat back to starboard, hundreds ran, limped, and wheeled their overfed bodies across the decks to warm their souls and stay close to the cerulean wall of ice—like an inverse rotisserie. I rushed out to find June and Nicholas.

We joined the crowd and dutifully took our place at the end of a long line, next to the retractable-roofed swimming pool, for a plate of salmon and baked Alaska. From midqueue, standing next to the life-size bronze dolphins sculpture, an impatient and glandular-challenged woman with a Bronx accent turned our eyes away from the glacial walls alongside the ship. I had learned that the cruise ships served an invaluable function of opening apathetic souls to the stirring singularity of Glacier Bay, even if a few only appreciated its ice in their drinks. So I couldn't help but laugh when the woman—tired of waiting in line—carped the now-familiar refrain, inevitably cursing the hand that would feed us:

"Damned cruise ship!"

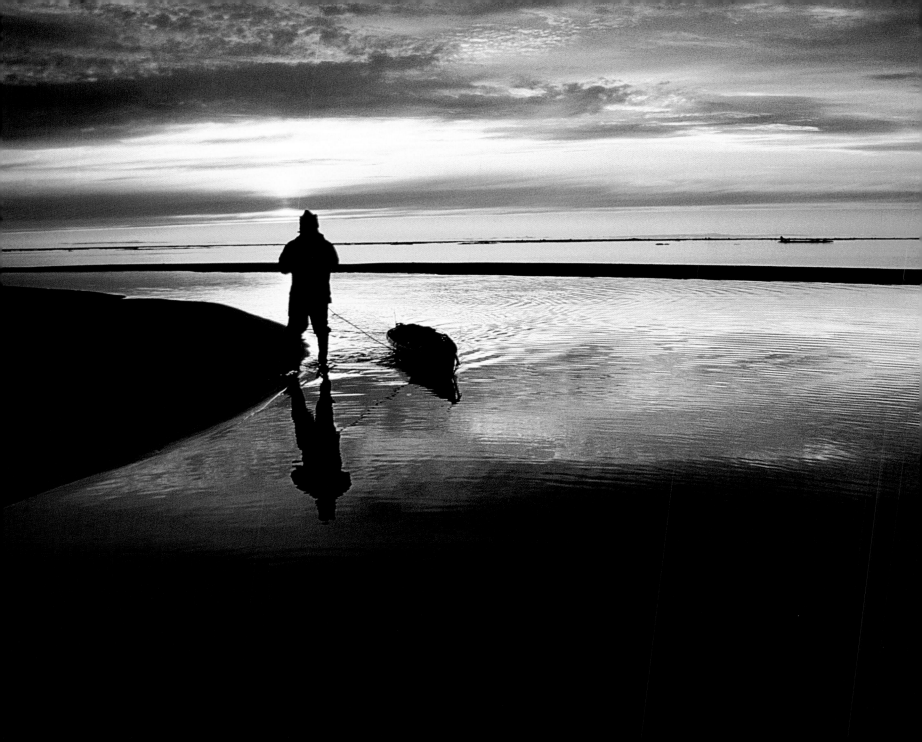

Northern Exposures

I conceived this June 2004 Hooked on the Outdoors *piece to run with specific photos that I shot in the Arctic National Wildlife Refuge. I wrote this short essay to help promote the cause of saving the place. The publication date coincided with the release of my book,* Where Mountains Are Nameless: Passion and Politics in the Arctic National Wildlife Refuge.

I structured the story locale around a kayaking journey I had taken in 1988. The guts of the story, however, revolved around a month-long course—accredited through the University of Alaska Fairbanks—that I guided in summer 1989. This "Wilderness versus Oil" course was conceived by my friend (and now UAF professor) Gary Kofinas, who taught me, as much as the high school students, how to think critically and objectively about potential oil development in the refuge. So I distilled many of the same discussions and experiences I had with those students into this essay.

Portaging a kayak along the Beaufort Sea shore, looking north at 11 p.m.

AMID A DELIRIUM of mosquitoes at eleven p.m. in mid-July, it's still bright enough for sunglasses and I'm clutching a camera on a muddy Beaufort Sea beach. To the north, a jaundiced-looking sun arcs above the white spine of sea ice. A warm land breeze hits the cool ocean air, and the light rays bend into mirages: The ice pack blurs into gleaming skyscrapers, the western coast morphs into vibrating lakes. Early arctic explorers called this phenomenon the Ice Blink.

These mirages only amplify my dilemma as a photographer: most photojournalists come to the Arctic National Wildlife Refuge with guides and expense accounts to pay for hours of airplane time. From the air, it's not hard to find the

130,000 caribou that, for better or worse, now symbolize this wilderness. On foot, unable to chase the herd, you must instead find subtleties that fully unveil a sense of place and that speak to the complex issue of drilling for oil in the refuge.

Folded up against the reflective skin of the sea, the coastal plain resembles a giant green garment: it's wrinkled by hills, furred with ankle-high plants, and—if you look closely along those seams chafed by seawater—you'll see ice exposed beneath the vast mat of tundra. Try putting all that on film, and you get unfathomable green space crushed by sky and blurred by brown insect clouds.

Unfortunately, this sort of imagery only supports corporate America's cry that this "deserted moonscape" is perfect for oil drilling. Likewise, photographing the caribou herd and calling the refuge "America's Serengeti"—even though the place has only one herd and bears no resemblance to African wildlife habitat—is to portray a misleading image. So my mission on this and previous trips to the refuge has been to liter-

ally expose the issue—made black and white by both the environmental community and oil lobbyists—in its true colors. I am hunting for visual messages from the land that I hope will show the detail, the desolation, or the vulnerability of this wilderness. But, so far, I haven't been able to fit the 19.5-million-acre refuge in my wide-angle lens.

Alongside the beach, a plop and splash alert me to a bearded seal. He's swimming at a walking pace, his whiskered face and earless head smiling at me through honey-thick light. But when the seal makes repeated eye contact—showing that rare and soulful curiosity of wildlife unafraid of people—I stop and sit down, if only to prolong the wonder. Some moments transcend photography.

Earlier tonight, I discovered oil leaking out of an unnamed creek in an iridescent blue sheen. I wet my fingertips with it and sniffed. The unmistakable pungency of acrid methane and polyethylene trash bags showed that it is indeed the remains of 350-million-year-old algae, seeping through the earth. Locals call

Grave markers show the bygone days when the Inuit lived as nomads along the coast.

this valuable resource "Alaska crude," paleontologists say "fossil fuel," while oil company geologists shout "petroleum!"

Based on seismic tests and sandstone outcrops within the refuge, the U.S. Geological Survey estimates a 95 percent probability of recovering 5.7 billion barrels of crude oil and a 5 percent probability of recovering sixteen billion barrels. Sixty miles west of here, at Prudhoe Bay, they've already extracted eleven billion barrels.

All of this science looks impressive on a subsurface map, wrinkled with anticlines and brightly colored with rock stratum, but petroleum geology is never a sure bet. If geothermal temperatures a mile under the earth have remained at a tea drinker's comfort for the last million years—between 90 and 190 degrees—and algae was there (usually in the form of a shale bedrock called kerogen), it becomes oil. Let it suffice to say that these temperatures are rare down in the earth's oven, explaining

Remains of an Inuit driftwood home
in the Arctic Refuge with the sea ice
lining the northern horizon.

the rising price of oil, its declining availability, and the likelihood of wars being fought near its source.

Whatever petroleum is found below the coastal plain will not wean the United States from Saudi Arabia's and Iraq's oil reservoirs, conservatively estimated at 412 billion barrels versus the refuge's 5.7 billion barrels. It's like comparing dollars to Iraq's dinars. As I snap a token photograph of the oil seep whorl, staining the creek like blue tree rings, I'm thinking, *This pretty blue sheen may be a valuable resource, but since the United States burns seven billion barrels a year, is it worth destroying paradise for only a year's supply of oil?*

Congress continues to defeat oil development legislation here, but by narrow margins. In the last quarter century, five leasing proposals have been overturned, but (at this writing) yet another arctic oil-drilling budget is pending. The irony is that every wilderness lover's plane ride to the remote refuge burns up more oil. And adventure equipment—including the color slide film that I'm shooting—often contains petroleum too. Of course, it's illogi-

cal to me, a longtime devotee of wild places, to build oil rigs, pipelines, airports, and roads in a wildlife sanctuary. But, in order to capture the essence of our last great refuge, I have to come to grips with my own feelings about oil versus wilderness.

I shrug on my pack and continue walking west, searching for visuals that might contain my hoped-for image and rid my mind of ambiguity. All evening, the coast has been hushed. Wind spills around boulders, sea sighs on shore, and birds cry into the everlasting sunset. Just an hour ago, a strange and distant thrumming arose from the sea, but I can't identify the source of this noise. Nonetheless, traveling in the alien North is all about being off-guard. From where I'm hopping across wet and swaying tussock heads, the refuge is not friendly, warm, dry, flat, outwardly colorful, or in any way familiar.

Ten feet above saltwater, I pass dryads, louseworts, lichens, diapensia, dwarf fireweed, horsetails, and arnicas. I can't begin to identify, let alone photograph, this Lilliputian pandemonium of photosynthesis. Looking south across

188

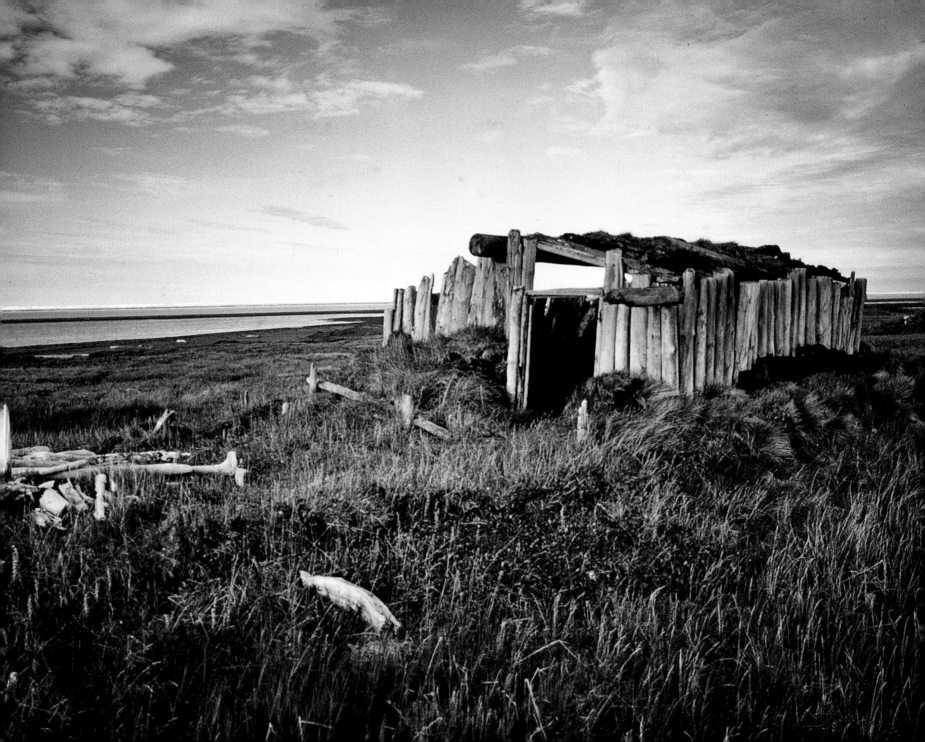

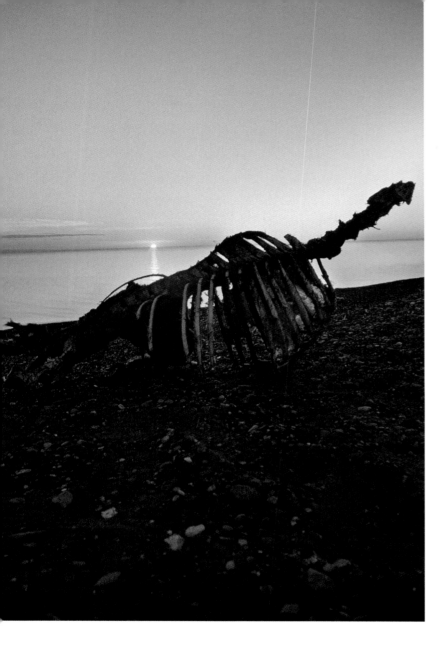

Bearded seal skeleton on the shoreline of
the Arctic National Wildlife Refuge.

the tundra is like looking north over the icebergs:
you can only see 5 percent of the plants. The
other 95 percent are sheltered underneath.

Early explorers searching for gold or a route
to the riches of the Orient called this the barren-
lands. Not until scientists arrived did we learn
that the seemingly infertile peat is a biomass, a
welter of trapped carbon and roots and larvae
and water as rich as a forest. But history, com-
bined with ambitious political agendas, has an
extraordinary way of repeating itself: today's
arctic explorers are wildcatting for black gold,
but they still call this place the barrenlands, a
lifeless swamp, even though science shows
otherwise. Drive across this thin biomass, or
build an oil field on top, and the tundra will un-
leash its stored carbons as greenhouse gases,
while the permafrost will melt and drown the
fragile constellation of plants.

It's hard to imagine where one would even
build a tangle of aluminum pipelines, elevated
gravel roads, and steel-girdered oil rigs with-
out literally crushing the coastal plain. But as I
approach an abandoned cabin of an early-day
trader, the scene—driftwood and sod ready to

fall back into the tundra from whence it came—fits. This is an architecture that belongs to the landscape and its human history. Inside the cabin, on a wooden shelf, a nesting Lapland longspur warbles in complacency. Although I don't know exactly what the scene really *says*—aside from the sod home appearing like a wooden scow floating across the surrounding sea of tundra—I click off all but my last frame of film.

I wander onward. The Canon sways across my chest as wet sphagnum moss sucks at my boots, and a thought runs through my mind like the looped music on a player piano: *If I'm going to promote this coastal plain as protected wilderness, I need to show its fragility.*

Once I descend to the beach for smoother and quieter walking, the source of the thrumming noise finally reveals itself. Above a small bank of offshore fog is an exploratory oil ship, so black and surreal that I blink my eyes to verify its presence, a mile out from the refuge. As conservationists fight to keep oil rigs off the caribou calving grounds, the oil companies are encroaching on both the northern and western boundaries. I recall the vision of dead seals and birds and whales as I kayaked through Alaska's Prince William Sound during the devastating 1989 oil spill.

I walk faster now, toward a strange yellow lump on the beach, a half-mile west. Near the eastern boundary of Alaska's most extensive oil fields, I remove the lens cap. I take a deep breath. The scene I've been seeking lies at my feet; the air is ripe with death. As the refuge glimmers behind me in all of its elusive brilliance, I kneel down to compose my last frame. I feel a deep sense of outrage. I steady my hands. The sun falls like a giant oil flare into the black sea, backlighting the skeleton of a bearded seal, washed up on the beach, and stinking of Alaska crude.

WELCOME TO THE
TALKEETNA RANGER STATIO
2006 CLIMBING SEASON
DENALI FO

CLIMBERS EXPECTED THIS SEASON	73
CLIMBERS ON MOUNTAIN	1
FINISHED CLIMBS	0
CLIMBERS THAT REACHED THE SUMMIT IN 2006	0
SUMMIT PERCENT RATE	0

Divine Wind: Masatoshi Kuriaki

14

In 2006, I pitched National Geographic Adventure this story about the humble Japanese climber Masatoshi Kuriaki, who was preparing to make his second solo climb of Denali in winter, one of many climbing trips he had taken alone into the Alaska Range in winter. After narrowly surviving on that mountain in winter with a strong team years before, I wanted to know what made this climber tick.

Adventure paid my travel expenses to Alaska, and I spent a week with Masa getting to know him and waiting for the weather to clear so he could fly in to the mountain. Ultimately Masa survived, and he wisely turned back many thousands of feet below the summit, both of which may have prompted Adventure to kill the story that I submitted. Unlike other killed stories that I have learned to file and forget about

gracefully, this piece resonated with Masa's reverent soul and corrected the decades-old stereotypes about gung-ho Japanese climbers. Subsequently, my friends at Rock and Ice magazine saw the value of the piece and immediately printed it without changing a paragraph.

I stay in touch with Masa, who is now raising two children. The year after this attempted climb of Denali, he became the first to solo neighboring Mount Foraker in winter. Over three winters since then, he has doggedly made solo attempts on Mount Hunter (on one climb, he turned around because he heard his son crying for him to come home). At press time, he has spent a phenomenal 662 days alone in the Alaska Range in winter.

In the ranger station, Masatoshi Kuriaki shows his statistical winter presence (in summer the rangers record 1,200 climbers) shortly before being flown onto the mountain.

LATE LAST WINTER, Masatoshi Kuriaki awoke alone, more amazed than rattled as an explosion shook the glacier beneath his tent.

He listened intently as a gargantuan slab of ice roared off Big Bertha, the infamous hanging glacier on Denali's south face. Then the phenomenal displacement of air began.

Kuriaki was attempting to solo the crevassed and serac-strewn Japanese Ramp route. It has never been soloed in summer, let alone attempted by any team in winter.

Here in 1992, as the accomplished alpinist Mugs Stump descended while roped to two clients, a massive crevasse bridge collapsed, sucking him in before the slack rope could tighten, burying him beneath tons of ice. Kuriaki had studied the accident report. He also knew that Stump had unlocked nearby Mount Hunter's five-thousand-foot North Buttress, dashed alone up Denali's Cassin Ridge in a day, and negotiated the execrable East Face of the Moose's Tooth. Kuriaki admired Stump, and thought of his demise as a terrible disaster.

Yet Kuriaki has his own strengths. While his chosen route had its dangers, he had repeatedly found safe solutions to other hazardous passages. More important, he considers it his "life's work" to witness in private the seldom-seen wonders of the Alaska Range in winter. Watching sunrises, northern lights, or collapsing glaciers were all part of a colossal gift package that rewarded him with awe and respect.

Now, as he sat alone in his tent, a minus-forty-degree-Fahrenheit avalanche cloud mushroomed. Luckily, or by Kuriaki's design, depending on how well one has studied his life's work, his tent lay sheltered behind a high corner of granite called Kahiltna Notch. He stayed inside, amazement growing, as the vortex of avalanche-displaced air did something new: it bent around the Notch, shaking, grasping, and pummeling the tent as if with the hands of Big Bertha itself.

Until the long night ended and the sun grudgingly warmed the blue-gilled East Fork of the Kahiltna Glacier several degrees, Kuriaki lay still, his fifty-below Valandré down bag cinched around his nose. Across the glacier, he had stashed his climbing rope, crevasse poles, ice screws, and snow flukes—begging the question: Did this monster ice avalanche bury his cache? He closed his eyes and forced himself to continue composing a haiku in honor of Big Bertha.

Kuriaki practices a hybridized form of solo winter mountaineering that numbs the minds of experienced Alaska Range traditionalists, let alone alpinists. He knows this game has killed several Japanese superstar climbers, so in effect he has turned back the evolution of modern alpinism by weaning himself off demanding sponsors, listening to nature, and watching each of his steps. In lieu of choosing unclimbed routes with continuous technical difficulties, or rushing his routes, he takes his time and lets the weather dictate his survival pace, amid unfathomably desperate wind and cold, with strict obeisance to those December and March dates that signal the beginning and end of winter. Even better, he loses no weight during his climbs and sits in an unfazed torpor inside of deep snow caves for days on end as ferocious wind events vibrate the mountain and rip the roofs off houses at sea level.

He is also the only contender for the ultimate hat trick of Alaska Range mountaineering: winter solos of Denali, Foraker, and Hunter. Several teams of climbers have made it up all three in summer, but until Kuriaki, no one has

rationally courted such a challenge in winter, solo. After ten winter solo trips, which collectively have absorbed fourteen months of his life, Masa only counts one summit on Denali as a success. But that doesn't tell the whole story. It is one of other summits, and of a man who, over a decade and during 416 days (and counting) logged alone here in winter, has never been frostbitten.

At Gifts and Collectibles store in Talkeetna, the nearest town to Denali, the owner, Suzie Kellard, said, "He's asking for trouble by repeatedly going up there alone in winter." Until now, no one has figured out how or why he keeps pulling it off.

The nearsighted Japanese mountaineer, thirty-three, deferentially describes himself as a "mountain traveler" amid the elite subculture of speed-climbing alpinists. A David amid the band of staid and bearded Goliaths who have climbed Denali in winter, he admits to being meticulous and easily excited, and he is an observer of a spiritual connection to the landscape. "Masa," as his language-challenged American friends call him, stands five foot five,

and 130 pounds wet, with a boyish stubble—sparing him the usual trouble of facial-hair ice-melt dampening the hood of his sleeping bag.

The bush pilot Doug Geeting describes picking Masa up after months alone cheerfully humming the Eric Carmen tune "All by Myself." Geeting adds that his client "looks more like a Poindexter studying books in the library than the mountaineers I usually fly in." Masa, in fact, crams from three anthologies of classic haiku that have been his only companions during the last decade of winter climbs in the Alaska Range.

Defying expectations of a laconic or prideful loner, he owns a radiant smile and a magnetic personality that endears him to strangers. Scores of Alaskans have taken him in, fed him, and laughed at his self-deprecating humor.

Before this most recent climb, during a week-long spell of minus-thirty temps followed by days of storm that kept ski planes grounded, he crashed at South District Ranger Daryl Miller's house. He bided ten days of latter January by reading haiku, writing in his journal, and replaying one of his favorite videos, *The Terminator*.

"What do you do in Japan?" people often ask, trying to plumb his depths.

"I am househusband and dishwasher for my wife, Seiko," he replies, eyes unblinking. Masa does not volunteer that he is in demand throughout Japan as a lecturer, flashing slides of mountains and northern lights on the screen as he plays the harmonica and reads haiku compositions to his audiences—causing both laughter and sniffles.

Masa is a rare species. He comes in winter bearing gifts of Japanese soda pop and flies out in spring. He doesn't drink, smoke, or chase skirt. His devotion has nothing to do with any particular religion because, despite at least one near-death experience, dropping into a deep crevasse on Foraker, he is agnostic. He is not blessed with an athlete's body, a genetic predisposition to high altitude, a thick fat layer for the cold, or a remarkable command of the English language.

"I don't *rike* cold," he insists to his many disbelieving hosts in Talkeetna on the potluck dinner circuit.

Masatoshi Kuriaki, in a Talkeetna hanger, with poles that will, theoretically, prevent a crevasse fall if he breaks through a snow bridge.

To attempt the Japanese Ramp, Masa had flown in five weeks earlier, to become accustomed to the cold and ferry loads and wait out the storms. His deliberately slow ascent schedule would allow him another two weeks to acclimatize.

Denali in winter is the Everest of North America. Consider tropospheric depression: the thick belt of oxygenated atmosphere hanging over the equator dissipates into a thin layer of colder air near the poles. Even in summer, Denali has 4 percent less oxygen than similar peaks near the equator. Due to the physiological effects, the summit, at 20,320 feet, feels a thousand feet higher than the same altitude on Everest. In winter, as the sun's southern arc and long nights freeze the Alaska Range, the air becomes even thinner, with about half as much oxygen, essentially turning Denali into a 23,465-foot peak.

While Everest and hundreds of other Himalayan summits are technically higher, none is colder than Denali. Summer in the Himalaya is, on average, twenty-two degrees warmer than Denali. Winter around Denali—measured

in the middle troposphere, from three to eight kilometers high—becomes thirty-eight degrees colder than in the Himalaya during the coldest time of year. Denali is also arguably windier than Everest because of the venturi effects of the polar jet stream, which funnels, accelerates, and then blasts through 18,200-foot Denali Pass.

Only sixteen people, including Masa in 1998, have climbed Denali in winter; fourteen have summited Everest in winter. Out of two dozen climbers who have reached above eighteen thousand feet on Denali in winter, five have died (not counting Jacques Batkin, who fell unroped into a crevasse on day two of the 1967 first winter ascent). Thirteen percent succeed on Denali in winter, compared to 52 percent of summer aspirants.

To succeed—meaning, in this most dangerous game, to survive—one continually has to play the head game of accepting retreat when conditions aren't perfect. Repeatedly tolerating retreat and failure is counterintuitive to most alpinists. So Masa's success in this bizarrely specialized solo-winter-mountaineering game is really about survival, and about tolerating what most of us would perceive as failures.

Masa favors an Asiatic-styled personification of Denali, Foraker, and Hunter. He speaks of them by their original Athapaskan names: the High One, the Wife, and the Child. In 2001 and 1999 he climbed the Wife in winter by the Southeast Ridge and the Sultana Ridge. Although he spent four months on these two climbs, mostly in winter, he didn't reach Foraker's 17,400-foot summit until April 3 and March 31. Occurring past the defined winter season of December 21 to March 20, these weren't successes to Masa, but he is nothing if not persistent. He returned in winter 2002 and failed again because of high winds and avalanche conditions. Before descending, he bowed in deference to the Wife, and he set one new record: carrying down thirty-eight pounds of trash bags containing fifty-six days' worth of his feces.

Except for Masa, only one climber, Dave Johnston, out of over a hundred suitors has made successful repeat winter visits. In 1967, Johnston saved himself and two companions—

Art Davidson and Ray Genet—on their way down from the successful first winter ascent by uncovering an old fuel cache that allowed them to survive a six-day windstorm. Twelve years later, Johnston and two friends—Brian Okonek and Roger Cowles—made the first ascent, and in winter, of Mount Foraker's Sultana Ridge. In 1985, Johnston spurned the bush pilots and walked alone into Denali, eighty miles from his cabin at four hundred feet above sea level, climbing to thirteen thousand feet before refreezing the toe stubs left from amputations after his first winter ascent.

Still, until Masa, no soloist has made the quantum psychological leap of repeatedly returning to tiptoe across crevasse bridges, bare his genitals to subzero toilets, assume the self-arrest position to prevent wind "liftoff," endure lumbar pain from endless shoveling, or generally cope with the loneliness, storm-bound ennui, and sterile-white, cornea-burning deprivation that is winter climbing in the Alaska Range.

Sitting in Talkeetna's Latitude 62 Restaurant, wolfing down a mountainous plate of burger and fries that could only be fueling an extraor-dinary metabolism, the gentle bantam-weight Masa claimed, "I enjoy my winter *criming*."

While *enjoy* might be a verb lost in translation by his Oxford Japanese-English dictionary, he says he does not entirely enjoy living in a country with a tradition of subway pushers, people whose job is to shove passengers behind the closing doors so that the commuter trains will be on time. He does enjoy being alone in the Alaska Range "having the chance to read or write haiku" and "quieting my mind down after being amid the crowds of Japan."

Over the years, for their sanity, Talkeetna mountaineering rangers have learned to avoid mingling with climbers they are likely to retrieve in body bags. Yet Masa's coolheaded approach and clean safety record make him a welcome guest in their homes. Unlike most Alaska Range climbers out to push the limits, anxiously spurring their bush pilots to fly, Masa exerts no pressure. In this regard, his patience and humble acceptance work poorly. In 2005, he never questioned a pilot's judgment in making him wait a record twenty-six days in Talkeetna before flying into the range. Eventually, an

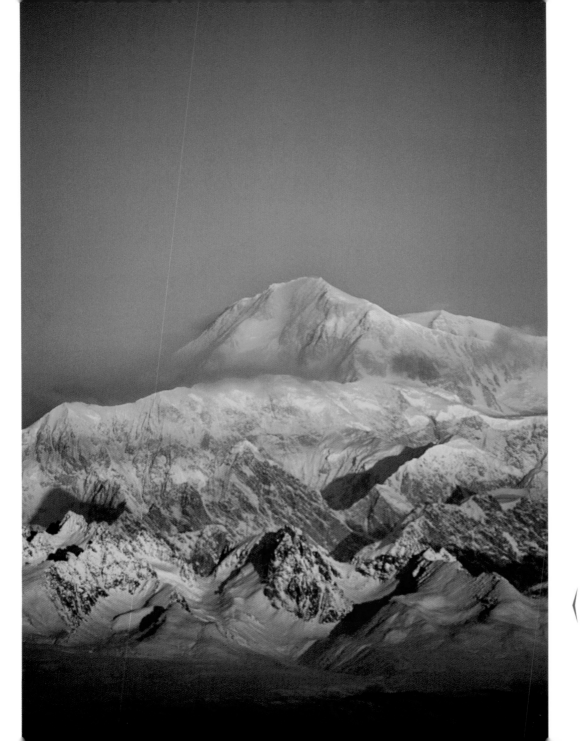

Denali breaching like a roseate whale, four vertical miles above Talkeetna in a January dawn.

outraged American friend switched Masa to another bush-pilot company.

Waiting for good flying weather has made him a fixture at the Talkeetna Ranger Station each winter. As he greeted Ranger Roger Robinson in mid-January 2006, he feigned the Schwarzenegger accent while shaking hands with a polite, faint grip, saying, "I'm back."

Daryl Miller, south district mountaineering ranger, says, "He is one of the most thoughtful persons ever to go into the Denali National Park regarding leave no trace. He is also very helpful to us in getting real-time winter glacier and snow conditions." In exchange, the park has waived Masa's special-use fees to climb the mountain. Recently, he translated the rangers' Mountaineering Booklet—a cautionary guide to surviving Denali—into Japanese. Masa spent months toiling over the work so his countrymen would better understand Denali.

Masa represents a changing trend in Japanese mountaineering philosophy. The old pattern has its roots in the Japanese determination to achieve lofty goals and restore their honor after the ignominy of World War II. *Kamikaze*—or Divine Wind, named after a thirteenth-century typhoon that saved Japan from a Mongol fleet of ships—came from the improperly translated word *shinpū* to describe World War II Japanese suicide attack pilots. Unknowingly, and under sponsorship obligation to accomplish "a first," green, cash-strapped Japanese teams often chose routes that were unclimbed and dangerous, rather than technically difficult routes that were a lot safer. As a result, many of the Yukon's and Alaska's greatest and most difficult peaks have avalanche-prone Japanese routes. The Japanese Direct South Face on Denali takes an unconscionably perilous line directly beneath Big Bertha (three Japanese were buried without recovery here in 1981). Neighboring Mount Foraker's Northeast Ridge route, vulnerable to hanging-glacier avalanche, attracted dozens of Japanese until six were buried here in 1976. And Mount St. Elias's North Face has a huge hanging glacier precariously overhanging the entire route, so it seems a miracle that the only ascensionists—Japanese—made it off unscathed.

Masa offered an explanation for such questionable Japanese route choices. Until the yen strengthened against the dollar in the 1980s, he said without a hint of defensiveness, poor and inexperienced climbers, often from university climbing clubs, were greatly honored in receiving sponsorships from wealthy patrons. But the Faustian deal meant that, in expensive Alaska, "Japanese climbers have one-time shot to…)," Masa stopped and typed a word into his calculator-sized, electronic Oxford Japanese-English dictionary, and said, "perform first ascents to fulfill sponsors." He doesn't accept money, he explained, because this kind of pressure has killed climbers a lot more talented than he.

In winter 1989—when the thermometer at 17,200 feet on Denali registered -77 degrees—one of the world's most accomplished high-altitude climbers led his two companions to Denali's final camp. Noboru Yamada had climbed Everest three times: in winter, without bottled oxygen, and as a grand traverse.

Whatever happened to the three Japanese can only be imagined, because the rangers couldn't fly until the nearly two-hundred-mile-per-hour winds abated nearly three weeks later. The ground crew found the climbers "flash frozen" and tangled in the ropes below Denali Pass.

At fourteen, hair dyed blue, Masa was a guitarist in an urban rock band in Japan. A year later he joined the high school climbing team and as quickly dropped music.

To train for climbing, the slight sixteen-year-old, then 120 pounds, dropped 112 pounds of sandbags in his pack and joined his teammates by walking a block to the subway, riding to Tenjin, catching a bus to Red Road Station in Sasaguri, walking half an hour on pavement to the trailhead, then jogging fifteen miles through the hills. In summers, he traversed ridges in the Japanese Alps. Shuyukan High School, despite its otherwise rigid schedule, promoted this sort of "unsafe behavior," Masa believes, because unlike newer schools, the 223-year-

The soloist Masatoshi Kuriaki is a devotee of Talkeetna sunrises lighting the eighty-mile-distant Alaska Range.

watching the stars above. He played the harmonica, read, and finished his Big Bertha haiku:

OoNadare
GiaNominarazu
ShikiMoKiyu.
(Monster avalanche / Steals my hardware along with / My summit morale.)

Two nights before he had to leave, still studying the night sky, he finally found the redemption and a key to the tolerance he sought. He called it "a gift from the mountain for turning around."

Behind him, Mount Hunter—the Child—was lit by the waxing moon. Miles above his tent, far above the peaks that have become his life's work, the northern lights swayed in green-pleated curtains across the heavens, pushed by a divine wind.

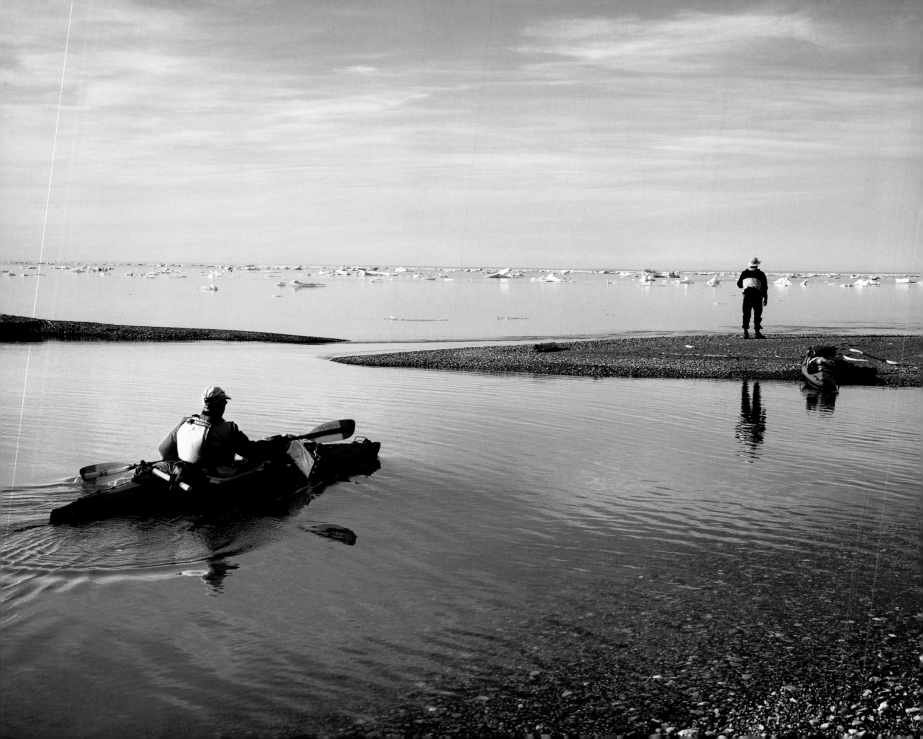

Final Refuge

15

In 2006, National Geographic's Expeditions Council awarded me a grant to lead an expedition to northern Alaska. After the trip was finished, I convinced John Rasmus, founder and editor of National Geographic Adventure magazine, that the latter part of this expedition merited a feature story about my source-to-sea trip down the Kongakut River. More important, I reasoned, unlike the previous years' movements to defend the place from bills that would open the Arctic Refuge to drilling, a shifting Congress had proposed new legislation to permanently close the coastal plain to development by declaring it protected wilderness. Rasmus (who also founded Men's Journal and worked as the editor at Outside) immediately saw the value of using the magazine to help launch an offensive with Congress.

The most surreal destination on the continent: the northern edge of the Arctic Refuge along the Beaufort Sea.

No matter that I had already paddled the Kongakut River twice before. This time I got to explore it all the way from its first trickles to the sea, thence for another sixty miles along the sublime Beaufort Sea. Because most magazine editors won't assign writers to take pictures, I invited the photographer John Burcham and learned a lot from his techniques: shooting from a tripod held high in the air, experimenting with flash photography, and squeezing every bit of beautiful light he could find into his camera. Still, I shot hundreds of photographs and used them for other magazine articles and a PowerPoint lecture campaign around the country promoting wilderness protection for the Arctic Refuge. Adventure ran the story as a full-length feature in summer 2007, just before that fall's vote on Capitol Hill.

As I write these words, our contentious Congress—thanks to the powerful oil lobby—has still done nothing to protect the refuge.

WE CLIMBED FROM the canyon floor onto a tableland of dry grass bent double in the afternoon wind. Photographer John Burcham and I doffed our hats and scanned the horizon. We'd begun a traverse of the Arctic National Wildlife Refuge the day before and still hadn't laid eyes on a creature larger than a hawk, let alone a human.

As I looked downwind, the scale of the valley below and the surrounding Brooks Range felt exponentially larger than anything I'd left behind at home in the Colorado Rockies. The arctic vastness, coupled with the lack of trees or other visual cues, makes gauging perspective a crapshoot. Somewhere in the distance, I watched what appeared to be a fleeing ground squirrel. I grabbed the binoculars.

The squirrel, to my surprise, swelled into a grizzly. John asked quietly, "That a problem?"

I didn't think so. While it had chosen the same route we planned to follow, over a ridge and into the next valley, it appeared amply rounded. With any luck, summer's roots and berries had left it ill disposed to chasing humans. We carried holsters of mace, six days' worth of freeze-dried food, John's arsenal of camera lenses, and seven maps that would steer us over land and water, but still we were not, as arctic bard Robert W. Service wrote, "armed for bear."

Service was one of two men responsible for my being here. My father presented me with a copy of the poet's 1907 collection, *The Spell of the Yukon*, when I was a teenager, and his tales had struck me like a fever. Today they read like an outdoorsman's Dr. Seuss: wild-eyed prospectors abandoning the search for riches and finding enlightenment among nameless mountains and "valleys unpeopled and still." I've spent most of my adult summers up north. Throughout the region, I've found no geography as singularly sublime as Alaska's northeast corner, alongside Canada's Yukon Territory, where glaciated mile-high mountains crowd the Arctic Ocean. It's the area now contained within the Arctic National Wildlife Refuge, a place conservationists adamantly refer to as simply "the refuge" and oil lobbyists prefer to call ANWR.

John and I had begun our midsummer walk in the Sheenjek River Valley, one of the most remote bush-pilot destinations in Alaska. The

Sheenjek was the terminus of a three-week-long journey I'd taken with the other man whose work had drawn me north, the renowned field biologist George Schaller. Schaller, at this point a friend, had agreed to join me and three graduate students on an expedition to celebrate the fiftieth anniversary of his now-famous trip, a journey that literally put the refuge on the map. In 1956 Schaller, then twenty-three, had been one of two students on a Sheenjek scientific survey led by conservationists Olaus and Mardy Murie. His "Arctic Valley" report opened with some Service poetry and detailed the diversity of flora and fauna in this mysterious region. The comprehensive paper, among other influences, helped convince Congress and the Eisenhower administration to protect the region in 1960.

Inspired by Schaller and the wonders he described, I first came to the refuge in 1984, hoping to catch the annual migration of nearly two hundred thousand caribou. It was the singular beauty of the Kongakut River, however, that drew me back time and again. Bursting from the six-thousand-foot-high glaciated spine of the Brooks Range, it is one of many ice-cold

rivers feeding a rich coastal plain. Yet the gin-clear, fish-dimpled Kongakut—which carves north, twisting and curling through limestone towers and minarets before abruptly plunging to the Beaufort Sea—is the only river in the refuge held captive by mountains for most of its length.

I'd always wanted to walk the thirty miles from the Sheenjek, on the southern side of the Brooks Range, north over the mountains to find the Kongakut's first trickle. Schaller, who thinks of himself as "a wanderer with a scientific bent," teaches that the best way to get to know a place is to undertake a long journey on foot, to develop an intimacy with the countryside and the movement of its animals. So John and I were taking the torch from Schaller and following the spirit of his 1956 sojourn. Then, evoking the obscure Alaska discipline of "turf and surf," John and I would raft twenty-five miles down the Kongakut headwaters, meet a friend stationed with kayaks, and paddle the rapids for seventy miles to the Beaufort Sea. Finally, we would thread fifty miles of icebergs west to the Iñupiat village of Kaktovik.

After seven visits to the refuge, I still found myself spellbound by its alien landscape. Its northern edge—free from the typical scars of glaciation—offers a rare glimpse back to a time before the last ice age, which miraculously skipped arctic Alaska. The wet coastal plain is formed into large polygons that resemble moon craters. The continuous summer sun transforms the midnight air into a honey-hued wonderland. The normal constraints of space and time feel askew, as if the creator of this place fumbled the assembly manual and accidentally created a world apart.

In large part, the state of Alaska owes its existence to oil. In 1959, a forty-year battle to earn statehood was won only after local officials proved to Washington that potential revenue from the territory's untapped petroleum reserves would offset the federal cost of maintaining a massive chunk of wilderness forty-five hundred miles from Capitol Hill. Nine years later, sixty miles west of the Arctic National Wildlife Range (as it was then named), amid a little-known tidal convergence of tundra and rivers called Prudhoe Bay, the Atlantic Richfield Company and Humble Oil (now Exxon) discovered the largest oil field in North America. In 1977, the $8 billion eight-hundred-mile Trans-Alaska Pipeline began pumping Prudhoe Bay oil to tanker ships in Valdez.

The ANWR controversy began in 1980, when Congress doubled the 8.9-million-acre range into a nineteen-million-acre refuge. It simultaneously mandated a study of the 1.5-million-acre coastal plain inside the refuge's northern boundaries—an area whose geologic foundations contained the same potentially oil-rich "Barrow Arch" formation found below Prudhoe Bay. To no one's surprise, a 1987 government report showed that the refuge's coastal plain potentially contained significant oil. The Department of the Interior recommended coastal-plain oil leasing in an orderly fashion but warned of possible adverse effects on the region's wildlife. Twenty years later, people are still arguing over exactly what that means.

The hundred-mile-long coastal plain is sandwiched to the north by the Beaufort Sea and forty miles to the south by the Brooks Range. Though it does not bring oohs and ahhs

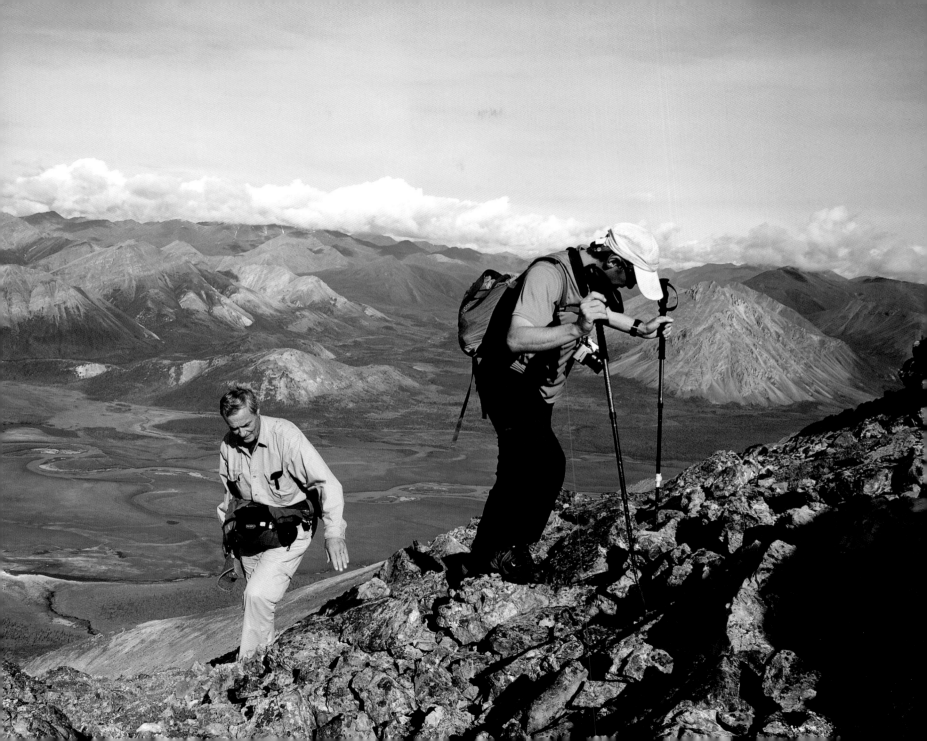

to the lips of nonbotanists, biologists refer to the coastal plain as a "kitchen," or a feeding ground, for nearly two hundred wildlife species. This includes the 110,000 members of the Porcupine caribou herd, 106,000 snow geese, a hundred or so grizzlies, and a seasonal population of polar bears that are already stressed by diminishing sea ice.

While the polar bear has emerged as the poster child of global warming, the Porcupine caribou herd has come to symbolize the refuge. From a plane a week earlier, Schaller and I had spotted a group of several thousand running across mountaintops in search of wind to quell the flies. These caribou travel up to thirty-one hundred miles a year, one of the longest terrestrial migrations on earth, traveling northwest in the spring from Canada's forested lowlands. Based on caribou behavior near Prudhoe Bay, up to thirty thousand pregnant cows a year might avoid the coastal plain if the morass of service roads, glinting pipes, and ever-churning derricks of the proposed oil field is built.

To those of us outside Alaska, the question of the refuge boils down to two positions, drill it or save it, which fall along major political party lines. A March 2007 Gallup poll shows that 57 percent of Americans oppose drilling. Within the state, however, feelings are more complicated. Alaska crude accounts for more than 85 percent of state revenue and could easily buy out the combined income of tourism, fishing, and mining. The pipeline hit its zenith in 1988, pumping some two million barrels of crude a day, and accounted for 13 percent of U.S. domestic oil demand. Ever since, Prudhoe Bay's subterranean dipstick has been running dry. The eight-hundred-mile pipeline has dropped to less than half of its capacity.

According to the most recent estimate of the U.S. Geological Survey, the ANWR coastal plain holds "between 4.3 and 11.8 billion barrels…with a mean value of 7.7 billion barrels." If Congress were to "open up ANWR," as the lobbyists say, federal, state, and Native Ukpeagvik Iñupiat Corporation landowners would earn billions from their oil company renters. But seven billion barrels is not a Middle Eastern king's ransom. Saudi Arabia, for instance, has more than 264 billion barrels beneath its sands. In total,

the refuge would provide less than two years' worth of U.S. oil. According to a 2005 report from the Energy Information Administration, twenty years into production the American public would save a penny per gallon at the gas pumps. The state of Alaska, taxing the oil company profits at 22.5 percent, would continue to prosper. So would its 626,932 residents, who since 1982 have been exempt from state income and sales taxes thanks to Alaska's oil investment portfolio. In addition, they receive yearly dividend checks, which in 2006 granted $1,106.96 per resident.

Led by U.S. Senator Ted Stevens from Alaska, who called the refuge "an empty, ugly place," every Congress since 1987 has proposed both wilderness bills (shutting out industry) and oil leasing bills. Liberal-leaning wilderness supporters plug up the phone lines, in-boxes, and mail slots of their representatives. Conservative politicians talk of "energy independence" as a security issue and tuck refuge drilling proposals within proposed energy, budget, and military appropriations bills. To date, no legislation has migrated past the White House.

Now, for the first time in more than a decade, the shifting Congress could ultimately protect the 1.5 million acres of coastal plain within the refuge. This fall, the Markey bill, which designates the coastal plain as wilderness and would close the door on oil development, could be put to a vote in the House. The prize defines the most epic battle of modern environmental politics: a chance to preserve the last undeveloped frontier of America, forever.

"Pretty amazing place, this ANN-Wahr," said John, referring to the meandering Sheenjek River valley that hyperextended below our feet. This was John's first visit, and he knew that the few who make it here—only about a thousand a year—either fall in love with the place or never return. I first arrived at the refuge as a twenty-eight-year-old Alaska resident, fresh from years of rescue work and climbing around Mount McKinley. Having finally shed the stigma of cheechako, as Robert Service called the green Lower Forty-Eight tourists who had never studied the northern lights, I was ready to do some exploring that did not involve crevasses, avalanches, and bushwhacking. So heeding the

During its annual 1,700-mile migration, a small band of the Porcupine caribou herd climbs into the wind to escape parasitic insects.

peculiar call of this land with no trees, I traded up for thick mosquitoes and thinning sea ice.

The land seemed largely unchanged in the twenty-two years since. The second day of our 2006 trek, we gazed at caribou trails lining a new valley like lifelines on a giant palm. John and I followed bear tracks down into a mossy creek flourishing with bones, tracks, and scat. Waist-high willows tangled the creek bottom, but large animals had kicked trails in any direction we cared to walk.

After dinner, while John photographed arctic poppies, I climbed a small peak to glass our route with binoculars. As a caribou bull clattered in rock fields below, a golden eagle rode the updrafts, and the next day's walk through a low pass looked dry and free of tussocks. During the two and a half months of arctic summer, each of these swaying, mushroom-shaped colonies of cotton grass swell to the size of a human head and poke a foot or two above shallow, bug-ridden bogs. These well-disguised minefields routinely fool cheechakos into feeding the mosquitoes and spraining their ankles.

The next two days proved typical of the Far North: wide-open spaces akin to the steppes of Mongolia and a gunmetal overcast that muted the daylight. The midnight sun parked on the northern horizon, beaming beneath the clouds with no discernible heat and shimmering ominously against the tent walls.

We crossed a five-thousand-foot-high pass into the Kongakut headwaters, our hoods up against an icy rain blowing off the Beaufort Sea. Mercifully, the cool weather had forced the mosquitoes to take the week off. Moving from the south side of the Brooks Range to the north is like passing from the eastern farms of the Rockies to the canyons of the West. The treeless landscape abounded with orange lichens, shed caribou antlers nibbled by voles, and knee-high willows.

Before leaving my family in early summer, I promised that I'd try to avoid another Alaska "adventure." My greatest hits in this category include, but are not limited to, overturning a kayak, dislocating a shoulder or two, and running out of food. Luckily, I didn't have to mention

you're traveling by air to track the herd, it's not unusual to go for days without sighting mega-fauna. After all, the refuge is thirty thousand square miles, nine times the size of Yellowstone National Park. For an astute observer, however, animal sign is everywhere. We could smell the ripened bowels of kill somewhere beyond the western bank. All day and through the bright nights, we listened to a biophony of unidentified birds. We could see tracks tamping the mud and willows waving shed fur.

The river dropped into a quandary of three braids. I back paddled. A poplar trunk blocked the right channel and shallow waters occluded the middle one. So I pulled hard left with my paddle to ferry upriver, then straightened out to surf river left, sweeping beneath a bank of dwarf birch and catching a smooth tongue of deep water that gave me an ice cream head-ache as I drank it out of my hat.

For all the route-finding challenges and spo-radic bear meetings, John and I were develop-ing a sense of place felt from within. Although we had come to celebrate the fiftieth anniver-sary of George Schaller's landmark scientific survey, one of the reasons for the refuge itself, I had been silently lamenting the fiftieth anni-versary of my birth in June. This was not the mere inexpressible angst of some midlife cri-sis, because I loved my flourishing family, home life, and work. I simply didn't understand how I could continue the epic journeys of my youth.

It was Schaller who cured me by example. At seventy-three, he had spent three weeks with our crew, shivering on a cold float down the Canning River, jumping tussocks, swatting mosquitoes, and climbing a mountain. His in-nate feel for the refuge freed me to build fur-ther intimacy and respect for the land. I took satisfaction in knowing that as I withered, lost my reading vision, and grew stooped in the shoulders, this place would remain unbent, un-aged, and as untouched as the first day of its creation. Or so I hoped.

After ten hours of hungry paddling, we reached a buddy of mine, Mike Freeman. He had flown in the week prior and was guarding our liquor and kayak cache with a shotgun at Drain Creek, the Kongakut River put-in along-side a bumpy airstrip.

Mike had dressed the gravel bar for us with a checkered tablecloth. He filled our plastic cups with red wine, our bowls with boiling water and freeze-dried lasagna. Over the last week of waiting at what passes for a major junction in the refuge, Mike, a psychologist in the Colorado public school system, had seen only a bug-eyed husband and wife from Illinois. That spring, after being introduced to the Kongakut by a TV show called *Rafting Alaska's Wildest Rivers*, they'd planned a trip. Their only practice was on two benign midwestern flows.

The couple learned, to their surprise, that the U.S. Fish and Wildlife Service requires no permits or registration of its visitors and in return provides no safety net. The trick would be to finish their float by early August before the nights re-darkened and the falling snow stuck for ten months.

Mike watched them struggle to squeeze into their brand-new dry suits. Seeing their light pile of gear, he was a bit concerned to learn that their plan for bears would be to employ their good vibes as Christians and "shoo" the beasts out of camp. He waved goodbye, partly wondering if they'd survive their first experience on a Class III river and in the Arctic, but mostly impressed that the refuge had the power to draw working-class midwesterners to the Far North.

As the Kongakut hummed its song, we pulled rubber and canvas hulls from the duffels and snapped together laminated birch frames. These folding boats had been inspired by early sealskin-and-driftwood Iñupiat kayaks. Our fifty- to seventy-pound Long Haul kayaks could carry weeks of food and were designed to take a beating. I had already paddled mine across the top of the continent. I levered my hips into the cockpit—like pulling up a treasured old pair of baggy jeans—then shoved off over the rounded cobblestones and led the way. Two miles later, I misread a narrow channel turn and nearly flipped while running it backward.

At low water, the Kongakut boulders formed a puzzling obstacle course. We leaned left and right, dodged snags, clipped rocks. Below purple scree fields, eroded thumbs of rock jabbed the blue sky and Dall sheep fled from the river. At times, we were all forced to jump out to escape

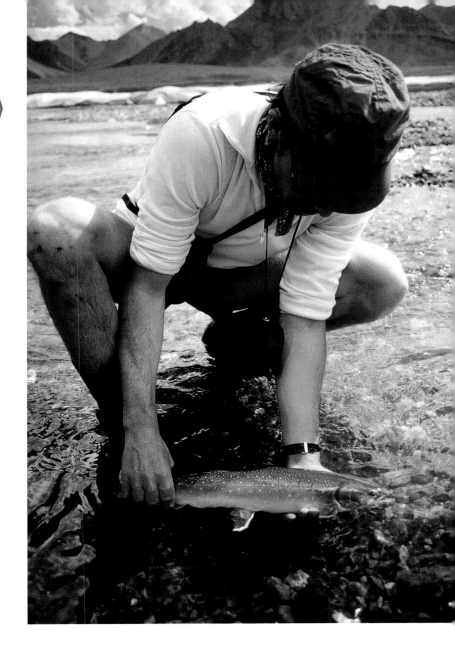

The river-spawning, sea-running Dolly Varden (seen in the Kongakut headwaters) is a trout named after a nineteenth-century sheer dress worn over a bright garment.

boulders, willow tangles, or deceiving shallow channels. Two dozen miles from Drain Creek, above a landslide that twisted the river, John, who had never steered a kayak down a river, made a quick turn to reach the main current. In an unexpected eddy, his boat spun broadside and flipped against a boulder, throwing him into the river.

From the shore I extended a paddle and hauled him out. Thigh-deep cold water didn't register through my adrenaline. Mike and I grabbed his submerged boat before the rapids could claim it. On previous trips down this river, I'd watched a more experienced kayaking companion destroy a kayak, so I was relieved to see both John and his boat intact. But as he held up a leaky dry bag filled with river water and a destroyed zoom lens, we all grew quiet. We shivered as the sun fell behind the canyon. John blasphemed both the river and the bag manufacturer. The mood of the evening and our thoughts went south for the first time on the trip.

That night, as John wrung out his gear, Mike extracted a liter of twelve-year-old single-malt

scotch from a well-padded bag. In our cold, makeshift camp amid a boulder-filled bog, surrounded by still-warm grizzly scat, the roar of the rapids and all would-be interlopers were chased away by laughter.

Two mornings later, Mike was relieved to see the Illinois couple, waiting anxiously for a planned deliverance by a bush pilot beneath the river takeout at Caribou Pass, a final ridge above the expanse of coastal plain. They ran excitedly from their tarp to greet us.

I tried to imagine her, slight and shivering with cold, playing pinball down the boulder-strewn river. As if reading my thoughts, she looked crossly at her husband.

"I thanked the Lord that we somehow made it through those rapids," she said.

I bit my cheek in consideration. For the moment, her rationale seemed as plausible as anything that I could think of, standing there under the penumbral light, surrounded by paradise, teeming with tiny plants like God's bonsai garden. As her husband chimed in that he was already planning their next arctic river trip, I nodded in hearty approval. She frowned.

I shook their hands in congratulations. We traded email addresses.

Two days later Mike, John, and I feathered our paddles in river delta mud, still talking about the couple's audacity. Then we too found ourselves confronting an apparent miracle. A mirage hovered on the northern horizon, a reddish ocean liner wavering next to giant, floating sapphires. I told my partners we were looking at an illusion created by the warm land air meeting the icebergs and sea air and bending the light waves.

"One time," I added, "I saw a city skyline out here."

We sneaked through a labyrinth of channels and immense, blinding expanses of leftover river ice. Hundreds of caribou sheltered from the bugs within the refrigerated atmosphere atop the ice. Mist bleached the air. Then everything blurred into the characteristic coastal fog.

In the heavily silted river we slipped past waving willows, bones, and a caribou carcass. Somewhere far below, amid the subterranean heat, reservoirs of ancient sea creatures rendered into combustible tar. We were pulled

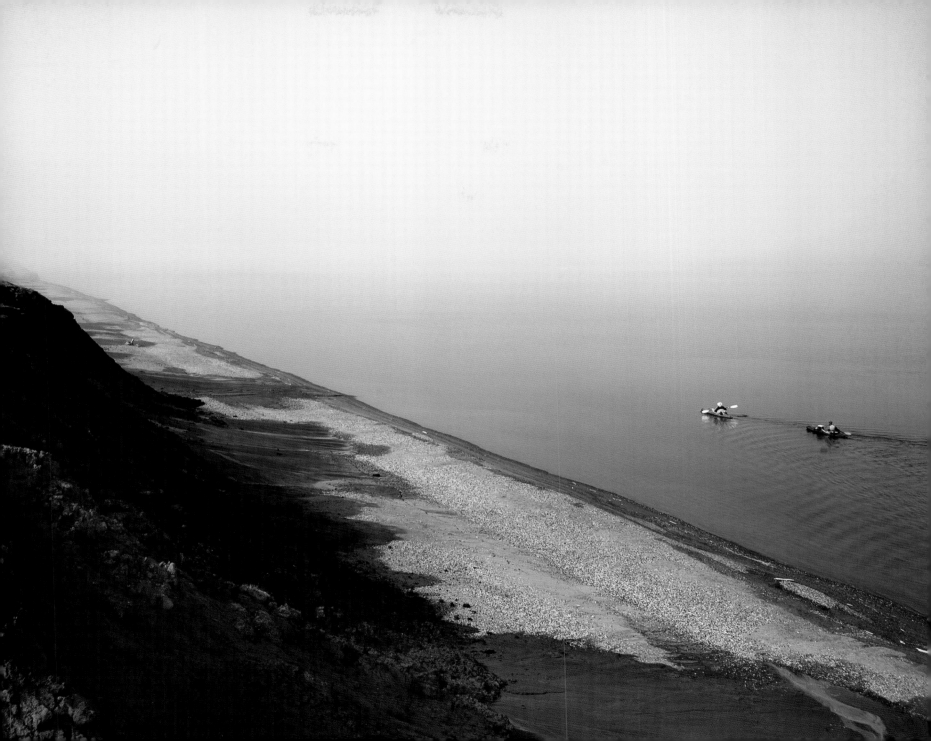

John Burcham, unable
to sleep for the beauty
of the midnight light
out on the mind-
blowing barrier islands
of the Arctic Refuge.

into a channel that resembled a great looping intestine, lined with half-foot-high banks blanketed in horsetail, until we finally plopped out into a lagoon at the edge of the Beaufort Sea. The barrier island known as Icy Reef lay another mile out, so we put our heads down and paddled seaward.

Twenty minutes later we wriggled out of our kayaks. Wearing rubber boots, I followed John and Mike. They stood atop the sands of Icy Reef, washed out of the refuge by a dozen rivers. Their mouths hung open.

To the southwest, forty miles away, the mountains (and what remained of their melting glaciers) rose above the foreshortened green blur of the coastal plain, the area some would festoon with oil rigs. To the north, amid icebergs riding the ocean currents, was the red mirage ship—except this was no illusion. It was a reality of black smoke and rattling chains, preparing to drill offshore the following summer.

We dove out of a quick-moving thunderstorm and into our tents, and as a rainbow appeared as an olive branch over the political battleground of the coastal plain, we tried to sleep with diesel engines growling offshore. The knowledge that oil drilling was imminent kept me turning in my sleeping bag. We could run a secluded river, but we couldn't hide from the long arm of Big Oil.

I reconsidered what had changed here over the past two decades. To my delight the military had completely cleaned up a cold war radar station at Beaufort Lagoon, in the middle of the refuge coastal plain. However, climate change had caused the melting of glaciers and permafrost, eroding the coastline in long, slumping tundra fractures. Storm surf, unchecked by a recent dearth of sea ice, appeared to be consuming the ocean bluffs. And now this Shell Oil ship had appeared, worrying offshore waters like an errant mosquito, preparing to drill within sound and sight of the refuge. I wondered, *Is my plan to grow old and watch this place remain untouched nothing more than a pipe dream?*

By early morning the ship had disappeared, and we hoped for a week of quiet while paddling to Kaktovik. Each day we fished for Dolly Varden and shuttled them straight into our frying pan. We poked through deserted sod and

driftwood ruins built by the local Iñupiat decades before. And quietly we picked our way along the most spectacular coast of the entire Northwest Passage.

I have spent decades chasing an elusive mastery and understanding of the Far North. My journeys in the Arctic have given me direction. George Schaller has referred to this pursuit as "finding his moral compass." In Schaller's distinguished career as a conservation biologist, he has always maintained that dispassionately sharing science about a place doesn't cut the mustard. The goal, he once wrote, is to balance knowledge with action, because "anyone who observes the exponential destruction of wilderness must become an advocate for conservation."

As we paddled the coast, two boatloads of Iñupiat hunters passed us in the fog, waving their ubiquitous Coke cans to us in friendly greeting. We were reminded that, historically, their marine-based culture centered on polar bears, seals, and whales. If an oil field came to the coastal plain and drove the caribou away,

these mariners would theoretically retain the riches of their sea.

As well, the tax revenue from oil companies has been good to these people. The first time I visited their village of Kaktovik twenty-two years ago, personal waste disposal systems consisted of plastic toilet seats over wastebaskets lined with trash bags. Now, along with a new school and improved health care, everyone has indoor plumbing. Not surprisingly, until several years ago, a large majority of Kaktovik Iñupiat had supported drilling in the refuge, which would bring further tax revenue.

The blades of my weary partners plopped like metronomes against the Beaufort Sea. I could guess what we'd find in the village. Offshore oil roughnecks and engineers working the exploration ship. Tourists like us, fleeing before winter and the returning polar bears. And the resident Iñupiat, who will reap the consequences of any congressional action.

For the first time since the oil development debate began a quarter century ago, local opinions now approach the divisive polarity

of the Lower Forty-Eight. Oil ships clang and probe and boom in the dwindling ice pack, throughout sacred Iñupiat waters. Concern is spreading that oil operations on the coastal plain could also cause an offshore spill. A 2005 petition against coastal plain development was signed by 57 of 188 adults in the village. The Kaktovik mayor can no longer say whether his constituency supports drilling in the refuge, let alone offshore drilling (which would not bring in any tax or lease revenue).

The oil lobby will keep trying to buy legislation for drilling within the refuge, and proponents like President Bush and Senator Stevens, who sarcastically invited Americans up to ANWR to decide for themselves if it's worth saving, will roll their eyes at pilgrims like us who continue to speak of the place as the Taj Mahal. Yet it is a nondenominational temple built for everyone: two midwesterners who have encountered the face of God, the Iñupiat who have lived here for several thousand years, and millions of urbanites who nobly embrace a far-sighted ideal of wilderness for its own sake.

Mike put on another layer of fleece; John pulled out the Yahtzee board. I pressed closer to the fire and, for comfort, recited the poem "The Spell of the Yukon," about a miner who cared naught for gold.

"It's the beauty that thrills me with wonder," Service finished. "It's the stillness that fills me with peace."

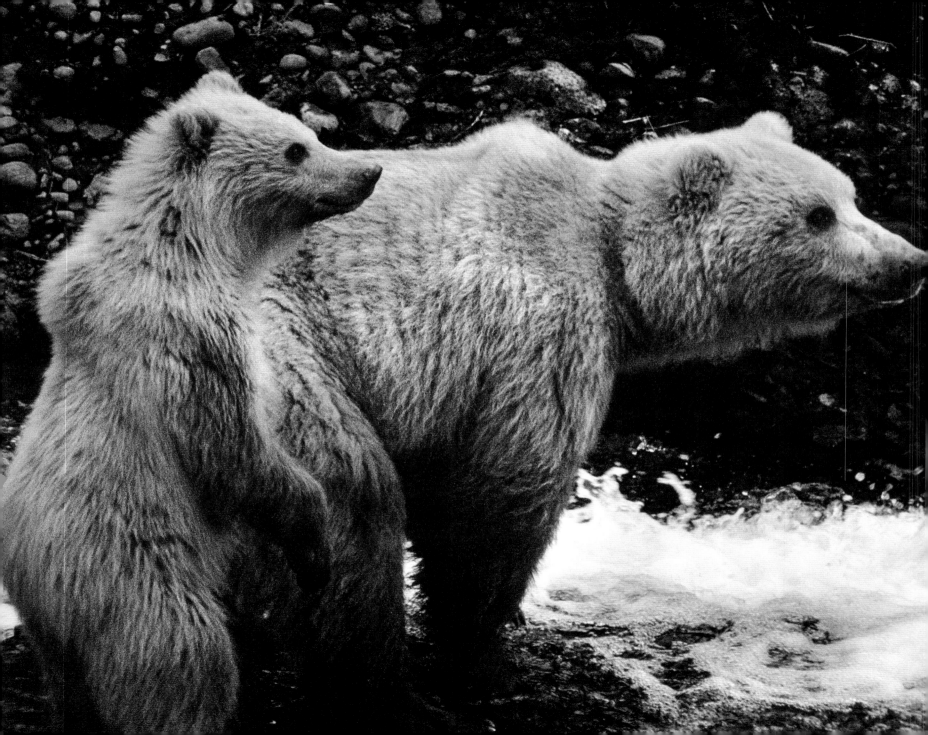

This would be one of my last stories for National Geographic Adventure *magazine, appearing in October 2005. As a sign of the times and a new path meted out to most outdoor writers and editors (many have turned to Internet blogging and management),* Adventure *bit the dust several years later due to lack of ad revenues and a declining budget. I had a hard time getting the green light for this story because Timothy Treadwell (who did little right when it came to interacting with bears in Alaska) had recently been mauled and eaten by a grizzly, and the media played that horrific disaster ad nauseam. First I had to convince the editor, John Rasmus, of the story's merit. Befitting his chosen career, John is a healthy skeptic, disinclined to retread old news. But in this case, the victims,* Rich and Kathy Huffman, did everything right. Also, from my time on the ground and numerous bear encounters, I knew that the rogue bear in this story was influenced by climate change. I wanted this story to reflect the radical transformation going on north of the Arctic Circle.

More precisely, the region's Porcupine caribou herd often didn't make it back to the coastal plain because of changing snow conditions, and it may be that the caribou herd's numbers have declined over two decades from 178,000 to 110,000 precisely because of changing climate. At the same time, opportunistic grizzly bears, adapting to these conditions, had been uncharacteristically preying upon and depleting musk ox populations on the plain where the Huffmans were attacked. And few would deny that the sea ice and permafrost are rapidly melting. The Arctic is a different place than the landscape I first saw thirty years ago—average temperatures have risen three degrees in that time span.

Spend enough time in the North and you'll meet a grizzly sow with cubs—don't run, act confident, but show respect as if you're meeting royalty.

After "They Did Everything Right" appeared on newsstands, Rich Huffman's daughter invited me out for coffee in downtown Seattle. Although she's not part of this story, I'm struck by her transformation too: from flying Apache attack helicopters in dangerous reconnaissance missions over Bosnia to speaking out to save the Arctic Refuge from oil development—as her dad did. After leaving active duty in the military, Shannon Huffman Polson has turned to freelance writing (her blog is at www.aborderlife.com) and she just published her first book, titled North of Hope, *about losing her dad.*

ON THE AFTERNOON of June 25, Robert Thompson, an Iñupiat rafting guide, was floating with two clients down the Hulahula River in Alaska's Arctic National Wildlife Refuge (ANWR) when he observed a blond adult grizzly bear lording over a wrecked campsite in an alcove beneath a low tundra bluff. Thompson could see scattered gear, a mangled tent, and the shredded remains of two inflatable kayaks. He hoped the campers were off somewhere hiking.

When he stopped the raft to get a better look, the bear suddenly charged. Thompson and his clients paddled frantically away, but the bear splashed into the river and began swimming after them. For half a mile the bear alternately swam, clambered to shore, and ran after the raft. It was gaining on them.

When it got within forty feet, the seasoned guide yanked his handgun from his dry bag but resisted the impulse to fire a warning shot, opting instead to save his bullets in case he had to drop it. But just then, the fast water slammed the grizzly into a boulder, which it climbed onto, snuffing at the rafters from this perch as the swift current carried them downriver. It continued the pursuit, halfheartedly now, and after fifteen terrifying minutes, it finally gave up the chase. A shaken Thompson called for help on his satellite phone.

Since the wildlife refuge's creation in 1960, only one person has been injured by bears within its 19.6 million acres; none have sustained bear-related injuries in the past two decades. But then, few people used to visit the area—something that's changed dramatically

in recent years as the region, known throughout the Lower Forty-Eight as ANWR and by locals simply as "the refuge," has become the subject of national debate. Each time the specter of Alaska oil drilling is raised in Washington, D.C., the number of visitors goes up: from 679 prior to 2000 to an annual average of 1,010 in 2004, not counting frequent trips by local indigenous people. Last spring, Congress approved a preliminary budget resolution with provisions for drilling in the sanctuary. Throughout the summer, hundreds of rafters arrived to rollick down its bouldered rivers.

"It wouldn't surprise me if we see an increase again because we're in the news more," said Joanna Fox, assistant refuge manager for the Arctic National Wildlife Refuge. "A lot of people are interested in seeing the area in case oil development comes."

However, unbeknownst to the scores of new visitors, this tundra is home to an opportunistic predator that has come to demand more and more respect. In local vernacular, it's known as the barren ground grizzly, and it's a different order of bear altogether.

Kathy and Rich Huffman had been eagerly anticipating their own paddling trip, a romantic ten-day kayaking run down the Hulahula, timed to beat the mosquitoes and, more importantly, to coincide with their sixteenth wedding anniversary. Rich, sixty-one, a utilities lawyer, and Kathy, fifty-eight, a retired schoolteacher, both from Anchorage, were careful and experienced backcountry travelers. Bush pilot Tom Johnston of Alaska Flyers in Kaktovik, an Iñupiat village on the shores of the Beaufort Sea, said he had never had a passenger grill him as Kathy did about his experience, his flight hours, and his airplane's emergency equipment. She insisted that Johnston show her where everything was stowed and made a point of asking for both his dispatcher's and the state trooper's phone numbers

While loading the Huffmans' gear into his wheeled Cessna 206, Johnston saw an EPIRB (Emergency Position Indicating Radio Beacon), two pepper spray canisters, bearproof food containers, dry bags that were worn but in good repair, and a rifle packed in a soft case. The only concern Kathy expressed openly was

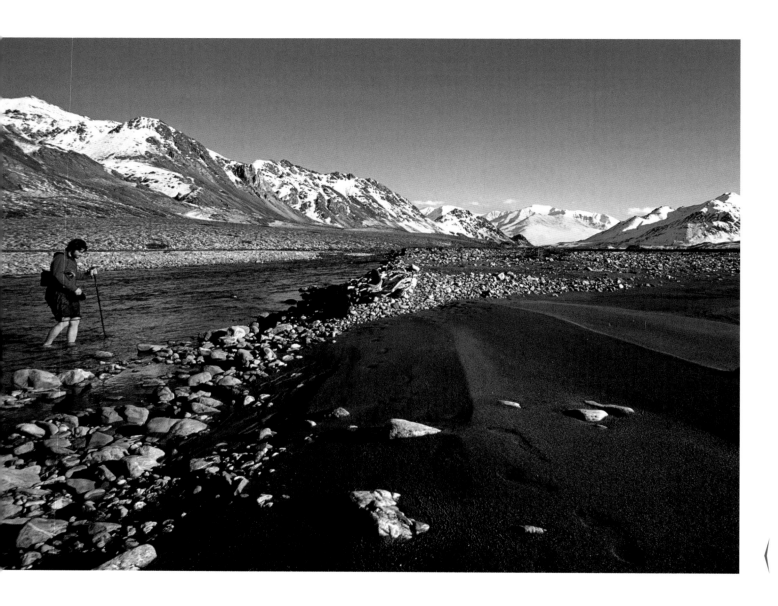

The upper Hulahula River at low, late-summer volume; Rich and Kathy Huffman put in here and floated north toward the coast.

for the Hulahula's rapids, which, after a flyover, she felt confident she could handle.

On June 23, eight days into their trip, they landed their inflatable kayaks and made camp on the edge of the refuge's coastal plain. As was their habit, they cooked miles upriver of camp and meticulously stowed their food and toothpaste away from their tent in bearproof containers. And, like most savvy Alaskans, they went to sleep that night next to their insurance policy: a .45-70 lever action CoPilot rifle. They never had a chance to use it.

In the predawn darkness, a three-hundred-pound, blond, male grizzly happened upon the camp. It could probably sense that this was a small group. (According to Stephen Herrero's seminal work, *Bear Attacks: Their Causes and Avoidance,* bears will rarely attack a group of three or more. A group of six or more has never been attacked.) The grizzly may have curiously swiped at the tent with its daggered claws and then reacted to the inevitable commotion inside. Or, even more disturbingly, it may have intended to kill and eat the Huffmans from the beginning.

Although genetically identical to the eight-foot, nine-hundred-pound coastal brown bears of southern Alaska, the barren ground grizzly rarely tops six feet and five hundred pounds. A scarcity of food in northern Alaska makes these grizzlies smaller, and they behave very differently from coastal brown bears. Well-fed brown bears sleep a lot and shamble around a ten-square-mile territory. In contrast, hungry barren ground grizzlies can prowl five-thousand-square-mile territories, constantly sniffing the air for scent. In the Arctic—where there are no streams filled with fat salmon, no forests to provide shade or cover, and food gathering is cut short by the long winters—the omnivorous barren ground's mission is simple: relentlessly hunt down and consume every available scrap of food.

Roots and sedges help them fend off starvation, but for thousands of years these grizzlies have preferred meat, found in fresh supply at the movable feasts that are Alaska's legendary caribou herd migrations. Each June on the refuge's coastal plain, caribou herds birth up to sixty thousand calves, and bears can kill

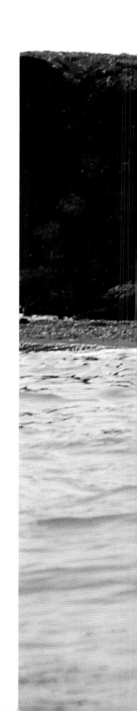

An omnivorous and fearless barren ground grizzly searching for food along the Beaufort Sea coast, in a territory that could include up to five thousand square miles.

up to six newborns a day. But this meat supply has been dwindling as the effects of climate change become manifest in the Arctic, and the habitually famished grizzlies are finding themselves in even more desperate straits.

According to a 2002 U.S. Geological Survey report, increased spring snow and ice—a paradoxical result of global warming trends—is burying the coastal plain plants essential to caribou and grizzly diets. The caribou are decreasing in number or seeking grazing land elsewhere, and the barren ground grizzlies, bereft of this supplemental protein, have been stalking the tundra for alternatives. U.S. Fish and Wildlife Service (USFWS) biologist Patricia Reynolds notes that over the past five or six years, the refuge's musk ox population has dwindled from around three hundred to no more than fifty. As human traffic increases in the refuge, one can only wonder if grizzlies might test them as new prey.

"That grizzly is more aggressive than the coastal brown bear," says Will Troyer, who began live-trapping bears in Alaska in the 1950s. "When I first went up there, you never saw any-body in that country except for the Eskimos. Now the climate is getting warmer, and there's more human activity."

Fran Mauer, a recently retired USFWS wildlife biologist, is one of many experts who say that bears could easily kill a lot more people, but don't. From 1900 to 2000, brown bears killed forty-two humans in Alaska (polar bears have killed one person in that time; black bears, six). But with more people visiting the north, it will only get more difficult for the emboldened barren ground grizzly to avoid human encounters. A day before the Huffmans were discovered, the bush pilot who dropped Mauer off in the refuge asked if he was packing a gun because the bears were acting up.

The grizzly was still there when North Slope Borough Search and Rescue pilot Bob Mercier hovered his helicopter over the Huffmans' camp. It was lingering near the couple's remains, which were tangled up in their ruined tent. As the rotor blades churned overhead, the bear ran off but sat a quarter mile away, unwilling to give up his kill. Because there were human

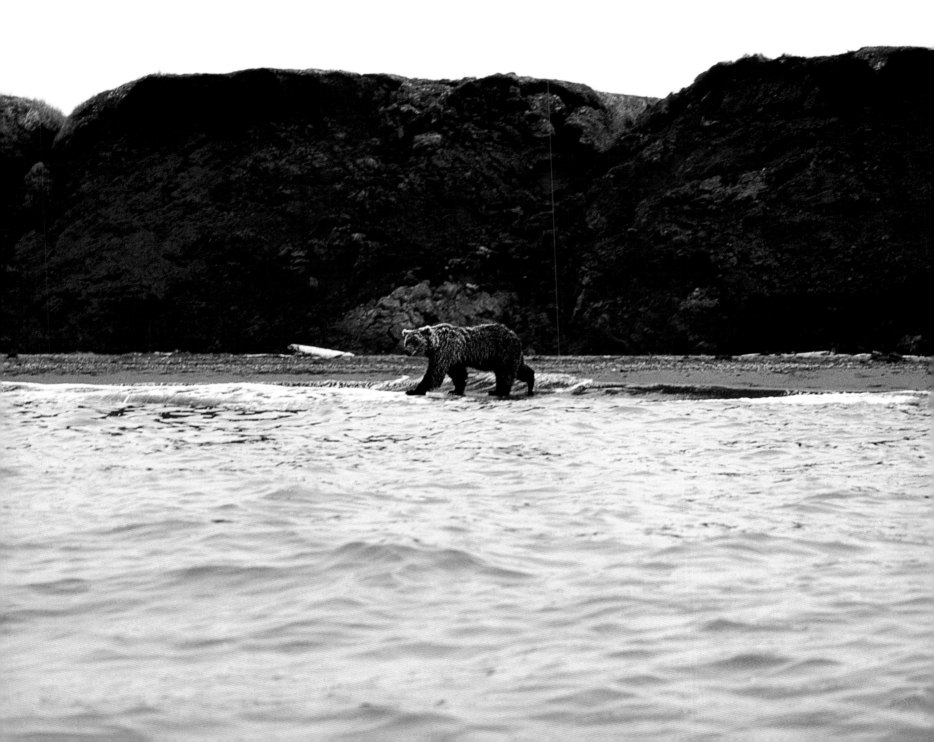

fatalities, the pilot flew straight to Kaktovik and picked up Officer Richard Holschen of the North Slope Borough Police Department. On their return, the helicopter again scared the bear away from the bodies, and Mercier was able to touch down so Holschen could investigate.

An initial examination of the scene revealed that Rich Huffman had tried to fend off the bear. He'd released the lever action of his rifle, but never had a chance to pull it back and chamber a round. The couple was likely startled awake and trapped inside their tent with mere seconds to defend themselves. In the three years Holschen had worked in Kaktovik, he had frequently driven polar bears out of town and away from whale carcasses, and they had always run far away. But when he looked up, he was unnerved to see the Hulahula grizzly lumbering back toward the campsite.

Holschen, armed with a shotgun, waited for the bear to come closer. Mercier, meanwhile, revved the Bell 412 into the air, and his co-captain, Randy Crosby, chambered a round in his rifle and dropped the grizzly with four bullets.

The next day, Alaska Department of Fish and Game biologist Dick Shideler arrived to inspect the scene. The bear containers had been scuffed and thrown around. Nearly every piece of gear, including the two inflatable kayaks, had been bitten or torn apart. A raw east wind had been blowing the past few evenings, so it seemed likely that the couple had chosen this spot along the river because it sat below a ten-foot-high tundra bluff. Even if the Huffmans weren't in their tent, they likely would not have seen the bear coming. "It was a site I would've picked as an experienced camper," Shideler said, "but as a bear person, I would've walked around and looked for fresh diggings." On the bench above the campsite, where the tents and bodies had been dragged, claw marks showed where a hungry grizzly had repeatedly raked the tundra for bear roots; several ground squirrel holes had been dug up. The tracks matched the dead bear's.

The following week, Shideler performed a necropsy on the bear. It was seven years old and in remarkably good health. It had no scars,

no old wounds, not even the expected broken canine from sparring with other males.

For weeks after the mauling, villagers in Kaktovik kept asking Officer Holschen what the Huffmans had done wrong. "The freaky thing," Holschen said, "is that they did most everything right."

Some in the region believe that this was simply a rogue bear, but Shideler dismisses those claims. "This bear was perfectly healthy and following normal predation patterns," he said. Others see a trend afoot. Last summer, Arctic Wild guide Jennifer van den Berg was briefly confronted by a bear that, despite her shouts, showed no fear of humans. Shortly before the Huffmans arrived, backpackers near the eastern boundry were bluff-charged by a grizzly. Whether rogue bear or emerging trend, the Huffman incident underscores the Achilles' heel of all arctic travelers: being stalked in your tent while asleep on the tundra.

Thompson, the river guide who found the Huffmans' campsite, believes that a floorless tent [to prevent the occupants from getting trapped inside], an electric fence, and a loaded pistol (that doesn't need to be cocked) might help future campers. "I never take bear food canisters," he said. "If the bear is hungry, he might get ticked off. It's no big deal for him to eat my food instead of me. Some guys stack pots on their food bags so that if a bear comes into camp, the pots fall off and wake them up."

Thompson is an environmentalist in a community that has a long tradition of bear hunting and is divided on the subject of oil development. For five seasons, he has managed to guide without killing a bear. "I've spent my whole life in the wilderness trapping and guiding," he said, "and this is my first close encounter." After the harrowing pursuit that day in June, he vows that he'll shoot to kill the next time he's chased by a barren ground grizzly.

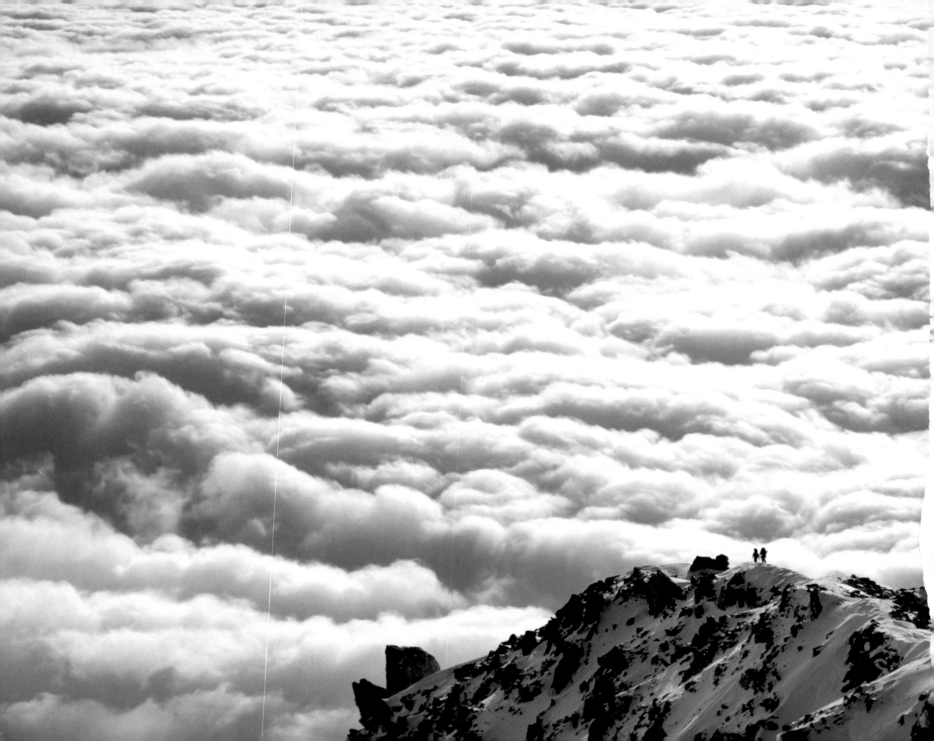